Maxfield Parrish

1870 – 1966

Maxfield Parrish

1870–1966

Sylvia Yount

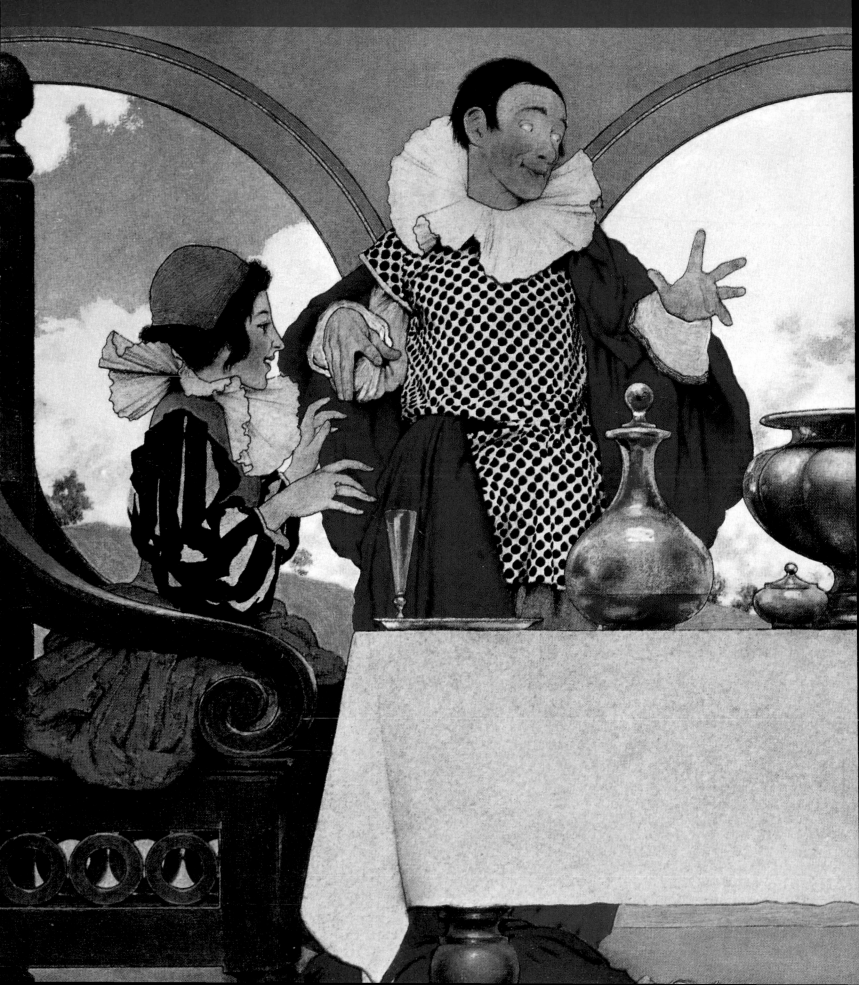

Harry N. Abrams, Inc., Publishers,

in association with the

Pennsylvania Academy of the Fine Arts

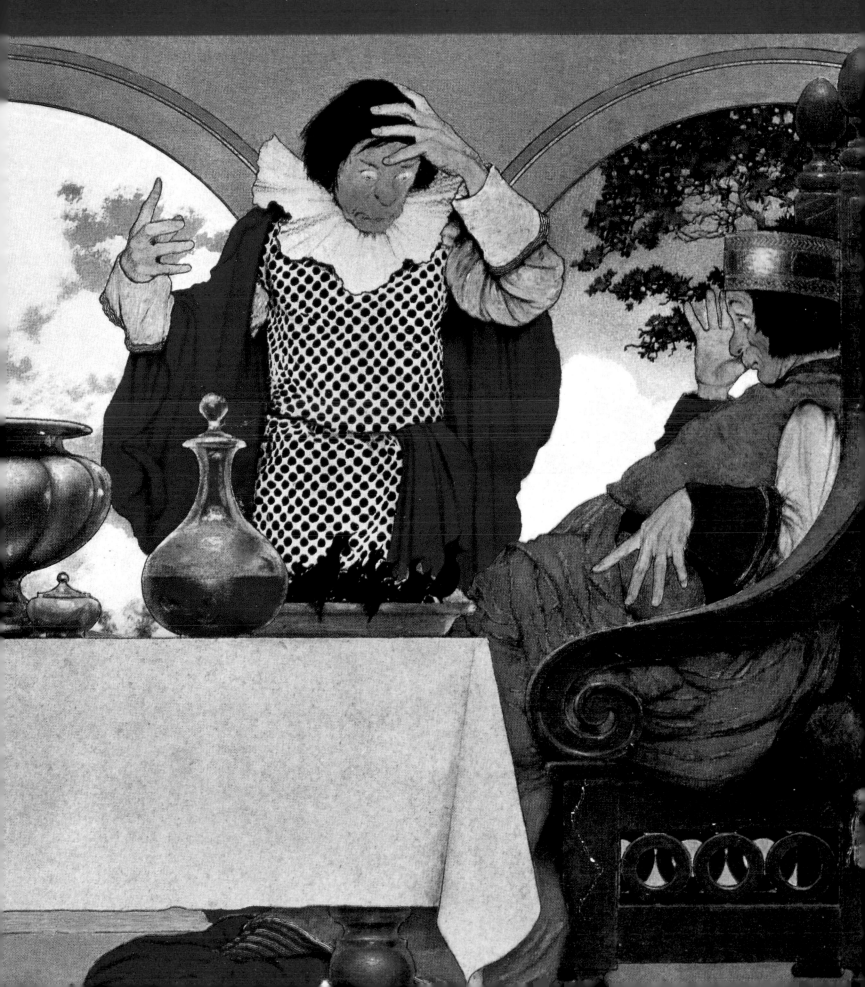

EXHIBITION ITINERARY

Pennsylvania Academy of the Fine Arts
Philadelphia, Pennsylvania
June 19–September 25, 1999

Memorial Art Gallery of the University of Rochester
Rochester, New York
February 19–April 30, 2000

Currier Gallery of Art
Manchester, New Hampshire
November 6, 1999–January 23, 2000

Brooklyn Museum of Art
Brooklyn, New York
May 26–August 6, 2000

PROJECT MANAGER: MARGARET RENNOLDS CHACE
EDITOR: HOWARD W. REEVES
DESIGNER: DARILYN LOWE CARNES

Library of Congress Cataloging-in-Publication Data
Yount, Sylvia.
 Maxfield Parrish, 1870–1966 / Sylvia Yount
 p. cm.
 Catalog of an exhibition held at the Pennsylvania Academy of the Fine Arts,
Philadelphia, Pa. and three other institutions between June 19, 1999 and Aug. 6, 2000.
 Includes bibliographical references and index.
 ISBN 0-8109-4367-0 (Abrams: hc)/ISBN 0–943836–19–0 (Mus: pbk)
 1. Parrish, Maxfield, 1870–1966 — Exhibitions. I. Parrish, Maxfield, 1870-1966.
 II. Pennsylvania Academy of the Fine Arts. III. Title.
N6537 .P264A4 1999
760' .09—dc21 98-40691

Half-title page: Mask and Wig Caricatures, 1895, detail from page 33.
Title page: *Sing A Song of Sixpence*, 1910, detail, see pages 46–47.
Contents page: *Haverford Classbook: Historian*, 1889, detail, see page 19.
Pages 16–17: *Perspective Manual*, ca. 1892–94, details, see page 29.

Printed and bound in Japan

Harry N. Abrams, Inc.
100 Fifth Avenue
New York, N.Y. 10011
www.abramsbooks.com

Contents

Acknowledgments

THIS PROJECT WOULD NOT HAVE BEEN REALIZED WITHOUT THE welcome collaboration of numerous parties. First, I wish to thank the lenders, both public and private, who provided the raw material for my reexamination of Maxfield Parrish's work and career. In particular, I am indebted to the staff of the Rare Book Department of the Free Library of Philadelphia—especially Karen Lightner and Bill Lang—as well as Jean Gilmore and Gene Harris of the Brandywine River Museum, for so generously sharing their Parrish collections with a national audience. Alma Gilbert, expert in all things "Parrish," and Ronald Winters offered crucial assistance in the development of the exhibition checklist. Ka-Kee Yan, doctoral candidate in the history of art at the University of Pennsylvania, was an ideal research intern, accommodating all requests with gracious equanimity and diligence.

From the beginning, the enthusiastic support of the American Federation of Arts, our partner in this enterprise, has been indispensable to its overall success. Particularly, I want to recognize the critical contributions of Donna Gustafson, curator and administrator of exhibitions; Mary Grace Knorr, registrar; and Amy Cooper, exhibitions assistant; they have been a joy to work with. At Harry N. Abrams, Inc., Margaret Rennolds Chace, managing editor; Howard W. Reeves, senior editor; and Lia Ronnen, editorial assistant, deserve high praise for their patience and professionalism. Darilyn Lowe Carnes is to be applauded for her inventive design of the book. A major grant from the Henry Luce Foundation, Inc., offered both significant material assistance and intellectual validation of the exhibition concept.

At the Pennsylvania Academy of the Fine Arts, recognition is particularly due to Daniel Rosenfeld, Edna S. Tuttleman Director of the Museum, for his endorsement of the Parrish project; Cheryl Leibold, archivist, for her expert guidance through the institution's rich history; Barbara Katus and Peter Cullum, rights and reproductions, for their unstinting hard work and good humor; and Mark F. Bockrath, formerly chief conservator, both for his insightful contribution to this book and his skillful treatment of numerous works in the exhibition.

Finally, I want to thank my family, Thomas and Tristan Genetta, who have lived with this challenging project from its inception (which in Tristan's case paralleled his own) and who, with my sister Caroline, offered much-needed encouragement and support throughout its development and realization.

SYLVIA YOUNT
CURATOR OF COLLECTIONS
PENNSYLVANIA ACADEMY
OF THE FINE ARTS

I WOULD LIKE TO THANK THE PENNSYLVANIA ACADEMY'S curator of collections, Sylvia Yount, for her editing of this manuscript and for her assistance with its preparation in so many ways; conservators Joanne Barry, Rikke Foulke, and Philip Klausmeyer for treatment and analytical work on several paintings in the exhibition; photographer Rick Echelmeyer, who produced many of the illustrations in the text; Jean Gilmore, registrar, and Christine Podmaniczky, associate curator, N. C. Wyeth Collections of the Brandywine River Museum, for their assistance in locating source material on Parrish and Wyeth, respectively; Professor Richard Wolbers of the University of Delaware for his documentation of paint cross sections; Kathryn Grimshaw, administrative assistant to the director, Museum of the Pennsylvania Academy, for typing the manuscript; and finally, my wife, conservator Barbara A. Buckley, for her many insights and suggestions made during the course of research on this project.

MARK F. BOCKRATH
PAINTINGS CONSERVATOR
THE HENRY FRANCIS DUPONT
WINTERTHUR MUSEUM

[Cutout Model for] Entrance to Old King Cole Room. 1936. Oil on paper mounted on Masonite and wood, 20½ x 21⅝" (52.07 x 54.93 cm). Collection of the Brandywine River Museum, Chadds Ford, PA. Anonymous Gift

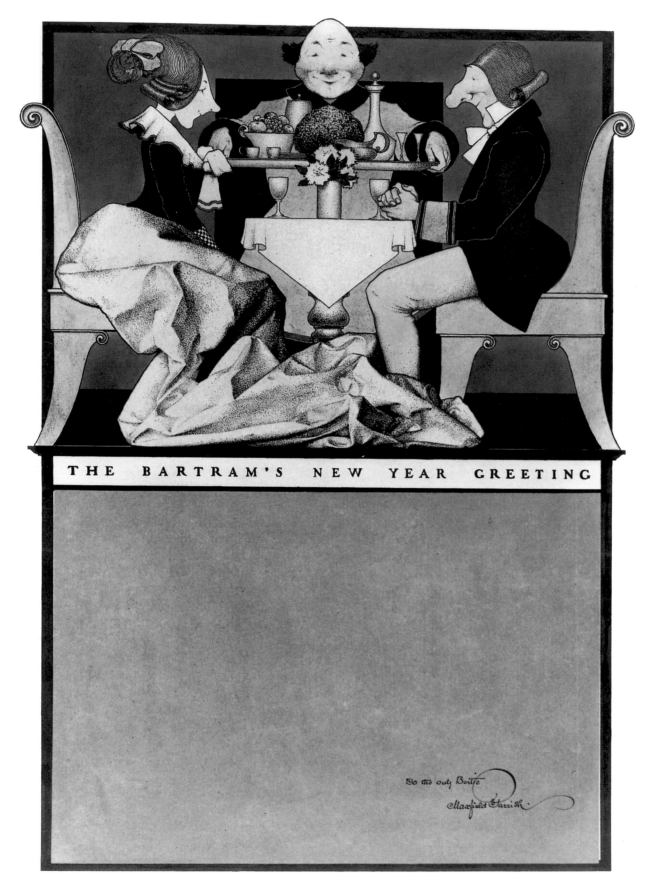

THE BARTRAM'S NEW YEAR GREETING

The Bartram's New Year Greeting. 1897. Mixed media on paper, 25¾ x 18¼" (65.40 x 46.35 cm). Collection of the Brandywine River Museum, Chadds Ford, PA. Gift of Bertha Bates Cole, in memory of Bertha Corson Day Bates

Forewords

MAXFIELD PARRISH WAS BORN IN PHILADELPHIA, STUDIED painting at the Pennsylvania Academy of the Fine Arts, and lived much of his adult life in Cornish, New Hampshire, where he produced work destined for a national audience. Deeply committed to the democratization of art and fully cognizant of the new printing technologies and publishing forums, he was America's first truly public artist. At the same time, he enjoyed membership in the Society of American Artists and competed and often won awards in such prestigious forums as the juried annual exhibitions of the Pennsylvania Academy of the Fine Arts and the Paris International Expositions. This book and the exhibition that it accompanies present new scholarship and celebrate Maxfield Parrish as an artist whose images transcend the categories of art and illustration. We also hope to challenge accepted notions about the artist and his place in the history of American art and culture.

The American Federation of Arts (AFA) is honored to work with the Pennsylvania Academy of the Fine Arts to bring this critical survey to a national audience. We are grateful to Daniel Rosenfeld, director of the museum, and Sylvia Yount, curator of collections. Credit for the curatorial acumen of the exhibition belongs to Dr. Yount, who conceived and developed the project and whose intelligence and good sense have contributed immeasurably to the success of this collaboration. We also wish to thank Mark F. Bockrath, paintings conservator at the Henry Francis duPont Winterthur Museum, and formerly chief conservator at the Academy, whose essay has provided a significant new understanding of the artist's method.

At the AFA, *Maxfield Parrish 1870–1966* has been realized through the efforts of numerous staff members. Donna Gustafson, curator and administrator of exhibitions, oversaw the organization of the exhibition and the national tour. Katey Brown, head of education, created the educational materials that accompany the exhibition in collaboration with Glenn Tomlinson, director of museum education and audience development at the Academy. Mary Grace Knorr, registrar, coordinated all aspects of the handling and packing of the exhibition. I also want to acknowledge Thomas Padon, director of exhibitions, whose support of the project was crucial to its success; Michaelyn Mitchell, head of publications; Amy Cooper, exhibitions assistant; and Stephanie Ruggiero, communications assistant.

Recognition is also due the museums participating in the national tour of the exhibition: the Currier Gallery of Art, Manchester, New Hampshire; the Memorial Art Gallery of the University of Rochester, Rochester, New York; and the Brooklyn Museum of Art, Brooklyn, New York.

SERENA RATTAZZI, DIRECTOR
THE AMERICAN FEDERATION OF ARTS

THIS BOOK AND EXHIBITION PRESENT THE OCCASION FOR A reexamination of one of the most unique, compelling, and problematic figures in the history of American art. An artist of consummate craft, invention, and imaginative appeal, Maxfield Parrish enjoyed a level of popular success unparalleled in the history of art. This was due in equal measure to the broad appeal of the artist's visionary imagination, to his seductive technique, and no less to his singular instinct for the dissemination of reproductions, suitable for framing, that were the product of newly developed, high-quality color printing technologies. Parrish was the first artist to exploit mass marketing in lieu of the art gallery system for the distribution of his work. As a result, he enjoyed extraordinary visibility that was achieved largely outside of the fine arts establishment, acquiring the status of both an "outsider" and one of the best-known and best-loved artists in America.

Parrish's art emerged and flourished largely apart from the critical debates surrounding the art of this century, and, hence, his work appears to have been sustained as if in a vacuum. In his own estimation, Parrish considered himself "strictly a 'popular' artist," who was suspicious of the critical attention directed to his achievements at the very end of his career. In addition to their role in introducing Parrish to a contemporary museum audience, it is hoped that this book and exhibition will begin to fill this vacuum and to enable the viewer to understand the artist's rather complex ties to the modern world.

The idea of reevaluating Parrish in these terms was the inspiration of Sylvia Yount. Against some initial skepticism, Dr. Yount had the insight to understand Parrish's singular importance to the history of American art and the concomitant importance of a critical reassessment of his work in view of its place outside the canons of American art history. She also had the foresight to understand that Parrish, a student of the Pennsylvania Academy, should be the beneficiary of its attention and celebration one hundred and eight years after he began his studies at this venerable institution of *fine* arts. In the melding of the "fine" and the "applied," Parrish also stands as somewhat of an anomaly and, hence, important to a more complex reading of this institution and its influence. Yount's essay is accompanied by another by Mark F. Bockrath, formerly chief conservator at the Pennsylvania Academy and currently paintings conservator at the Henry Francis duPont Winterthur Museum. We are grateful to Bockrath for the insights he has brought to Parrish's technical achievement, which is a critical component of his artistic appeal.

Research for this exhibition and book has been supported by a generous grant from the Henry Luce Foundation, Inc. We are grateful to the Luce Foundation for its financial support and for acknowledging the importance of bringing Parrish within the historiography of American art. We are also very grateful to the American Federation of Arts and, in particular, Serena Rattazzi, director, and Donna Gustafson,

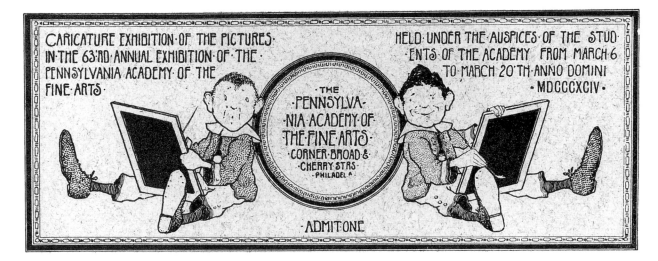

Student Caricature Exhibition of the Pennsylvania Academy of the Fine Arts. 1893–94. Souvenir ticket. Pennsylvania Academy of the Fine Arts

curator and administrator of exhibitions, for their support of this enterprise and for the opportunity to see it travel to three distinguished museums.

In his 1964 article "The Return of Maxfield Parrish," Lawrence Alloway observed, "There is, behind the prestigious and visible mainstream of art . . . an invisible art world, with its own heroes and its own specialized tastes." Both areas, he continued, "have opposed views of what art is and both disbelieve in the other's relevance and seriousness." Maxfield Parrish was clearly the hero par excellence of this "invisible" art world and, notably, in his time, the most visible artist in the world. We hope this exhibition and book may serve to explore the gap between these two worlds and, ideally, to reveal the potential of the work of Maxfield Parrish—at least in our own time—to bridge the gap between the two.

DANIEL ROSENFELD

THE EDNA S. TUTTLEMAN DIRECTOR

OF THE MUSEUM OF THE PENNSYLVANIA

ACADEMY OF THE FINE ARTS

Lenders to the Exhibition

Joan Purves Adams

Addison Gallery of American Art, Phillips Academy,
 Andover, MA

American Precision Museum, Windsor, VT

Brandywine River Museum, Chadds Ford, PA

Bryn Mawr College Archives, Bryn Mawr, PA

Mr. and Mrs. Donald Caldwell

Carnegie Museum of Art, Pittsburgh, PA

Cleveland Museum of Art, OH

Mr. and Mrs. Michael L. Crippen

Mr. and Mrs. Thomas Davies

Delaware Art Museum, Wilmington

Detroit Institute of Arts, MI

Fine Arts Museums of San Francisco, CA

Free Library of Philadelphia, PA

Beatrice W. B. Garvan

Alma Gilbert and Peter Smith

Haggin Museum, Stockton, CA

Harvard University Art Museums, Cambridge, MA

Haverford College Library, Special Collections, PA

High Museum of Art, Atlanta, GA

Historical Society of Pennsylvania, Philadelphia

Hood Museum of Art, Dartmouth College, Hanover, NH

Jim and Judi Kaiser

Jason Karp and Sandra Lake

Frances Lehman Loeb Art Center, Vassar College,
 Poughkeepsie, NY

Virgil Marti

Memorial Art Gallery of the University of Rochester,
 Rochester, NY

Metropolitan Museum of Art, New York, NY

Robert Miller and Betsy Wittenborn Miller

Robert Miller Gallery, New York

Minneapolis Institute of Arts, MN

Charles Hosmer Morse Museum of American Art,
 Winter Park, FL

Museum of Art, Rhode Island School of Design,
 Providence

Museum of Fine Arts, Boston, MA

National Academy Museum, New York, NY

National Museum of American Art, Washington, DC

New Britain Museum of American Art, CT

Pennsylvania Academy of the Fine Arts,
 Philadelphia, PA

Philadelphia Museum of Art, PA

Phoenix Art Museum, AZ

Private Collectors

Saint-Gaudens National Historical Site, Cornish, NH

Louis Sanchez

Ron and Marilyn Sanchez

Justin G. Schiller

Syracuse University Art Collection, NY

Creston Tanner

University of California Library, Special Collections,
 Davis

Virginia Museum of Fine Arts, Richmond

Joseph Zicherman

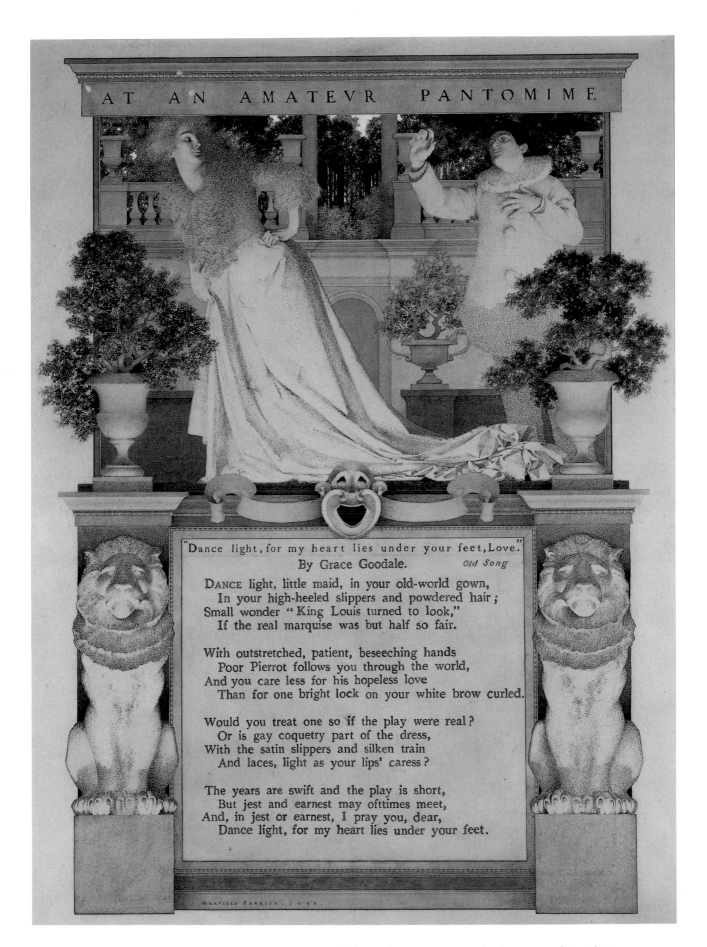

At an Amateur Pantomime. 1898. Wash, ink, pencil, crayon, and lithographic crayon on Steinbach® paper, 27 ⅜ x 18 ½"
(69.55 x 46.99 cm). Museum of Fine Arts, Boston. Gift of Mrs. J. Templeman Coolidge

DREAM DAYS
The Art of Maxfield Parrish

Sylvia Yount

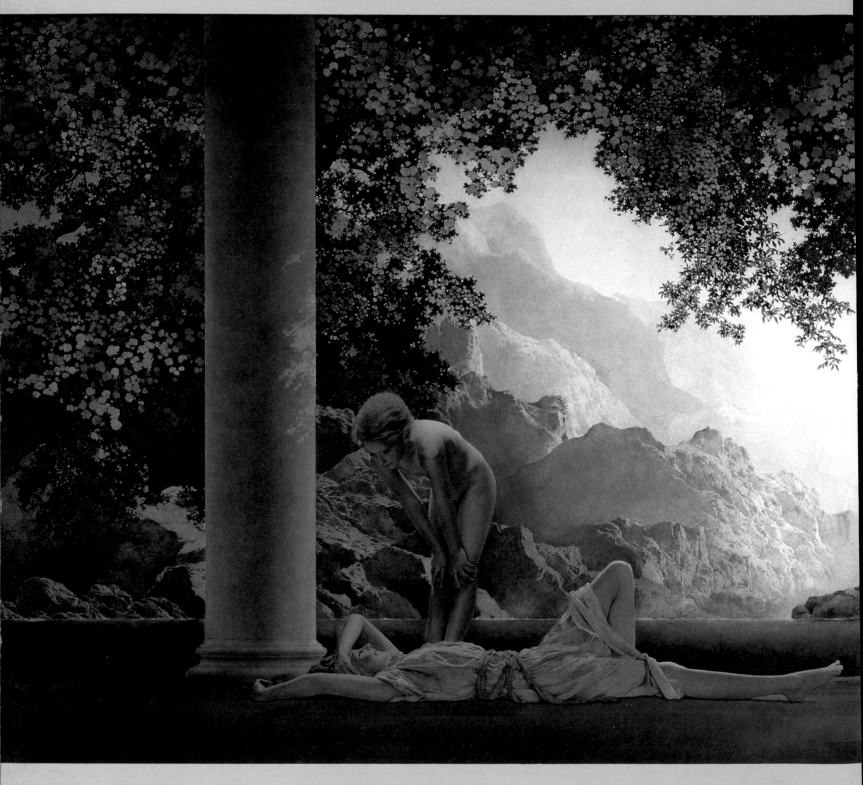

Daybreak. 1922. Oil on panel, 26 x 45" (66.04 x 114.3 cm). Private Collection

I N 1993, THE RUSSIAN émigré artists Vitaly Komar and Alexander Melamid conducted what they billed the "first-ever comprehensive, scientific poll of American tastes in art," specifically painting. Questioning whether or not there is such a thing as truly public art, the artists—working with a professional polling firm—discovered that a cross section of Americans favored a "tranquil, realistic blue landscape," the kind of work derided by the art world. The results of this conceptual project, documented in both exhibition and book form, suggest that the division between elite and popular taste is alive and well in 1990s America despite the long-standing, mutually informing relationship between both forms of artistic production.[1]

Seven decades earlier, Maxfield Parrish's *Daybreak*, the first work by the artist created specifically for reproduction as an art print, achieved extraordinary success as a popular icon. The New York and London–based publishing firm that commissioned the work, the House of Art, estimated that, by 1925, both high- and low-end reproductions of the painting could be found in one out of every four American households.[2] What was it about this image that appealed to a mass audience at a particular time and place? Could it have been

the work's thinly veiled erotic innocence, suggesting a metaphor for female sexual awakening, or something even more universal? Komar and Melamid's data offer some possible answers.

The public's elusive blue landscape turned out to be the "most wanted" painting by focus groups surveyed on four different continents, leading Melamid to ponder whether this type of work "is genetically imprinted in us, that it's the paradise within, that we came from the blue landscape and we want it."[3] As a master of "ever-deepening blues" whose name became synonymous with a certain hue, Parrish may have achieved what Melamid calls the "dream of modernism . . . to find a universal art" that speaks to all humankind.[4]

This rhetoric of universality shaped the critical and general reception of Parrish's art throughout his seventy-year career, leading *Time* magazine, in 1936, to declare: "as far as the sale of expensive color reproductions is concerned, the three most popular artists in the world are [Vincent] van Gogh, [Paul] Cézanne, and Maxfield Parrish."[5] Parrish, unlike the other two painters, lived long enough to see his career rise, fall, and rise again, defying the conventional wisdom that the creative individual must suffer for success. As one of the most beloved artists of this century, Parrish (like van Gogh and Cézanne) continues posthumously to excite the public imagination. The current market for Parrish originals and reproductions—not to mention such consumer merchandise as calendars, cards, magnets, and so on—has never been stronger.[6]

The popular distinction Parrish enjoyed both then and now, however, has affected his standing in the larger art world. Much as Komar and Melamid's contemporary project was met with derision by noted members of the establishment, who deemed popular taste irrelevant to art, Parrish's reputation suffered as the ever-widening gap between "high" and "low" art, painting and illustration, polarized in the postwar years. As a result, his work is given scant, if any, attention in art-historical scholarship, even by those writers who claim to take a more inclusive view of visual culture.[7]

Lawrence Alloway, the critic and curator responsible for the rediscovery of Parrish in 1964, identified the artist at that time as belonging to the "invisible art world . . . unseen and undiscussed by all those concerned with the traditions of fine art," noting the radical distance his reputation had traveled.[8] For at least the first three decades of Parrish's career (1890s–1920s), he was highly regarded by both critics and colleagues as a fine artist, whose work just happened to appeal to a large public. That Parrish was acutely aware of his audience from the start suggests a market savvy that, while creating his once-celebrity status, has not endeared him to the postwar art world despite the fact that throughout history artists have more or less targeted their production—be it to the church, state, or anonymous market.[9] A broader investigation of Parrish's life and work, in the context of American culture, yields a clearer understanding of the ups and downs of his public profile, both then and now.

Master of Make-Believe

Parrish was truly a figure of his transitional time, a man for whom life and art were mutually reinforcing.[10] Coming of age in a world shaped by new technologies and a

heightened commercial awareness, he embodied both the nineteenth-century's spiritual love of nature and the twentieth-century's optimistic fascination with the machine. Frederick Maxfield Parrish was born into Philadelphia's Quaker elite and raised in a culturally privileged environment. From his father Stephen (1848–1938), an acclaimed etcher and land-scape painter, he inherited his talent for natural observation and an understanding of the business of art. (The senior Parrish ran a stationery shop until 1877, at which time he devoted himself full time to his creative work.) Parrish's mother, Elizabeth Bancroft, whose family the artist credited for his life-long interest in machinery, also instilled in him a love of music. (Later in life he wrote, "I wish with all my heart [music] were my medium instead of bad pictures."[11])

In addition to parental encouragement, Parrish's creative interests were nurtured by a broader cultural phenomenon—the so-called American Renaissance.[12] This epoch, stretching from the mid-1870s to the first decade of the twentieth century, witnessed a flowering of artistic practice—from painting, sculpture, and the graphic arts to the decorative arts, architecture, and landscape design—with an emphasis on aesthetic unity. Encompassing both the Aesthetic and the Arts and Crafts movements, this phenomenon challenged traditional artistic hierarchies of fine and applied arts; reconsidered the relationship between amateur and professional; and prompted a great deal of experimentation and collaboration in the art world. As multitalented painters, illustrators, sculptors, and architects explored a variety of decorative media, a more fluid conception of artistic production became the norm. That Parrish's expansive artistic sensibility found expression in all of these forms throughout his career marks him as an exemplary product of this age.[13]

With boundless energy and a workmanlike diligence—perhaps a by-product of his Quaker heritage—Parrish committed himself to the popularization and democratization of art, viewing beauty as a form of social betterment.[14] He took equal care with work destined for private and public enjoyment—be it easel and mural painting, book and magazine illustration, or advertising art. Contemporaries heralded his fundamentally "aristocratic genius," "dedicated by choice to democratic ends," and went so far as to lay the "brightest hope for democracy" at his feet on account of his tireless attempts to "bring 'the best' a little nearer to everybody, and everybody a little nearer to 'the best.'"[15]

In addition to his aesthetic philosophy, much of the hows and whats of Parrish's art, that is, the form and content, was shaped by the American Renaissance as it was enacted in Philadelphia and beyond. Early critical accounts of the artist emphasized his status as an "American original," a primarily self-taught individual who arrived on the scene with a fully developed talent. Parrish's early education, both formal and informal, however, had a profound impact on the trajectory of his career and merits examination.

According to family lore, Parrish's creative impulses first took flight into the realm of fantasy that would become his trademark on his third Christmas. A gift of a sketchbook from his father, filled with humorous drawings of animals and elfin creatures, sparked the boy's imagination and provided a form of

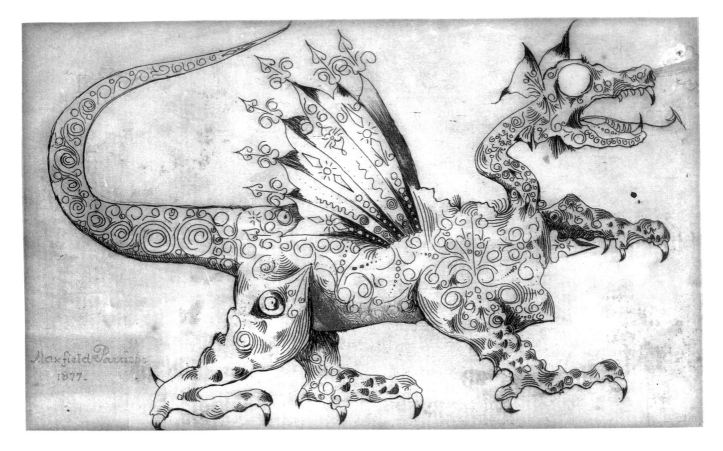

Dragon. 1877. Pen and ink on paper, 4½ x 7¾" (11.43 x 19.69 cm). Haverford College Library, PA. Special Collections

instruction. Numerous sketches in Parrish's own hand followed, including a drawing of a "demonical" dragon produced at the age of seven, a work that anticipated some of the artist's later themes.[16]

In a bit of whimsical hagiography, Christian Brinton, the artist's Haverford College roommate and later renowned art critic, observed that as a boy, Parrish, endowed with a "liberal allowance of Make-Believe . . . [and] armed with scissors and paste-pot," lived in a "cosmos entirely of his own concoction. . . . Artist and artisan were from the outset inseparable."[17]

Parrish's constant urge to embellish became most apparent on the extended European sojourn he spent with his parents from 1884 to 1886. (The artist had first visited the Continent at the age of seven.) In a series of letters to his cousin Henry Bancroft, Parrish recounted his experiences in a fanciful combination of word and caricatured image that underscored his wide-ranging interests: from architecture and music to machinery and nature.[18] The "olden-time" themes that would dominate his artistic career undoubtedly were drawn from these early travels throughout England, France, Italy, and Switzerland.

On the family's return to Philadelphia, Parrish worked with his father—whom he later credited as his most important teacher—and became increasingly interested in studying architecture, no doubt a desire that was encouraged by a family friend, the noted local Arts and Crafts architect Wilson Eyre.

In 1888, he reentered the Quaker educational system—having attended one year of Swarthmore

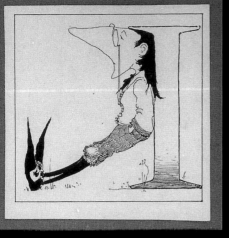

College's preparatory school before his European adventure—by enrolling at Haverford. Although there was no formal art program at the college, Parrish created his own aesthetic environment, both in the rooms he shared with Brinton and through various school projects. Architectural design and caricature were Parrish's two primary vehicles of expression during the two years he spent at Haverford, providing decorations for student publications and alumni functions

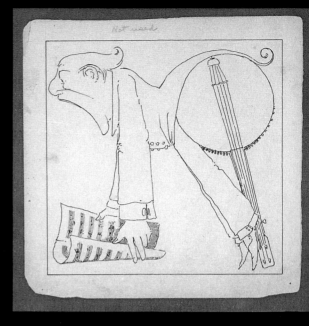

as well as embellishing his own chemistry notebook and ukulele (see page 20). As Brinton later observed, Parrish imported to college the "ripening legacy of play-room and workshop . . . creat[ing] about himself an atmosphere of decorative fantasy."[19]

In later years, Parrish observed that more than formal studies Haverford encouraged a love of nature, thereby providing inspiration for his future work: "Lying under those copper beeches, when we should have been doing something else, looking into the cathedral windows above did a lot more for us than contemplation of the Roman Colosseum. There were grand trees in those days, and grand trees do something to you."[20]

Parrish left Haverford after his junior year, having decided to pursue the visual arts rather than architecture.[21] Accordingly, in December 1891, he enrolled in Philadelphia's leading art institution, the

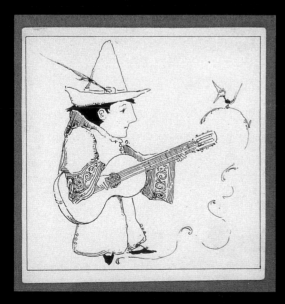

Pennsylvania Academy of the Fine Arts. As America's oldest art school and museum, the Academy offered Parrish a rigorous program of study that included drawing from plaster casts and

Haverford Classbook: Class Poet; Glee Club; Ukulele Player; Historian. 1889. Pen and ink on paper, 4½ x 4½" each (11.43 x 11.43 cm). Haverford College Library, PA. Special Collections

drawing and painting from the model—"antique" and "life" classes, respectively—(see page 21) as well as composition class.

Chemistry Notebook. 1889–90. Pen, ink, and watercolor on paper, 8½ x 7"
(21.59 x 17.78 cm). Haverford College Library, PA. Special Collections

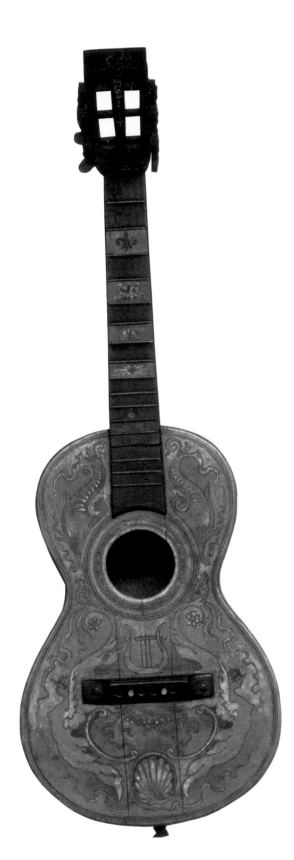

Ukulele. ca. 1889. Hand-painted
wood, 25 x 8 x 2" (63.5 x 20.32 x
5.08 cm). Haverford College
Library, PA. Special Collections

Based on student records, Parrish worked under the likes of Thomas Anshutz, the noted realist painter who, at the time, directed the Academy school; Robert Vonnoh, an American Impressionist to whom Parrish became particularly close; Carl Newman, a budding modernist known for his talent as a colorist; and Henry Thouron, the Academy's beloved composition instructor.

The cumulative influence of this eclectic group of instructors gave Parrish a solid background in both traditional and more progressive approaches to art making, despite Brinton's assessment that his friend's time at the Academy was "wholly superfluous, for he was already a draftsman and colorist of individuality and power."[22] Indeed, Parrish may have most enjoyed the composition

Men's Day Life. 1892–94. Charcoal and pencil on paper, 24⅝ x 19⅛" (62.56 x 48.59 cm). Pennsylvania Academy of the Fine Arts. Acquired by exchange through the gift of Mrs. Morris Fussell

class, in which he was able to explore his interest in decorative design: watercolors of a clockface and a stained-glass nursery window were just two class projects to receive early attention.[23] An 1895 exhibition review remarked on the fine "sense of color . . . and decorative composition" apparent in the work of Thouron's students, singling out Parrish in a prescient manner:

> . . . *in Mr. Parrish the academy has to-day [sic] among its students one of the most brilliant and most suggestive decorative painters in the country. With the ease of genius, he is accomplishing wonderful results at a stage when usually only the merest student crudities are turned out, and it is safe to say that all his work will be in swift and growing demand.*[24]

Parrish also likely benefited from the many special lectures presented at the Academy during his tenure. In February 1894, two on the history and current practice of illustration by W. Lewis Fraser, former art director of *Century* magazine, would have caught the young artist's attention and may even have served as the beginning of his future relationship with the respected journal.[25] Fraser and others like him, rather than artists, were employed by the Academy to meet the growing student demand for practical forms of instruction. At this time, the board did not consider illustration to be an appropriate part of a formal fine arts curriculum, assuming that such vocational training could be readily acquired on the job.

Howard Pyle. *A Great, Ugly, Poisonous Snake Crept Out of a Hole in the Wall.* ca. 1888. Pen and ink on paper, 12⅞ x 11¾" (33.02 x 30.12 cm). Delaware Art Museum. Museum Purchase

One of the figures who tried to change this perception on the part of art academies in general and the Pennsylvania Academy in particular was Howard Pyle. The Wilmington, Delaware–based artist served as staff illustrator for the Harper and Brothers publishing house during the 1870s, along with the Academy graduates Arthur B. Frost and Edwin Austin Abbey. Pyle achieved his greatest success in the 1880s with a series of children's books, written and illustrated by the artist and acclaimed as popular classics. Unlike many of his colleagues who increasingly turned to easel and mural painting, Pyle remained committed to illustration and became well known for his chivalric subjects. In 1894, perceiving a lack of serious attention to the art form, Pyle offered his services as instructor to the Academy, which the board declined. The nearby Drexel Institute of Art, Science, and Industry, however, due to its focus on the applied arts, welcomed Pyle in the same year to inaugurate a black-and-white illustration course. Two years later, he became director of Drexel's full-fledged School of Illustration, a position he occupied until 1900.[26]

Many Academy students interested in illustration attended Pyle's Drexel course, including future successes such as Violet Oakley, Jessie Willcox Smith, and Parrish. Although never formally enrolled at the school, Parrish established a relationship with Pyle that influenced his auspicious start in the commercial field. Apparently, having presented a portfolio of work for critical review, Parrish was told by the elder illustrator that there was nothing more Pyle could teach him and advised Parrish to focus on establishing his own individual style. Pyle further encouraged Parrish to enter the field professionally, offering to provide him with a letter of introduction to Harper and Brothers. Whether the letter was indeed sent, Parrish won his first magazine cover commission from *Harper's Bazar* in 1895.[27]

The tremendous popularity of Pyle's Drexel class among Academy students led the board to reconsider its earlier rejection of his services. In 1895, the Academy invited Pyle to teach an illustration course, an offer he promptly refused.[28] While illustrators such as Pyle had to overcome a certain amount of bias in establishing themselves as professionals in the 1870s and 1880s, a decade later a younger generation found greater opportunities in the field due to the expansion of the publishing industry. This boom in illustrated mass-market periodicals and newspapers, in turn, generated a growing respect for the skills of the artist–illustrator.

Overall, what Parrish appeared to value most about his Academy years was the social network of classmates and the myriad experiences this fellowship engendered. (After his 1898 move to Plainfield, New Hampshire, he would find such community in the artists' colony of nearby Cornish.) A series of letters between Parrish and an Academy friend, Daisy Evangeline Deming, reveals much about the development of his artistic identity during these student years.

Corresponding with Deming while away from the city, Parrish waxes poetical about nature and its power over him; gossips about Academy happenings; and discusses his "philosophy of work."[29] In one letter in particular, written from Annisquam, Massachusetts, where Parrish shared a studio with his father during the summer of 1893, the artist goes on at length about the intensity of his labors and how little he has to show for them:

> You can scarcely imagine what I have been through. Most of the time wading through impossible phases of ideas and practices. I paint, and then scrape it out at night, trying to overcome my evil tendencies of last summer. That is what I have been doing ever since I have been here, and if I have learned nothing else, I know that art is no picnic.[30]

In the same letter, Parrish shares what amounts to an epiphany in terms of his future career choices: "I have had a solitary existence, and never before knew what a new, glorious life it was when spent out of doors with nature and things . . . maybe it has changed me in many ways." Later, he connects this general recognition of the importance of place in his work to the specific, describing his parents' new home, "Northcote," in Cornish:

> Oh, Daisy, you should see our place up on the hillside in New Hampshire. I was there for a week, and it went away ahead of my expectations. Wilson Eyre is putting us a pretty house upon it. . . . Such an ideal country, so paintable and beautiful, so far away from everything—and a place to dream one's life away. . . . I long to be up there and become identified with it.[31]

Although Parrish could not extract himself from city life—keeping busy with commissions in various Philadelphia studios—for nearly five more years, from 1898 until his death in 1966, both his life and work would be inextricably linked to that "paradise in the mountains."[32]

Parrish's social circle at the Academy included a number of women and men who would make their mark as artist–illustrators after the turn of the century, namely, Florence Scovel, who, with her future husband, Ashcan artist Everett Shinn, would summer in Cornish in later years; James M. Preston, later associated with the Pennsylvania Post-Impressionists; and William Glackens, one of the founding members of the Ashcan group of artists.[33] A circa 1893 photograph of Parrish and his colleagues, possibly documenting an outdoor session of Thouron's composition class, suggests the easy camaraderie that existed between these students who shared design interests.

Although it is clear from Parrish's student writings that he thought of himself as a painter, it is no less clear that he did not view fine and applied art as mutually exclusive. Having gained an early introduction to and respect for reproductive media through his father's practice—coupled with an ambition to establish a successful career that would afford him a certain amount of artistic freedom—Parrish turned his attention to the popular arts of illustration and mural design. While this ambition was hardly unique to the artist—countless Academy classmates surely shared it—the raw material was. Indeed, Parrish's distinctive technique and sensibility attracted a great deal of public attention in these early years.

Seeking sources and influences for his artistic approach in the Academy context is tempting. For example, Parrish was a sophisticated and discriminating viewer of art and surely benefited from the variety of exhibitions sponsored by the institution. From the juried annuals of generally mainstream work to the more progressive roster of special displays, the Academy presented Parrish with a wealth of material from which to learn and define himself against. During his student years, the artist would have seen, among others, an 1892 exhibition of English Pre-Raphaelite painters and William Blake, from the Wilmington, Delaware, collection of Samuel Bancroft (Parrish's cousin, brother of Henry), and, in 1893, loan exhibitions of decorative bindings, rare books, and manuscripts; a collection of facsimiles of ancient memorial brasses; and the Photographic Society of Philadelphia's Sixth Annual Exhibition.[34]

All of these efforts suggest future interests of Parrish—from his stylistic phase that found a vigorous middle ground between the work of Edward Burne-Jones and Frederic Leighton to his affection for books, metalwork, and photography. But perhaps the most significant influence stemmed from the Academy's Sixty-third Annual Exhibition. The prizewinning work in this Annual suggested the poles of stylistic taste advanced by the Academy in the 1890s. This institutional aesthetic of the ideal and the real (and their frequent conflation) had a notable impact on Parrish.[35]

Running from December 1893 to February 1894, the Sixty-third Annual featured a large selection of work from the American art display at the Chicago World's Fair. Paintings by such "masters" as John Singer Sargent, James McNeill Whistler, Winslow Homer, and Frank Duveneck revealed the cosmopolitan eclecticism that characterized progressive American art at the time. Sargent's spectacular portrait of *Ellen Terry as Lady Macbeth*—the most critically acclaimed painting in Chicago—also won accolades in Philadelphia, forming the centerpiece of the Academy's display and securing the Temple Gold Medal for the best figurative painting in the exhibition (see page 26). This portrait of the leading Shakespearean actress of the Victorian stage, which had entranced critics at the exposition as a "*tour de force* of realism applied to

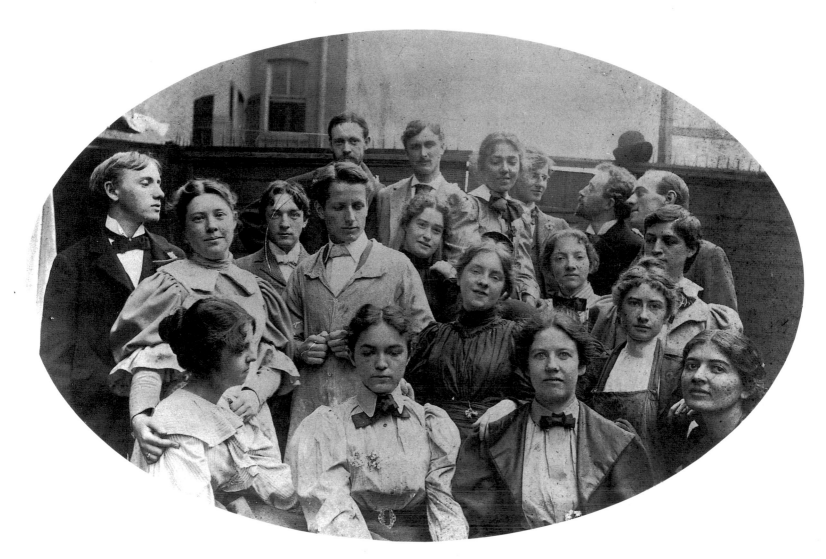

Pennsylvania Academy of the Fine Arts Composition Class. ca. 1893. Photograph. Collection of Alma Gilbert

the artificial," reinforced the Academy's particular interest in work that combined fantasy and reality.[36]

An art school tradition that came to Philadelphia on the tails of the Sixty-third Annual was an irreverent student response to their elders, known as the caricature exhibition.[37] Approximately two hundred pictures spoofing some of the more notable works in the Annual were on view at the Academy following the close of the official exhibition. Parrish designed the souvenir ticket (see page 11) for this special event and submitted a humorous take on the work of one of his favorite teachers, Robert Vonnoh's *Coquelicots (Poppies)* (see page 27). Both designs were highly regarded as more than just sport; one reviewer described the ticket as "remarkably clever . . . so thoroughly in keeping with the spirit of the occasion." Parrish's other contribution was singled out for praise in various accounts:

The "Poppy Field" of Mr. Vonnoh's has provoked what is probably the most unique piece of work in the exhibition. Mr. Vonnoh's picture is particularly strong, especially in color, the poppies in the foreground being realistic in the extreme. The color, too, has been used unsparingly, appearing in

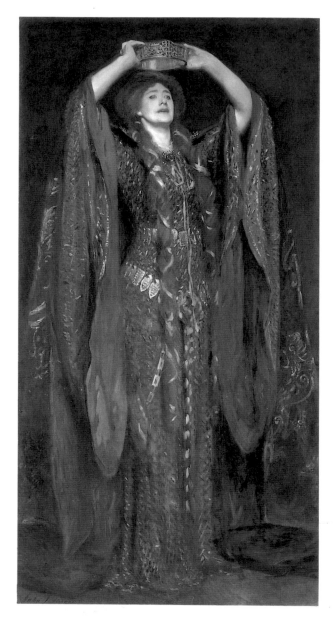

John Singer Sargent. *Ellen Terry as Lady Macbeth.* 1889.
Oil on canvas, 87 x 45" (221 x 114.3 cm). Tate Gallery,
London. Gift of Sir Joseph Duveen

huge lumps, the object being to get purity of color. The caricaturist has gone him one better on all of these peculiarities, and the color has been modeled in bold relief, while the poppies in the foreground are made of paper, and attached to the canvas by the means of wire stems. The whole is a remarkably successful result, both in a humorous and artistic sense.[38]

This witty picture, which won second prize, reveals Parrish's "mechanical" skills, as it suggests a working method—the use of paper cutouts—he would employ throughout his career.[39]

The caricature exhibition was so popular with both the critical and general public that at least two more followed in 1895 and 1896. Parrish participated in the second effort, serving on the exhibition committee (with Florence Scovel and John Sloan) and creating the exhibition poster, which was recognized as one of the finest pieces in the show: "a very beautiful study

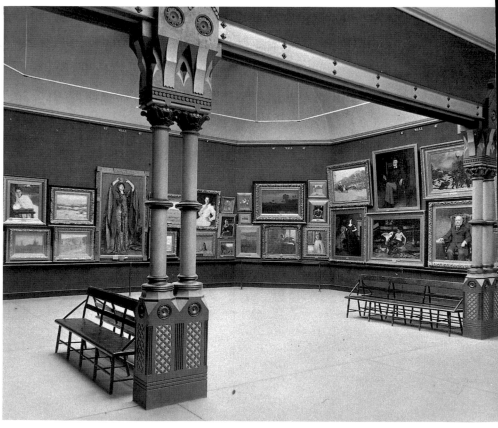

Sixty-third Annual Exhibition of the Pennsylvania Academy of the Fine Arts. 1893–94.
Installation photograph. Pennsylvania Academy of the Fine Arts

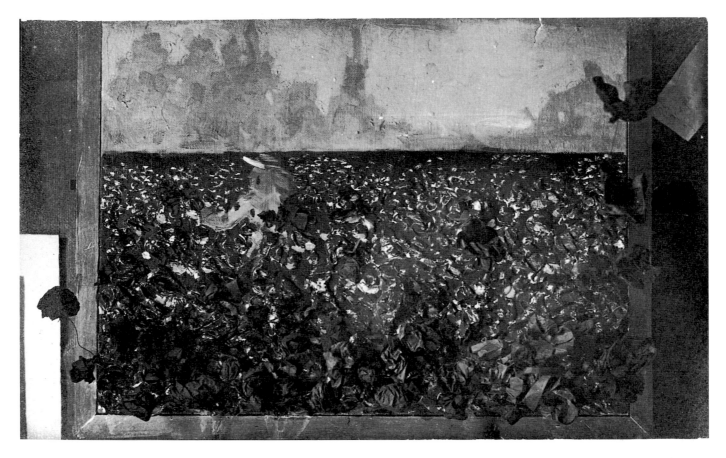

Caricature of Robert Vonnoh's Coquelicots (Poppies). 1894. Installation photograph. Pennsylvania Academy of the Fine Arts

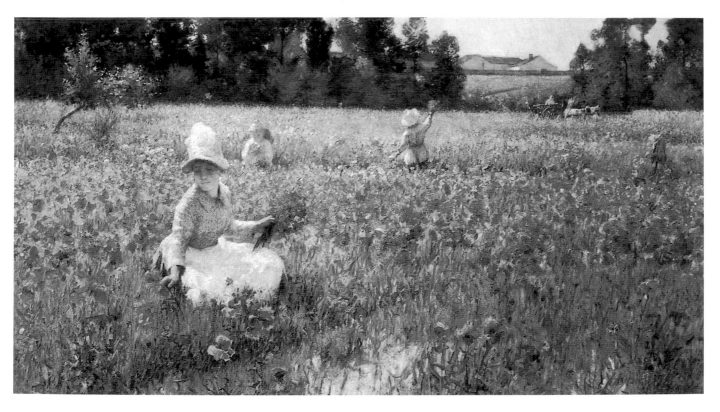

Robert Vonnoh. *In Flander's Field—Where Soldiers Sleep and Poppies Grow.* 1890; originally *Coquelicots (Poppies).*
Oil on canvas, 58 x 104" (147.32 x 264.16 cm). Butler Institute of American Art, Youngstown, OH

in original effects of color and more than clever in its drawing."[40] This work, now lost, depicted a king—"of the 'children's picture book' order"—being rendered in caricature by his jester. One reviewer noted that it had "made such an impression that it is probable the drawing will be bought by the academy."[41]

Considering Parrish's natural talent for caricature, apparent in some of his early illustrated letters and Haverford designs, it is clear the Academy exhibitions offered him a more elevated venue through which to explore a stylistic approach and sensibility that would shape all his future work. The exaggeration and theatricality that defined the art of caricature as practiced by Parrish undoubtedly contributed to the inimitable quality of his overall production—shaded with wit and humor—that made him such a popular favorite.

Caricature, at this time, was widely regarded as an important artistic tool. Indeed, Parrish himself defined the form, in the context of people-watching at the 1893 Columbian Exposition, as a "literal rendering of truth."[42] More than thirty years' later, then president of the Academy John Frederick Lewis reinstated the tradition of the student caricature exhibition in order to "stimulate a genuine interest in the art of caricature" and even suggested the possibility of offering a special class conducted by an artist–illustrator. In a school circular, Lewis enumerated the art form's significance for formal study: "No application of the art of drawing or painting is more far-reaching, and none more lasting, than the art of caricature. . . . Caricature affords a profitable avenue for the exercise of art."[43]

The notion of Parrish's piquant individuality, touted by so many of his fans, distinguishes his early imagery from the romanticism of Pyle, the sentimentality of Jessie Willcox Smith, and the contemporaneity of the Ashcan group. Brinton credited the broad appeal of Parrish's work to its "persistent juvenility"— that "naive apposition of modern and medieval motive which is [its] essence."[44]

The distinctively modern note in the artist's work, interestingly, lies in its inherent artificiality, apparent in both its storybook subject matter and synthetic construction.[45] As a master of stagecraft, Parrish designed his highly theatrical images vis-à-vis a variety of techniques, from an early use of collage and seriality to photography and dioramas. The artist even produced an illustrated perspective manual during his Academy years, a treatise that reveals Parrish's acute understanding of the systematic spatial differences between photography and painting.[46] (Like his Haverford chemistry notebook, the perspective study suggests the artist's penchant for exploring the basic mechanics of a problem while enlivening even the driest material with playful humor.) The overall effect of his nonnaturalistic approach gave Parrish's work its idyllic air, suggesting, in Brinton's words, the frozen "calm of the dream world."[47] This "Peter Pan" quality, marked by "mischief and merriment," permeated Parrish's first major commission—the decoration of the Mask and Wig clubhouse and theater—obtained while still a student at the Academy.[48]

In 1893, the University of Pennsylvania's dramatic society, the Mask and Wig Club, hired Wilson Eyre to redesign their recently acquired home (a former stable) in Philadelphia. One year later, Eyre secured the talents of Parrish to carry out the interior decorations, which included designs for a ticket window, bulletin board, proscenium arch, and the club's grill room. In keeping with Eyre's rustic Tyrolean effects for the building, Parrish chose a fairy-tale theme as his decorative program, incorporating Elizabethan and

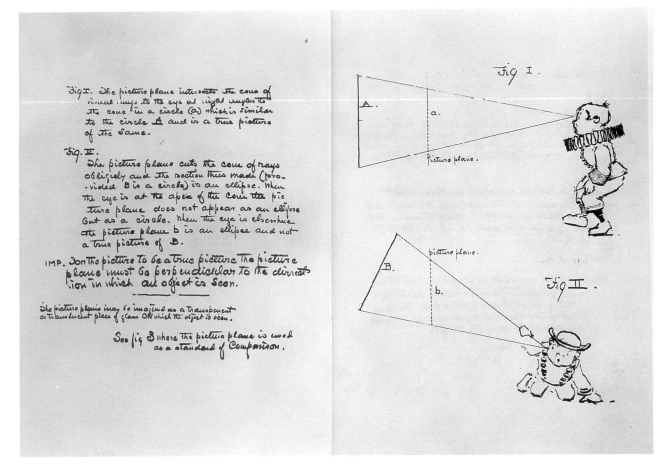

Perspective Manual. ca. 1892–94. Book facsimile. Collection of Alma Gilbert

commedia dell'arte players; masks of comedy; and storybook castles and characters—all elements of his later work.[49]

In the grill room, his "decorative grotesquery" ranged from droll caricatures surrounding beer-stein pegs (see page 33) to the centerpiece of the room, the *Old King Cole* mural. This triptych, for which Parrish designed an architectonic frame, depicts the incomparable principal characters of the nursery rhyme— the attendants bearing pipe and bowl, the fiddlers three, and the merry king—in a style suggestive of the art of such English illustrators as Randolph Caldecott and Walter Crane. In true caricature form, the figures' appearances and gestures seem to reinforce their distinctive roles, from the lean and jangly fiddlers to the roly-poly bowl-bearing chef and the jolly king himself. The work, which in Brinton's words betrayed a "wholesome gusto, a lusty sense of good living," reflected Parrish's graphic style at the time: flat areas of color, bold contours, and an overall linearity that together produced an active surface.[50] The artist would later rework the Old King Cole theme in his more streamlined 1905 mural commission for John Jacob Astor's Knickerbocker Hotel, in New York City, transferred in 1935 to the St. Regis Hotel.[51]

A graphic study (see pages 32 and 33) for the Mask and Wig mural was included in a special architecture exhibition at the Academy in 1894–95 and was purchased by the museum, becoming the first

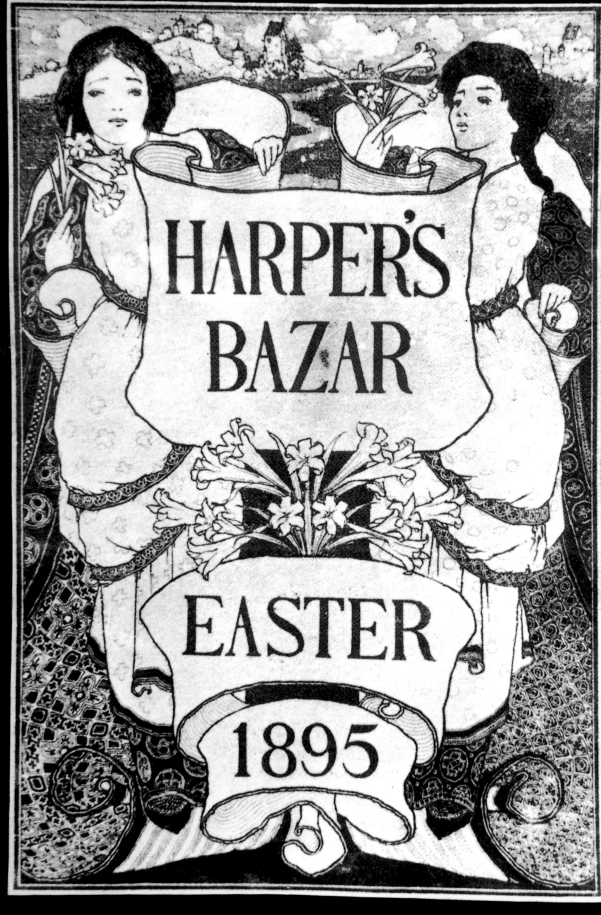

Harper's Bazar Easter. 1895. Magazine cover. Photograph: Coy Ludwig, *Maxfield Parrish* (New York: Watson-Guptill Publications, 1973)

of Parrish's work to enter a public collection.[52] This same exhibition was later seen in New York and reviewed in *Harper's Weekly* (with a reproduction of Parrish's study), giving the artist his first national exposure and leading to an active relationship with the publishing house.[53]

Significantly, it was at this exhibition where Parrish's career in magazine illustration per se was launched. Thomas Ball, a member of Harper and Brothers' art department, first encountered the young artist's work in this display and invited him to submit a cover design for the 1895 Easter issue of *Harper's Bazar*. Parrish produced a decidedly Pre-Raphaelite image of two medieval maidens clutching lilies—a popular Aesthetic accessory. Quite unlike his whimsical caricatures, this work revealed the artist's penchant for an evocative romanticism that would become his other defining style. Characterized by an increasing delicacy of line and compositional elegance, the *Harper's* cover, nevertheless, retained playful elements of his Mask and Wig designs, from the storybook landscape to the geometric patterning of the figures' dresses and the ornamental furls that serve as the magazine's masthead.

The design also suggests Parrish's sensitivity to audience. As a magazine with a large female readership, *Harper's Bazar* clearly called for a different treatment than one accorded the decoration of a men's club devoted to raucous play and gastronomic pleasures. What can be termed Parrish's poster style—an artistic subject rendered in eye-catching bold lines and flat colors—would define most of his commissioned work at the turn of the century.[54]

So began a very busy time for Parrish, fresh from his Academy studies and eager to make his mark in the art world. The success of his Mask and Wig designs led to various developments, one being a teaching position at the Pennsylvania School of Industrial Art (now incorporated into the University of the Arts). From 1894 to 1896, Parrish served as an instructor in interior and mural decoration.[55] His illustration work, meanwhile, expanded to include not only national magazine covers but playbills for the Mask and Wig Club and other dramatic societies; posters for various local amusements; menu covers (see page 8); and assorted advertisements.

There were also new developments in the artist's personal life. In June 1895, Parrish married Lydia Austin, a painting instructor he had met at the Drexel Institute while frequenting some of Howard Pyle's classes. Moving his Philadelphia studio from the School of Industrial Art at 320 South Broad Street to the couple's apartment a few blocks away at Twelfth and Spruce, Parrish, after a summer of European travel, settled into a steady stream of commissions.

The trip abroad was notable for the artist, not least because he chose to travel without family. It was his first visit to the Continent as an adult, and, unlike his youthful trips—during which he took pleasure in contemporary machinery, music, architecture, and archaeological treasures—this time his attention was focused on seeing paintings and painters; many of his Academy colleagues, including Robert Henri, Walter Schofield, William Glackens, and Robert Vonnoh, also were sojourning abroad. In letters to his new wife, he vividly recounted his European impressions: In Brussels, he marveled at Dutch and Flemish painting, which would inspire his own future use of pure color and glazes; in Paris, he was nearly overwhelmed by the Louvre's collection of Old Masters—the Rembrandts, Botticellis, Correggios, van Eycks,

Mask and Wig Caricatures. 1895. Oil on oak paneling. Mask and Wig Club, Philadelphia

Old King Cole. 1894. Ink, graphite, watercolor, gouache, and collage on wove paper, 13½ x 32" (34.29 x 81.28 cm). Pennsylvania Academy of the Fine Arts. Gilpin Fund Purchase

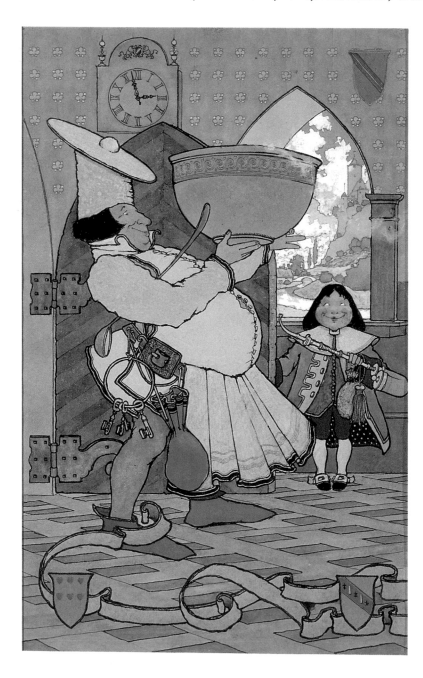
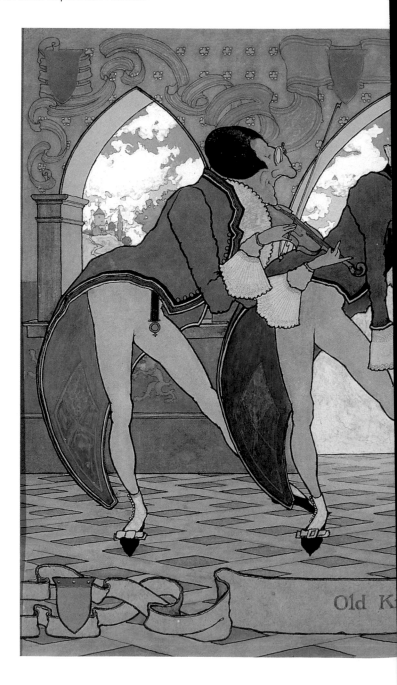

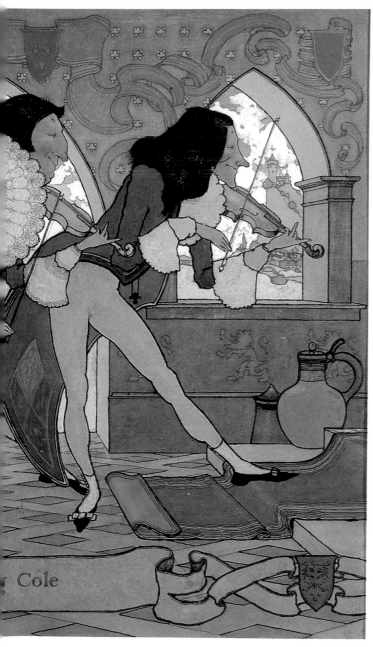

Cole

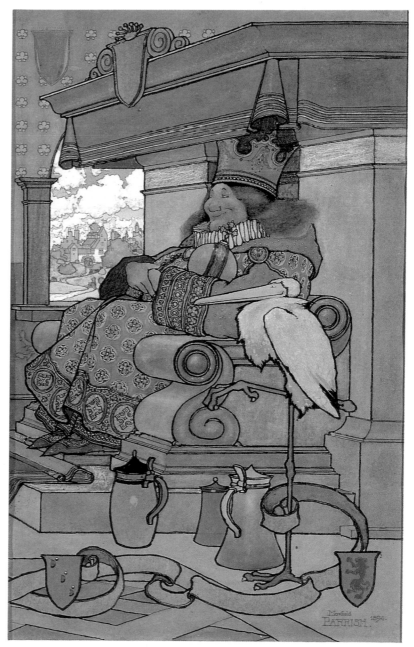

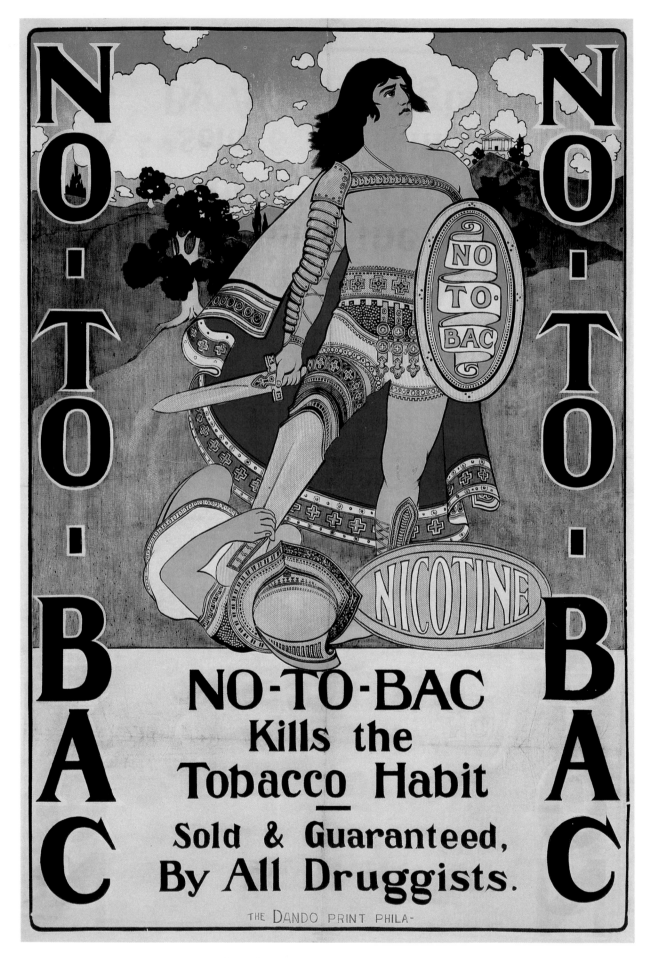

No-To-Bac. 1896. Lithograph on paper, 44¾ x 31⅛" (114 x 79 cm). Philadelphia Museum of Art. The William H. Helfand Collection

and Titians—the latter particularly moving him. In London, however, he was again more impressed with the architecture than with contemporary painting, of which he could find praise only for the expatriate Sargent.[56]

Parrish returned to Philadelphia intent on making his living as a professional artist. Leading an "artistic" lifestyle was central to such an identity in these years, and Parrish's taste for embellishment extended to his domestic environment. Just as he had decorated his rooms at Haverford's Barclay Hall with antique furniture and bric-a-brac, so would he fill his urban studio, described by one writer as a "thoroughly workmanlike place" (see page 37).[57]

Parrish's collecting tastes at this time extended well beyond pewter, which would appear in many of his later works—especially images from his last book commission, *The Knave of Hearts* (1925) (see page 36)—into the realm of the art poster. Indeed, this interest in both the production and reception of poster design led to his co-organization—with former teacher Robert Vonnoh—of a special exhibition of the art form held at the Academy in 1896. Along with Vonnoh and Wilson Eyre, Parrish lent posters from his personal collection, exhibited seven of his own works, and contributed a design that appeared as the catalogue cover and a promotional poster (see page 37). While the majority of these broadsides were posted around Philadelphia, a select number were available for purchase during the exhibition.[58]

Parrish's design, with its bold form and subtle color, transformed the female fashion plate into an abstracted icon. Interestingly, his posters that followed the Academy show were more compositionally complex, particularly in their use of ornament—evoking the Art Nouveau influence of Aubrey Beardsley, whose work also was featured in the exhibition. For example, the spring 1896 catalogue cover for Wanamaker's department store (see page 38) as well as the *Very Little Red Riding Hood* program design, commissioned by the Mask and Wig in 1897 (see page 39), revealed a similarly stylized approach to the female figure. In decidedly two-dimensional, frontal presentations, the heart-shaped face and simplified body risk being overwhelmed by the intricate geometric detailing of the costume.

Capitalizing on both current European trends and the American public's interest in commercial artwork, the Academy exhibition—the first of its kind in this country—included such American artists (in addition to Parrish) as: Will H. Bradley, Kenyon Cox, Charles Dana Gibson, Joseph J. Gould, Jr., Edward Penfield, and John Sloan. (The latter's work at this time, so distinct from his future Ashcan production, revealed an aesthetic similar to Parrish's[59] [see page 38].) The European contribution was equally prestigious, with Aubrey Beardsley, Pierre Bonnard, Walter Crane, Théophile Alexandre Steinlen, Franz von Stuck, and Henri Toulouse-Lautrec, among others, represented.

The catalogue to the exhibition noted the "democratic" character of the art poster and its "distinct appeal to the American public."[60] Integral to the Academy's goal to attract a large, diversified local and national audience—in the managing director Harrison S. Morris's words, "the more docile, kindlier groups of the city, who needed culture, taste, the love of the beauty as much as those of the social elect who pretended they had them"—the poster exhibition exemplified the widespread appeal of this new art form to both the general public and collectors.[61]

A Corner of the Studio. ca. 1898. Photograph: James B. Carrington, "The Work of Maxfield Parrish," *Book Buyer* 16 (April 1898)

Poster Show: Pennsylvania Academy of the Fine Arts, Philadelphia. 1896. Silkscreen on paper, 37½ x 27⅞" (95.25 x 70.82 cm). Pennsylvania Academy of the Fine Arts. Asbell Fund Purchase and Gift of Dr. Edgar P. Richardson

Opposite:
Lady Violetta and the Knave. 1923. Oil on board, 19¼ x 14¾" (48.90 x 37.47 cm). Private Collection. Photograph courtesy of Alma Gilbert

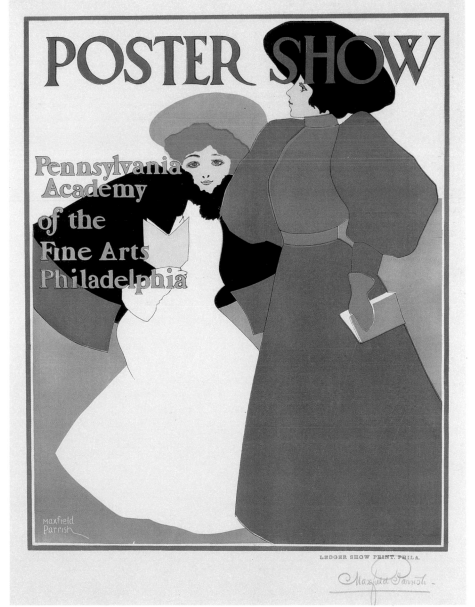

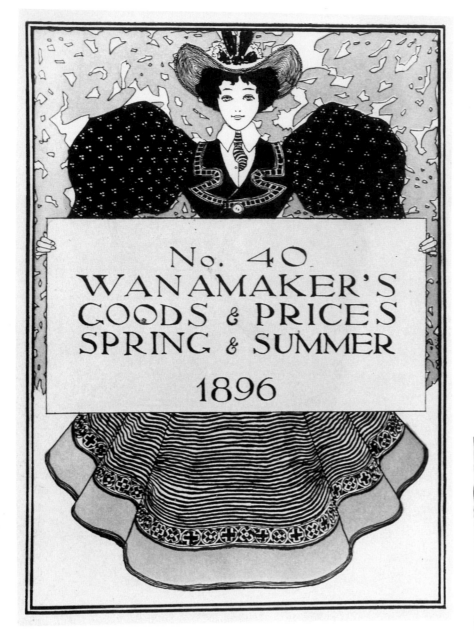

Wanamaker's Goods & Prices, No. 40. 1896. Printed catalogue. 10 x 7"
(25.64 x 43.59 cm). Historical Society of Pennsylvania, Philadelphia

Opposite:
Very Little Red Riding Hood. 1897. Oil and
pen and black ink on paper, 24⅛ x 17½"
(61.29 x 44.45 cm). Private Collection.
Photograph courtesy of the Mask and
Wig Club, Philadelphia

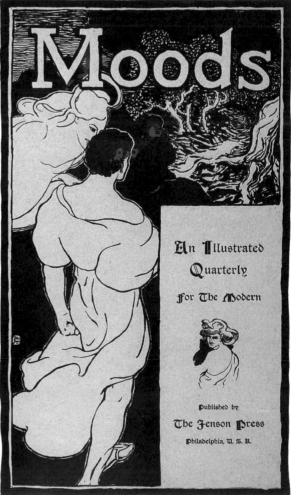

John Sloan. *Moods.* 1895. Linocut poster,
20¼ x 12⅜" (51.44 x 31.44 cm). Pennsylvania
Academy of the Fine Arts. Gift of an
unidentified friend of PAFA

VERY LITTLE RED RIDING HOOD THE
MASK AND WIG CLVB
UNIVERSITY OF PENNSYLVANIA

In light of Morris's interest in organizing popular exhibitions, it is not surprising that he would have cherished Parrish's association with the Academy and sought to maintain it even after the artist's 1898 departure for New Hampshire. Only a year later, Morris extended an offer to Parrish to teach an illustration course (the same course earlier declined by Pyle). Morris noted that the board was seeking "some criticism in illustration based on the prevailing method of development of individuality rather than mere manual instruction."[62] He added that the Academy was always eager to hire alumni and went on to stress the seriousness of the enterprise:

> We conceive that illustration should be taught just as Miss [Cecilia] Beaux teaches the head, [William Merritt] Chase teaches drawing or Thouron teaches composition, and not as Pyle teaches. This latter method sinks the students in the instructor's method and that we should hope to avoid.[63]

By citing the names of such distinguished painters as Beaux and Chase, Morris clearly sought to both flatter Parrish (implying his superiority to Pyle) and to convince him of the Academy's new position on the art of illustration. Neither tactic worked. Parrish, whose fame extended well beyond Philadelphia by this time, wrote from his New England home just three days later, thanking Morris for the honor (which he viewed as "far above" him) but citing both his workload and desire to remain in "these glorious hills" as preventing his acceptance.[64] This would be the first of many invitations Parrish would decline over the years, revealing both a professional discipline and freedom afforded by his numerous commissions.[65]

In a 1905 article for *Century* titled "Philadelphia's Contribution to American Art," Morris traced an artistic pantheon stretching from Benjamin West and Charles Willson Peale to the city's contemporary talents in illustration and design. Citing Parrish as a "child of genius," who "in the twinkling of an eye became an original and established artist," Morris expressed his admiration for Parrish's "self-invented method" while claiming him as one of the Academy's own.[66]

Over the years, Morris (and Academy directors who followed) sent Parrish effusive letters of praise on a regular basis, soliciting his work for exhibitions and his presence on juries, both of which the artist contributed as time allowed. For example, in a 1905 correspondence with Parrish, then director John Trask wrote, "It is unthinkable that we should have an exhibition without anything of yours in it. . . . I know the many demands on you for your work but really, whatever other people may think, you belong to us. . . . We cannot have too many of your things."[67]

Unfortunately, the Academy's attempt to acquire another, more permanent work by Parrish was unsuccessful. In the same year as the poster exhibition, the much-needed renovation and electrification of the Academy's auditorium gave the school another opportunity to involve past and present students in a contemporary artistic trend—mural decoration. Since the 1893 Columbian Exposition, mural painting in America had established itself as a legitimate and lucrative form of production. (Parrish remarked on the decorative program during his visit to the Chicago fair.) In 1895 the National Society of Mural Painters was

incorporated in order to regulate this new profession and to educate the public about murals and other civic art.

Winners of the Academy's 1896 mural-painting class competition were directed in the execution of a series of decorations for the upper walls of the auditorium by the venerable composition instructor Henry Thouron. Unveiled in the spring of 1897, two of the twenty-two murals were by John Sloan and two by William Glackens.[68] Parrish was commissioned to execute the proscenium decoration, a project he had to decline "owing to the pressure of work."[69] In light of Parrish's activities at the Academy in the realms of illustration and decoration, it is not unreasonable to ascribe the future shape of his popular career to this Philadelphia experience.[70]

Peculiar Magic

Despite the largely commercial nature of his work at the turn of the century, Parrish continued to think of himself as a painter, viewing the poster commissions as simply part of his larger creative output. In 1896, the artist painted *The Sandman*, an uncommissioned work containing the hallmarks of his future production—from the romantic castle and majestic oak to the suggestion of a self-portrait—that Parrish would

The Sandman. 1896. Oil on canvas. 22 x 28" (56.41 x 71.80 cm). Location unknown. Photograph: Coy Ludwig,
Maxfield Parrish (New York: Watson-Guptill Publications, 1973).

later consider to be the most significant of his fledgling career.[71] Noted for its "subdued yet rich color quality," *The Sandman* was exhibited in the 1897 annual exhibition of New York's Society of American Artists (SAA) and, consequently, gained Parrish membership to this prestigious artists' organization. (The painting would later win an honorable mention at the Paris Exposition of 1900.) This critical recognition by his peers meant a great deal to Parrish, who was heralded as "not only a finished draughtsman but a man of imagination" on the basis of the SAA exhibition; for, despite the artist's insistence on the importance of both decorative and pictorial values in his work, he sometimes smarted from criticism of his populist practice.[72]

Yet, it was precisely the interconnectedness of Parrish's popular and fine work that ensured his critical standing in the art world and beyond. For example, the SAA was indirectly linked to the world of publishing through the figure of Richard Watson Gilder—the poet–editor of *Century* and a leading cultural arbiter in New York. (His artist–wife, Helena de Kay, was one of the founding members of the SAA in 1877, along with Parrish's future Cornish neighbor and admirer, Augustus Saint-Gaudens.[73])

Parrish's election to the SAA was preceded by his participation in one of the major poster competitions of 1896 and another Gilder-related project: the design for *The Century Midsummer Holiday Number*. As an important product of the publishing business, art posters were used to sell magazines through distribution to newstands and bookstores for public display. Contests created advance publicity for the issues and ensured the quality of the artistic features, as editors clearly understood the consumer command of well-known illustrators. In fact, Gilder was a strong believer in using popular means, such as posters, to "educate the general art feeling" among his middle-class readers.[74]

The rules for the 1896 *Century* competition called for a design requiring no more than three color printings, with entries to be judged by the painters Elihu Vedder and Francis Hopkinson Smith and the architect Henry J. Hardenbergh.[75] The jurors' directive was to "consider the effectiveness of the posters

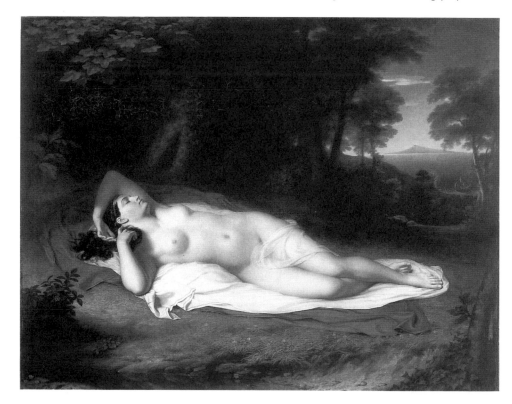

John Vanderlyn. *Ariadne Asleep on the Island of Naxos*. 1809–14. Oil on canvas, 68½ x 87" (174 x 221 cm). Pennsylvania Academy of the Fine Arts. Gift of Mrs. Sarah Harrison (The Joseph Harrison, Jr., Collection)

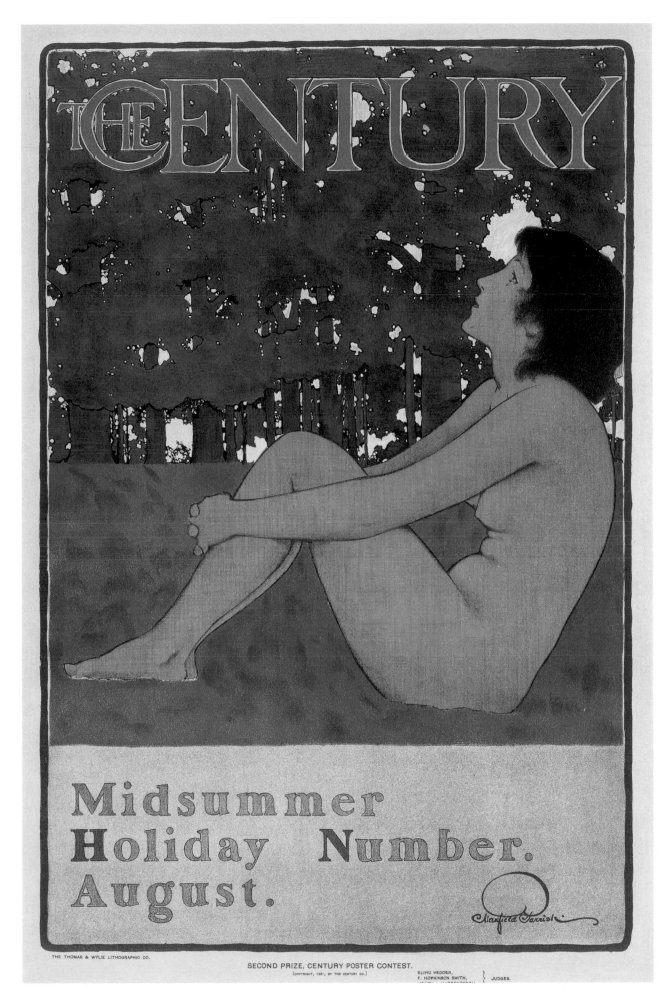

The Century Midsummer Holiday Number. 1896. Lithograph on paper, 19 15/16 x 13 9/16" (50.64 x 34.61 cm). The Metropolitan Museum of Art, New York. Leonard A. Lauder Collection of American Posters. Gift of Leonard A. Lauder

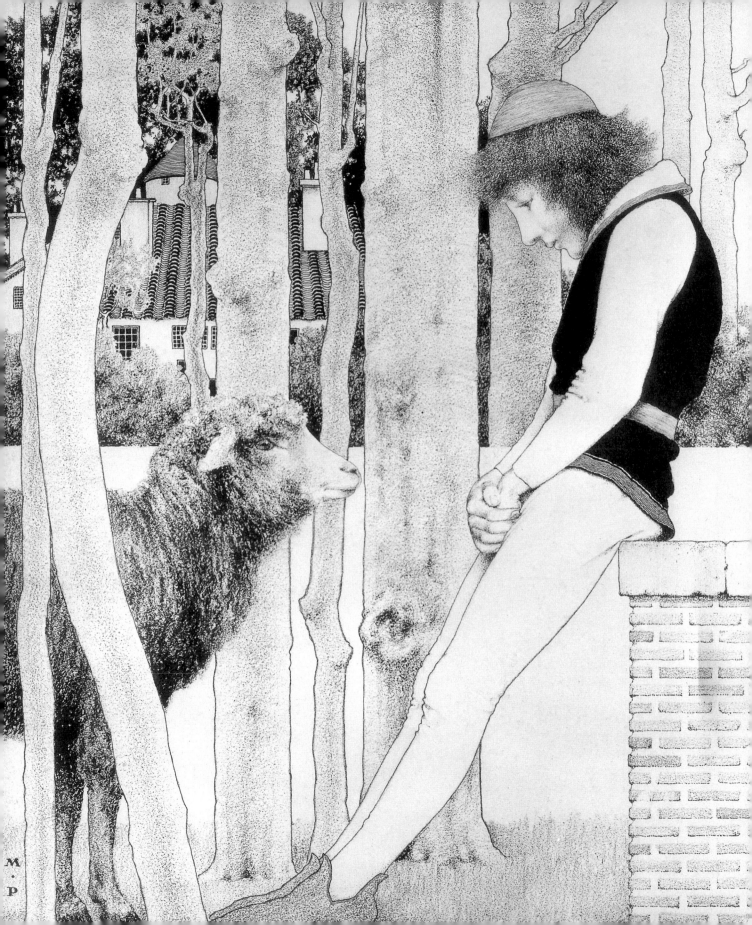

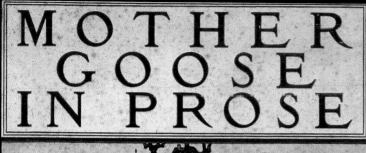

MOTHER GOOSE IN PROSE

L. FRANK BAUM

Mother Goose in Prose. 1897. Printed book, 11⅜ x 9½" (28.89 x 24 cm).
Chicago and New York: George M. Hill Company. The Free Library of
Philadelphia. Rare Book Department

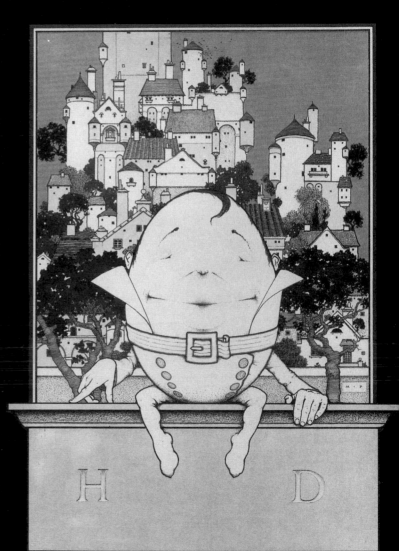

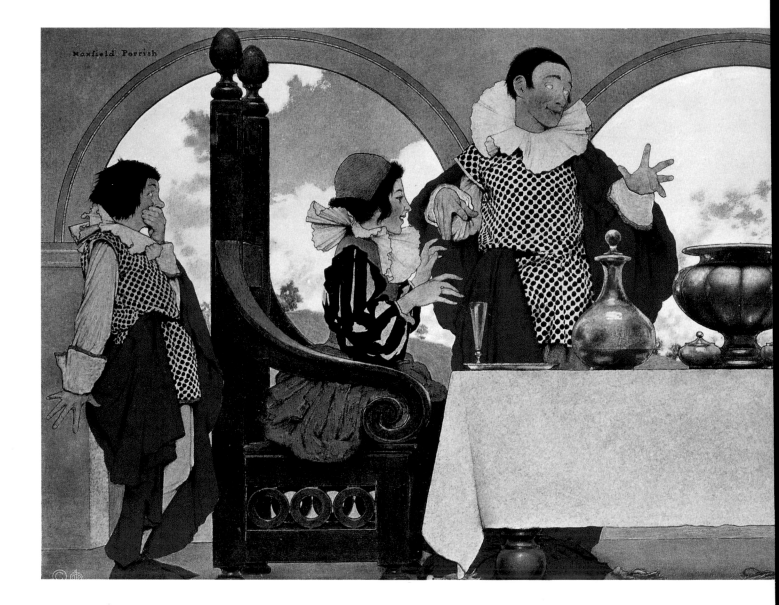

from the advertising standpoint, and the ease and cheapness with which they can be reproduced."[76] Apparently, Parrish received second prize for his design because it used five colors; it was issued as the following year's holiday number, becoming one of the most widely reproduced posters of the period. This evocative image of an adolescent female, shown in profile in a sylvan setting, suggests the art-historical tradition of the pastoral nude—a genre Parrish would have been well familiar with as one of the most important American examples, John Vanderlyn's *Ariadne Asleep on the Island of Naxos* (see page 42), was a central feature of the Academy's permanent collection. Interestingly, the provocative eroticism of Vanderlyn's nude is entirely absent from Parrish's design as well as from his future chaste treatments of the subject.[77] The success of the *Century* issue secured for the artist many additional commissions for posters and, eventually, book and magazine illustrations.

In 1897, Parrish received his first book commission: providing fourteen black-and-white illustrations and a color cover for L. Frank Baum's renditions of famous nursery rhymes—*Mother Goose in Prose* (see page 45). While not a true collaboration—the book's Chicago publisher approached Parrish directly—the

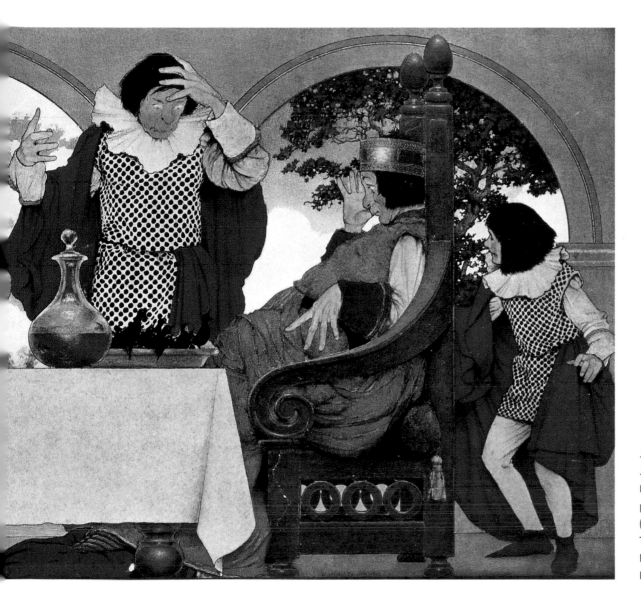

Sing a Song of Sixpence. 1910. Lithograph on paper, 8⅝ x 20⅞" (21.91 x 53.02 cm). The Free Library of Philadelphia. Rare Book Department

artist and first-time writer were aptly matched. Baum, who three years later would make his name with the publication of *The Wizard of Oz*, at the time was embarking on a successful career in merchandising—particularly, the design of shop windows. It's tempting to consider the relationship of Baum's novel display strategies, which combined fairy tales, theater, and technology, to Parrish's growing market savvy in these years.[78] Moreover, such a comparison suggests the important link between fantasy and consumer desire that partly accounted for the artist's popular appeal.

Parrish's Mother Goose illustrations ranged from the whimsical (see page 45) to the lyrical (see page 44), revealing the artist's talent for caricature and romance as well as his technical skill in combining media.[79] His interests in nature and architecture also are apparent in the backgrounds of all the illustrations. Significantly, the popular and critical success of *Mother Goose in Prose* codified the characteristics of Parrish's fairy-tale phase, with its requisite medieval castles and costumes, into a visual language that he would employ in a wide range of future commissions, from hotel-bar murals to advertisements (see page 48).

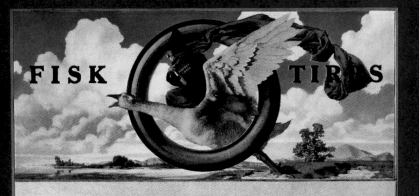

Fisk Tires: Mother Goose. 1919. Country Life advertisement, 12 x 8⅜" (30.5 x 21.2 cm). The Free Library of Philadelphia. Rare Book Department

Next Time—Buy Fisk

ENDURANCE is the supreme test of tires. Quality, experience and high manufacturing standards build into a tire the properties which insure long mileage — which roll off the miles, thousand after thousand, without interruption and without inconvenience to the user.

BIG TIRES—gas-saving, easy riding, good looking with the endurance qualities which produce excess mileage and a final saving in real money—such are Fisk Cord Tires.

FISK CORD TIRES

Made with both Ribbed and Fisk Non-Skid Treads

The Adlake Camera. 1897. Lithograph on paper, 11 x 17" (27.94 x 43.18 cm). Haverford College Library, PA. Special Collections

THE ADLAKE CAMERA
4" x 5", with twelve plate holders, $15.

One critic linked the success of Parrish's nursery-rhyme themes to his serious treatment of the subjects from a child's point of view.[80] That every adult can recall some of these magical rhymes, so deeply lodged are they within our consciousness, also points to their origins as, in the folklorists Iona and Peter Opie's words, "survivals of an adult code of joviality . . . some com[ing] out of taverns," that is, not composed for children at all.[81] Indeed, the popularity of Mother Goose rhymes in America up to the present day suggests their continuing universality while it explains their attraction to advertisers intent on creating warm, familiar feelings and immediate recognition in consumers.[82]

Interestingly, Parrish followed the *Mother Goose in Prose* commission with a poster for the Chicago manufacturer of the Adlake Camera, probably obtained through the book's publishers. In this image—a direct reference to the title page of the book—Parrish juxtaposed the medieval and modern worlds vis-à-vis the male and female figures, respectively dressed in historical and contemporary costume and paired with symbols of the technological present (a black camera) and the superstitious past (a black cat).

Mother Goose in Prose, with its historical flavor, led directly to another book commission in the spring of 1898 for a series of drawings to illustrate Washington Irving's *Knickerbocker's History of New York,* written in 1809 and reprinted with Parrish's images in 1900. The artist complemented Irving's parodic voice with technically complex, droll images that, as with his *Mother Goose* drawings, added a rich texture and tone to the traditional black-and-white medium (see page 125).

Yankee Arcadia

At the time of the *Knickerbocker's History* commission, there was a change in Parrish's personal life that would have serious repercussions for his professional career: the 1898 move to Plainfield, New Hampshire. Having spent a good deal of his time visiting his parents (who had become year-round residents of Cornish in 1894), Parrish and his wife purchased a plot of land on a secluded hillside pasture about a mile away.

The younger Parrishes called their home-to-be "The Oaks," due to the central feature of the landscape, and proceeded to carve out a distinctive place for themselves in the artists' colony. Both designed and constructed by Parrish, with only the help of a local carpenter, George Ruggles, who subsequently worked for the artist as a handyman, "The Oaks" soon became one of the most talked about residences in the area.

Parrish worked on the house for more than ten years, living in a half-finished portion while the rest went up informally—according to the artist, "it just grew. No plans were ever drawn."[83] In its final form, the unconventional property included a rambling twenty-room house (complete with a large music and living room with a twelve-foot fireplace and stage); a fifteen-room studio equipped with a machine shop, darkroom, and devices for mural painting; and landscaped gardens.[84] Parrish designed and fabricated nearly every architectural detail in the living and work spaces—from the garden gate to the interior hardware and

woodwork. As one of the few houses in America designed by its owner and said to possess "genuine archi-
tectural character," "The Oaks" was featured in numerous architectural journals.[85] These life-style profiles—
so common today—both contributed to and reflected Parrish's growing celebrity as a multitalented artist.

Parrish's status as an amateur architect at a time of increased professionalization throughout
society was endlessly fascinating to both general and specialized readers, and his home was praised for its
"genuine personal expression," reflecting the artist's individuality, rhetoric that echoed the critical assess-

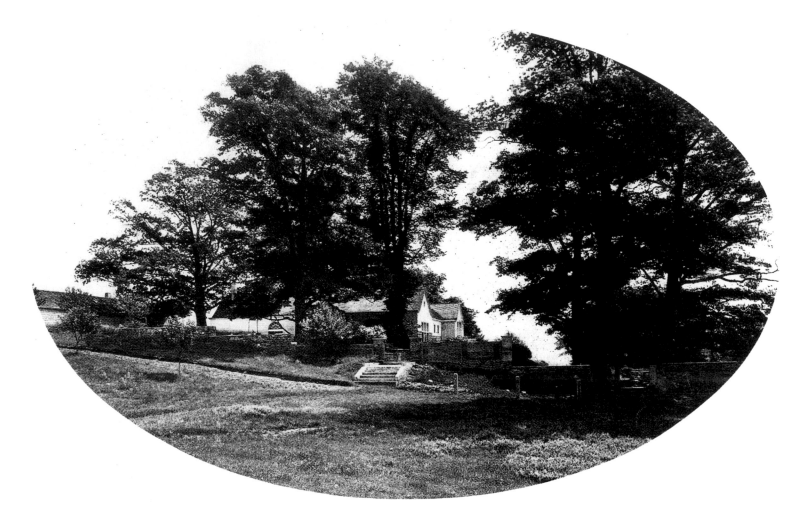

The Oaks. ca. 1907. Photograph: "The House of Mr. Maxfield Parrish," *Architectural Record* 22 (October 1907)

ment of his visual production.[86] In 1905, Homer Saint-Gaudens (son of sculptor and Cornish colony
"founder" Augustus) referred to "The Oaks" as a "child's dream house in every sense of the word" and a
place of "serenity," reiterating the connection between the artist and his fairy-tale themes.[87] In fact, the
house was an amalgam of New England Colonial traditions, contemporary Arts and Crafts touches, and
old-world designs; what was unique was the overall conception of the property.

As a landscape artist par excellence, Parrish himself found the setting to be the most interesting

thing about the estate and sensitively shaped the design of the architecture accordingly, using "highly arti-ficial and formal means."[88] Having chosen an "outlook of which one never tires"—a breathtaking view of the verdant Connecticut Valley, with the majestic Mount Ascutney "placed to perfection, a little to the right"—Parrish proceeded to create and frame vistas with sashless windows inside, terraces and porches out.[89] Homer Saint-Gaudens noted the parallels between Parrish's life and art, dating from his move to New Hampshire: "His surroundings possess the charm of his work, with the same interesting detail and the same poetic width of landscape." Likewise, he continued:

> To one who has been in Cornish, Parrish's landscapes bring back a remembrance of each
> characteristic of that country; the scent of raspberry bushes, and of the parched grass of the pas-
> ture sprinkled with tall yellow-flowering mullen stalks, the cadence of the hot screech of the
> cicada, or the occasional lazy bleat of an absent-minded sheep.[90]

The *Architectural Record* could also have been referring to Parrish's artwork, rather than "The Oaks," when the writer remarked: "It is very personal, it is very local, it is very American."[91] The influence of Parrish's sense of place on his future artistic production—from the wonders of the natural setting and his charming abode to the cultural community of Cornish itself—cannot be understated.

Christian Brinton, in keeping with the whimsical tone of his 1912 accolade for his former roommate, wrote at length of Parrish's New Hampshire residence:

> While it is possible, both historically and geographically, that Cornish may have existed before his
> advent, there are grounds for doubting this, and every reason for affirming that, esthetically, it was
> still to be divined. In short, he remade Cornish, just as years before he remade his rooms at col-
> lege. After his coming, folk began remarking that the hills seemed to shape and group themselves
> more effectively, that certain trees stood forth more picturesquely against the horizon, and that
> those swift-scudding cloud-forms marshaled themselves almost as majestically across the sky as
> they did in the backgrounds of his canvases. . . . He appeared to have a secret understanding with,
> as well as of, Nature. And every one about him, from racy, angular native to easeful, plutocratic
> summer resident, responded to the spell of his personality.[92]

In addition to being inspired by its stunning scenery, Parrish found in New Hampshire the privacy and lack of distractions he so craved. Never wanting for commissions, the artist led a very disciplined existence that allowed him to concentrate fully on his painting.[93] (A 1907 account of life in Cornish described the atmosphere as "one of culture and hard work, for the men [*sic*] who go there do not go to spend their time in idleness, and some of their best accomplishments have been achieved in the little colony among the hills of New Hampshire."[94]) Occasional visits to Boston, New York, and Philadelphia were sometimes necessary, but, for the most part, Parrish was able to conduct his considerable business from "The Oaks."

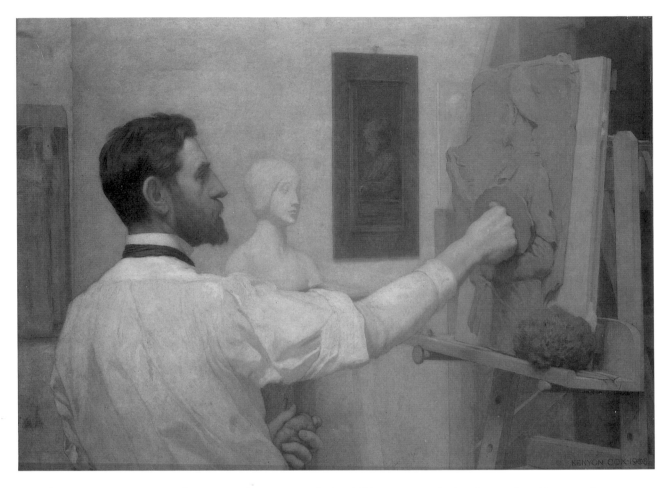

Kenyon Cox. *Augustus Saint-Gaudens*. 1908. Oil on canvas, 33½ x 47⅛" (85.1 x 119.7 cm). The Metropolitan Museum of Art, New York. Gift of friends of the sculptor through August F. Jaccaci, 1908

Historically, Cornish has always been associated first and foremost with the artist who purportedly "discovered" it—the leading American sculptor of the late nineteenth century, Augustus Saint-Gaudens. In 1885, Saint-Gaudens was coaxed by Charles Cotesworth Beaman, Jr.—a successful New York lawyer and patron who bought land in the relatively impoverished farm communities of Plainfield and Cornish in the 1880s—to rent a house on his property. The sculptor and his family returned every summer thereafter, finally purchasing the house in 1891.[95]

Saint-Gaudens' and Beaman's partnership, with their respective celebrity and generosity, nurtured Cornish as a colony for artists; George de Forest Brush and Thomas Wilmer Dewing were two of the first to establish summer residences there. Stephen Parrish was introduced to the colony, in 1891, through his friendship with fellow etcher and later architect and garden designer Charles A. Platt; other artists who purchased land and built homes in Cornish in the 1890s (in addition to the younger Parrish) included Kenyon Cox and Academy alumni Everett and Florence Scovel Shinn. Daniel Chester French, Paul Manship, and John Alexander were in residence for a few summers; Willard Metcalf favored the winter months. Writers, editors, actors, musicians, dancers, and politicians further expanded the summer mix.

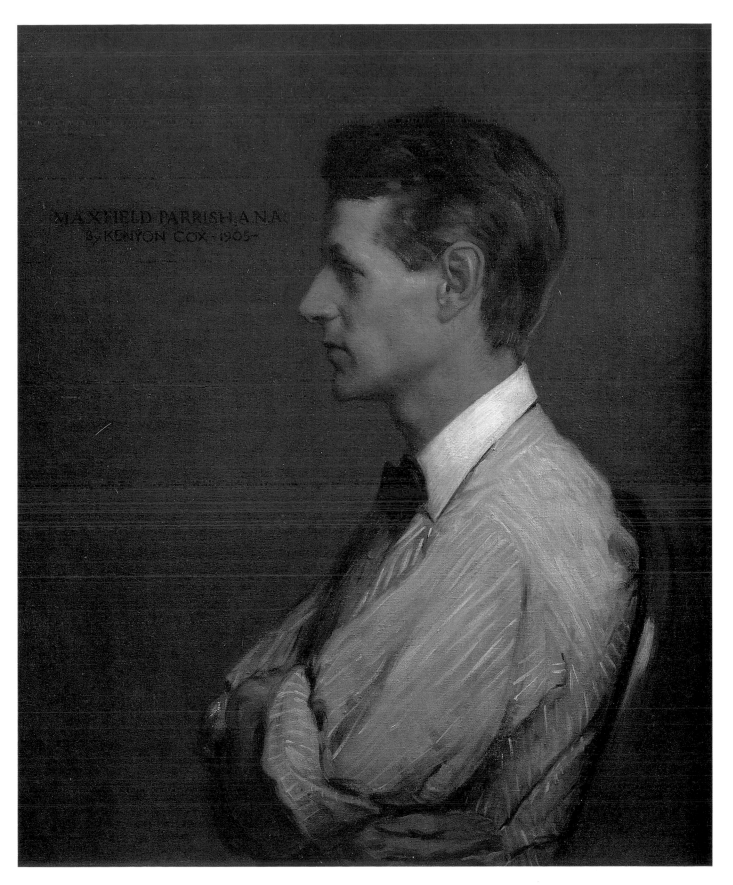

Kenyon Cox. *Maxfield Parrish*.
1910. Oil on canvas, 30 x 25"
(76.2 x 63.5 cm). National
Academy Museum, New York

This professional and personal network of sculptors, painters, illustrators, and muralists—many key players in the so-called American Renaissance—encompassed a constellation of artistic practices and sensibilities that reflected the expansive nature of art production at the turn of the century. That Parrish was an active and popular member of this "aristocracy of brains," choosing Cornish for his permanent residence, suggests a less hierarchical art world that allowed for a rich degree of exchange and collaboration.[96] (Significantly, four years after his 1906 election as a full member of the National Academy of Design, Parrish submitted a customary portrait (see page 53), painted by his neighbor and fellow academician Kenyon Cox.)

Cornish provided a locus for some of Parrish's earliest critical successes and appraisals by his peers. In 1899, while completing his illustrations for the *Knickerbocker's History,* Parrish produced thirty-two drawings (full page and small tailpieces) for the English writer Kenneth Grahame's *The Golden Age.* Published simultaneously in New York and London by John Lane: The Bodley Head, the book was heralded in Anglo-American circles as a work of genius. This reception marked the beginning of Parrish's international reputation, as he had previously been known abroad primarily for his poster designs.[97]

No less a figure than Hubert von Herkomer—the noted painter, critic, and Oxford University Slade Professor of Art—on reviewing the volume, wrote a letter to its publisher that later appeared in their house journal, the *International Studio,* in the guise of an article on Parrish's book illustrations—a not so subtle form of advertising.[98] While focusing on *The Golden Age* illustrations in particular, this famous letter reveals much about the nature of both Parrish's popular appeal and his critical standing in the art world at this time.

Herkomer began by focusing on the "strong original identity" of Parrish's work, which he identified as combining the "photographic vision with the Pre-Raphaelite feeling." To be sure, the artist's dialectic approach—his ability to combine the "poetic" with the "humorous," a "strong sense of romance" with "every modern oddity"—seemed to be the key to Herkomer's fascination. Categorizing Parrish's *Golden Age* drawings stylistically as variously "modern," "medieval" (see page 56), and "classical," Herkomer confessed: "this original artist is the strangest mixture I have ever met with. This man should paint, and not lose himself for the art world by merely doing illustrations. He will do much to reconcile the extreme and sober elements of our times." When later asked to expand upon these comments in the *International Studio,* Herkomer emphasized Parrish's remarkable drawing technique and characterization, commending the artist's work to "every student, to every lover of art, and to the public at large."[99] Such an accolade, which revealed the still-common prejudice that illustration was a lesser art form than painting, contributed to Parrish's commercial viability in the publishing industry as it, simultaneously, raised his status as a serious artist among critics and peers.

The subject matter of *The Golden Age* and its sequel published three years later, *Dream Days,* for which Parrish also produced a series of drawings, concerned the fanciful adventures of four English children.[100] Told entirely from the young children's point of view, the stories, interestingly, appealed more to an audience of older children and adults; thus, Herkomer's response. Just as Parrish's humorous illustrations complemented Irving's satirical style in the *Knickerbocker's History,* so were word and image well matched in the Grahame commissions. The artist's drawings captured in tone and touch the mood of the stories—

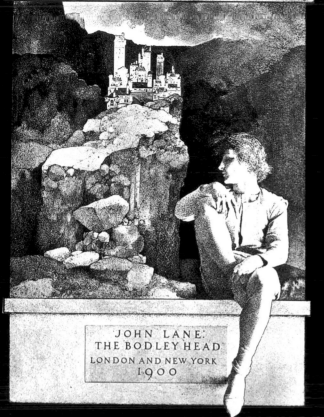

The Golden Age. 1899. Printed book, 8 ⅛ x 6 ¼" (20.64 x 15.88 cm). London and New York: John Lane: The Bodley Head. The Free Library of Philadelphia. Rare Book Department

Alarums and Excursions.
1899. Pen and India ink,
India wash drawing with
Chinese white over
pencil on paper, 11 x 7"
(27.94 x 17.78 cm). Cleve-
land Museum of Art.
Bequest of James
Parmelee

drawn from a child's creative perspective—as they poignantly emphasized a youthful sense of innocence and freedom, received by an adult audience as nostalgic loss. Parrish's inability to merely illustrate a text without adding his own imaginative flourishes led Herkomer to label him an "annotator rather than an illustrator."[101]

As had been true of the *Mother Goose in Prose* themes, the Grahame commissions gave the artist full range to explore the magic of childhood. A 1905 account noted that much of Parrish's fame would forever be ascribed to *Dream Days* (both the specific book and the abstract concept) due to the "youthful

Phoebus on Halzaphron. 1901. Oil on paper, 5¾ x 7½" (14.61 x 19.05 cm). Charles Hosmer Morse Museum of American Art, Winter Park, FL

enchantment" that surrounded all of his work: ". . . always magical in color, always reflecting the blue sky and green hills about him, and, above all, the far-off grace and fancy of dream days."[102]

While reality was hardly a foreign country to the artist in these years, Parrish had a talent for turning hardship to his advantage. Soon after he and Lydia settled in New Hampshire, money became scarce. According to one account, they were almost on the verge of losing "The Oaks," around 1900, when Parrish won a thousand-dollar prize in an unidentified poster competition. In the meantime, the artist had contracted tuberculosis. The prize money enabled the Parrishes to follow medical advice, spending the winter of 1900–1901 recuperating at Saranac Lake, New York, in the Adirondacks. This sojourn, which marked the beginning of a period of travel for personal and professional reasons, coincided with Parrish's move from black and white to a greater use of color in his art. Purportedly working out of doors in frigid temperatures, the artist found that while ink froze oil glazes remained fluid.[103]

The works Parrish produced in the Adirondacks share a lyrical, romantic tone as well as a more sensitive use of color, suggesting somewhat of a departure from his earlier humorous designs. For example, his illustrations to A. T. Quiller-Couch's imaginary tale of an ancient civilization on the English coast,

"Phoebus on Halzaphron" (see page 57), which appeared in *Scribner's,* and the three drawings that accompanied John Milton's "L'Allegro" in *Century,* revealed Parrish's newly poetic approach.

The "Allegro" pictures in particular—suggestive of the work of another noted illustrator–painter and Academy alumnus Edwin Austin Abbey—drew praise from a number of leading artists, including the Academy alumna and instructor Cecilia Beaux as well as Augustus Saint-Gaudens, who was moved to write an extraordinarily effusive letter to Parrish, who was on assignment in Arizona:

> *The three drawings for Milton's "Allegro" you have done for the* Century *are superb, and I want to tell you how they impressed me. They are big and on looking at them I felt that choking sensation that one has only in the presence of the really swell thing. The* Shepherds on the Hill, *the* Poet in the Valley *[Poet's Dream] [see page 60] are great in composition and with the* Blithesome Maid *[Milkmaid] [see page 61] are among the most beautiful things I have ever seen. . . . It is always an astonishment to me how after all the fine things that have been done and which seem to have exhausted all the possibilities of beauty, some man like you will come along and strike another note just as distinctive and just as fine. It is encouraging and stimulating.*[104]

Saint-Gaudens was so taken with the drawings that he expressed keen interest in buying them. Parrish responded, clearly flattered and charmed: "I have nothing I value so much as that letter of yours. If I owned the drawings you should have them all, and your letter would pay for them many times over. As it is I think the Century Co. still owns them. . . ."[105] This situation would recur throughout Parrish's career as he painted on commission and often did not retain the original works. However, as he became more successful and savvy, he insisted on maintaining control of his images, thereby receiving royalties on reproductions.[106]

This issue of originals and reproductions is a significant one in Parrish's career. In his 1901 response to Saint-Gaudens he noted, "If you liked the reproductions, I do wish you had seen the originals, for the ones in the magazine as usual suffered greatly."[107] It is striking that the two most important critical responses to Parrish's work at this time—Herkomer's and Saint-Gaudens'—were based on viewing his work in reproduction. As Parrish had no exclusive dealer or agent, it was not easy to see or purchase his original designs.

In the fall of 1899, an exhibition of the artist's drawings for book commissions, including *The Golden Age,* had been

Comic Mask. 1905. Bronze, 8 x 6¼"
(20.32 x 15.88 cm). American Precision
Museum, Windsor, VT

held at New York's Keppel Gallery.[108] Moreover, as previously noted, Parrish often submitted work to the Pennsylvania Academy's annuals as well as to the Philadelphia Water Color Club's exhibitions held at the Academy.[109] Yet, the majority of the critical and general public knew Parrish's work via reproduction—a fact that both ensured his national, even international, standing and frustrated his artistic ambitions. Indeed, Parrish was always exploring new techniques that promised to narrow the gap between the quality of his original design and its printed form. For example, he executed the "Allegro" drawings in fewer tints so that they would reproduce well in both color and black and white. In his later works, he approximated a four-color printing process in his painting method—using transparent glazes and high-keyed underlayers—in an effort to counteract the reproduction's inevitable muting of texture and tone.

Clearly, admirers such as Herkomer and Saint-Gaudens were not troubled by issues of reproductive illustration when considering the aesthetic merits of Parrish's work, thereby revealing a larger cultural bias. In 1907, no less an art institution than the Metropolitan Museum of Art was engaged in discussions concerning the establishment of a collection of black-and-white illustrations. The proposal was viewed by its proponents—leading painters, illustrators, and the museum's director—as of great "educational value" for art students and the public alike, in that the collection would distinguish between illustration as an art form and the "mass of commercial trash that under the name of art is daily being dished up to an unsuspecting public."[110]

The New York Herald queried a number of leading illustrators for responses to the debate, including Parrish, who questioned the fundamental definition of illustration:

> I am tempted to ask, why should not all such things, illustrations, decorations, miniatures, etc., be looked upon as pictures? . . . If they are good of their kind they are good as pictures. The Museum has on its walls many pictures which are purely illustrative and nothing else. How is one to know whether they were originally made as illustrations or not? . . . Why not judge all these things by one standard? To tell the difference between an illustration and a picture is as difficult as to tell the difference between a picture and a study, a picture and a decoration, prose and poetry. . . . It seems to me the original purpose of the work has precious little to do with the subject.[111]

Interestingly, Parrish's former Academy classmate, William Glackens, felt differently, noting that the "gross commercialism of the present day illustrations" made him question the aesthetic merit of forming a permanent collection: "The exhibit, no doubt, would be pleasing to the public—to the artist, hardly." As Glackens, unlike Parrish, made a clear distinction between his illustrations and his paintings—viewing the former in purely commercial terms—his ambivalence is unsurprising.[112]

Throughout his early career, Parrish impressed countless critics as being unique in his field—"one of those rare illustrators who never disappoint . . . [whose] pictures and decorations have a distinct place of their own in modern American art, and . . . have won for him a special kind of admiration, differentiating him in the public mind from his contemporaries"—and particularly worthy of his broad following[113]:

His public is a wide one, including the student of art, who finds satisfaction in his supremely clever technique; the thoughtful man, who is impressed by the highly imaginative poetry revealed in his work; and the average person of taste, who is charmed by the richness of his color compositions. His work, while enjoying popularity, at the same time wins the most exacting critic.[114]

At Home and Abroad

Parrish's increasingly democratic appeal in these years was linked to both the distinctive production and reception of his work. Having not fully recovered his health by the end of his stay in the Adirondacks, the artist gladly accepted a commission from *Century,* in the fall of 1901, to illustrate a series of articles by Ray Stannard Baker titled "The Great Southwest" (see page 64). Hence, he and Lydia spent the winter of 1901–1902 convalescing in Castle Creek (Hot Springs), Arizona.

The Western sojourn became another defining moment in Parrish's career, adding a new dimension to the importance of place in his work. The riotous colors of the desert and canyons and the region's vast sense of "largeness" and "loneliness" made a lasting impression on Parrish's approach to landscape painting.[115] Arguably, both his developing skill as a colorist and his perfection of a decidedly American scenery can be ascribed to this formative trip.

In an open letter published in *Century,* Parrish detailed his impressions of the locale in relation to his beloved New England. Noting that while there was not the same variety of light and color that one found in the moist climate of the Northeast, the Southwest had its own, rightly celebrated, local color. Parrish went on to describe the landscape in pictorial terms, comparing the formal effects of the desert's palette to the techniques of Titian. Remarking on the intense color of the sky—"a blue from dreamland, a blue from which all the skies of the world were made"—Parrish added, "the more you look, the more unreal it grows," a comment that could just as readily be made about the artist's later iconic landscapes[116] (see page 65).

Of the nineteen illustrations Parrish executed in Arizona, only two were originally reproduced in color as frontispieces to the travelogue. However, the drawings created such a sensation among readers that *Century* chose to translate seven additional renderings from black and white into color. The magazine heralded Parrish's imaginative southwestern pictures as a "new and striking pictorial contribution to the knowledge of that most interesting country," adding his name to an art-historical lineage that stretched from Albert Bierstadt to Thomas Moran to Frederic Remington.[117]

The Arizona trip also points to the artist's involvement in a larger cultural phenomenon of the period—the "rest cure," which, in its masculine form, drew many Eastern artists and intellectuals to the West in search of, ironically, the "strenuous life." Like Theodore Roosevelt and Thomas Eakins before him, Parrish sought the spaciousness of the plains as a tonic for his troubles, noting "in the Southwest your face is always lifted up, looking into air and space and freedom."[118]

Parrish's curious self-portrait of 1909, *The Artist, Sex, Male* (see page 66), may be read as a humorous commentary on this cultural equating of nature and virility. Posed in what could be called modified cowboy gear, set in a Western landscape, the artist displays the stereotypical fustiness of a creative type, as it was viewed at the time. However, by contrasting the "masculine" ideal of (Western) vitalism with the "feminine" notion of (Eastern) artistic expression, Parrish challenged a complex cultural norm. That fantasy and creativity were coded "childlike" and "feminine" in the culture at large suggests Parrish's interest in seeking what T. J. Jackson Lears has termed "androgynous alternatives to bourgeois masculinity" in his life and work.[119] For example, Parrish frequently engaged in what may be viewed as gender inversion or cross-dressing in his artistic practice—turning female models into male figures and vice versa (see page 67). Moreover, in other works from this period, including *Dream Castle in the Sky* and *Hermes* (see pages 68 and 69), the artist celebrated the androgynous male nude in much the same way he would treat the female form in his later "girl-on-the-rock" imagery.

While the Arizona sojourn led Parrish in his future work to iconographically fuse the landscapes of two distinctive regions of the country associated with national authenticity—New England and the Southwest—thereby creating a visual definition of Americanness, his next *Century* commission allowed him to pair the Old World with the New.

In the winter of 1903, Parrish received a commission to illustrate Edith Wharton's *Italian Villas and Their Gardens*, a series of articles that later appeared in book form. The pairing of the populist artist with the chronicler of upper-class social mores may have seemed unlikely, yet both Parrish and Wharton shared an interest in architecture and landscape design that went beyond their popular reputations.[120]

Italian Villas. 1915. Lithograph on paper, 19¾ x 13" (50 x 33.02 cm). The Free Library of Philadelphia. Rare Book Department

Cowboys, Hot Springs, Arizona. 1902. Oil mixed with melted wax on cardboard mounted on wood, 17 x 14³⁄₁₆"
(43.18 x 36.2 cm). Museum of Art, Rhode Island School of Design, Providence

Opposite:
Arizona. 1950. Oil on board, 20½ x 17"
(52.07 x 43.18 cm). Phoenix Art Museum.
Bequest of Thelma Kieckhefer

"Ah never in this world were there such roses." 1905. Oil on stretched paper, 16 x 14" (40.64 x 35.56 cm). The Memorial Art Gallery of the University of Rochester, NY

Potpourri: Maxfield Parrish Posing. 1904. Gelatin silver print, 8 x 10" (20.32 x 25.4 cm). The Memorial Art Gallery of the University of Rochester, NY

Opposite:
The Artist, Sex, Male. 1909. Oil on paper, 19¾ x 16" (50.17 x 40.64 cm). Collection of the Brandywine River Museum, Chadds Ford, PA. Gift of Mrs. Andrew Wyeth

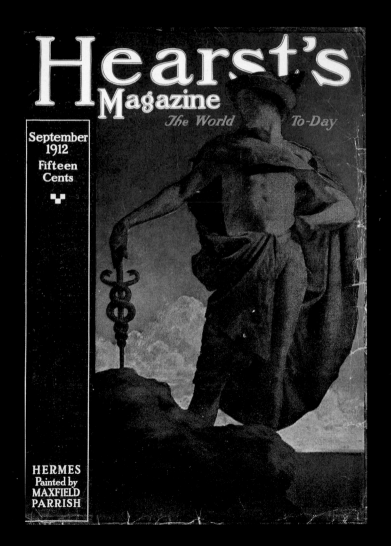

Hearst's Magazine: Hermes. 1912. Lithograph
on paper, 9¾ x 7" (25 x 18 cm). The Free
Library of Philadelphia. Rare Book
Department

Dream Castle in the Sky. 1908. Oil on
canvas, 6' x 10'11" (182.88 x 332.74 cm).
Lent by the Minneapolis Institute of
Arts. The Putnam Dana McMillan Fund

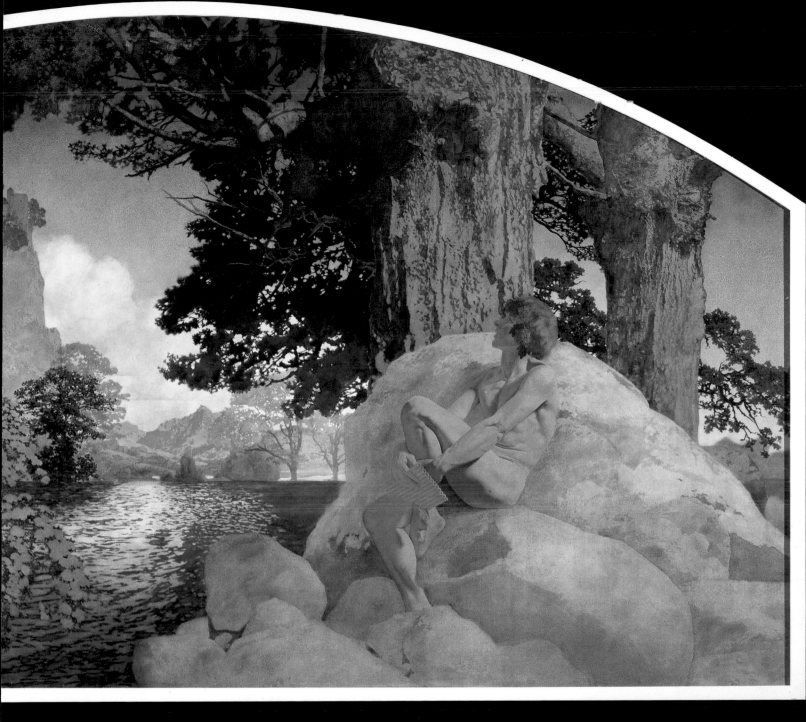

Unlike his Southwest project, all of the artist's illustrations for the Italian commission were to be produced in Cornish, working from sketches and photographs completed abroad. Moreover, with this commission, Parrish initiated a new arrangement with his publishers: while the Century Company would receive reproduction rights, the original works would be returned to the artist.[121] (Excepting advertising designs, this would become Parrish's standard arrangement from this point in his career.)

While Parrish and Wharton neither met to discuss the commission before their respective departures for Italy nor visited the sites together, they did convene at the writer's Lenox, Massachusetts, home on their return from Europe to discuss the book's viewpoint. Both artist and writer wanted to go beyond

Untitled (Blue Tones). Watercolor on board, 5⅛ x 4⅛" (13.01 x 10.48 cm). Collection of the Brandywine River Museum, Chadds Ford, PA. Gift of Maxfield Parrish Museum, Inc., Plainfield, NH. Courtesy of Alma Gilbert

the conventional travelogue (à la Baedecker) to present a novel look at the villa and its setting; according to critical reception, their results were mixed. One writer found Wharton's text overly pedantic for a book aimed at a popular audience but complimented Parrish on his illustrations: "He has put the best of his art into the subject, and he has succeeded in depicting the beauties of the Italian gardens as they have never been depicted before. His interest in architectural subjects, in color and form, has here found a field giving him ample scope."[122]

Executing the drawings in Cornish no doubt influenced the artist's ongoing design of his own homestead; indeed, the gardens of "The Oaks," which were just beginning to take shape after Parrish's three-month Italian sojourn, would eventually reflect a decidedly classical character.[123] Happy to be home again, Parrish proceeded to translate memories of his travels into a Yankee idiom, whereby the painted canyons of Arizona and the classical garden villas of Italy became the lush mountains and waterways of the Connecticut Valley. As critic, friend, and neighbor Adeline Adams remarked: "After Saranac, Arizona, and Italy, came Cornish to crown all . . . being given the fairest trees, hills, and skies in New Hampshire and on earth, things that his art and his nature alike demand, he has for the rest created his own environment."[124] That this environment was a conflation of a variety of locales explains the national (or even international) rather than regional appeal of Parrish's work throughout his career.

GAMBERAIA

Villa Gamberaia, Settignano. 1903. Oil on canvas, 28½ x 18½" (72.39 x 45.72 cm). Lent by the Minneapolis Institute of Arts. Bequest of Margaret B. Hawkes

The Idiot. 1910. Oil paint over graphite and ink on stretched paper, 22 x 16" (55.88 x 40.64 cm). Fine Arts Museums of San Francisco, Achenbach Foundation for Graphic Arts. Bequest of Arthur W. Barney

Opposite:
School Days (Alphabet). 1908. Oil on board, 22 x 16" (55.88 x 40.64 cm). Collection of Joan Purves Adams

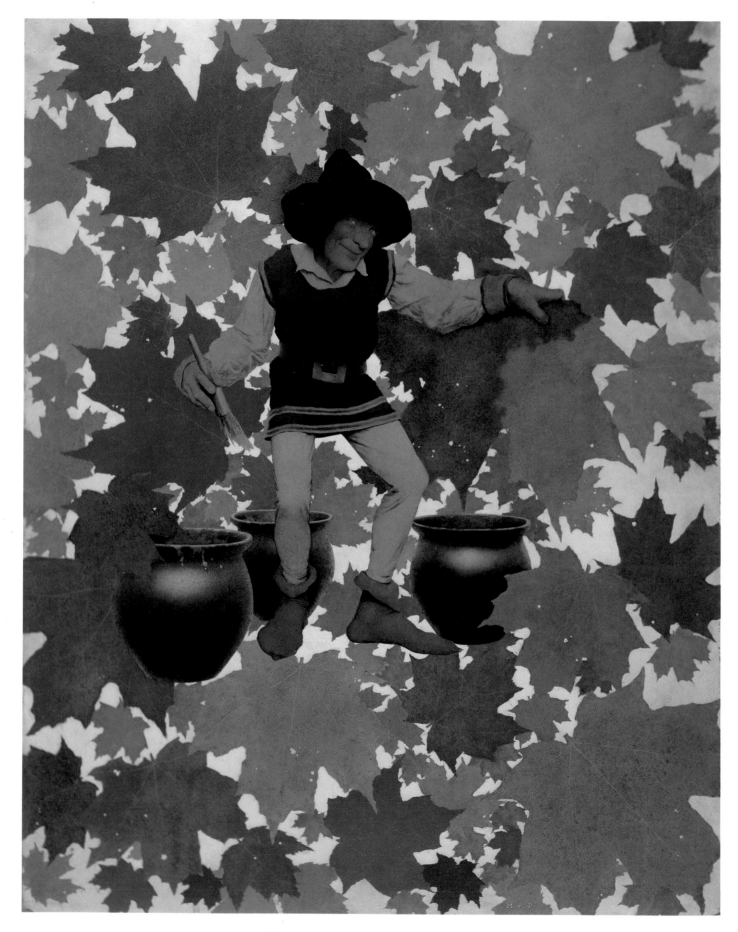

Jack Frost. 1936. Oil on board, 25 x 19" (63.5 x 48.26 cm). Haggin Museum, Stockton, CA

For Parrish 1904 was a year of both personal and professional milestones. Lydia gave birth to their first of four children, and the artist signed an exclusive six-year contract with *Collier's* magazine. In addition, Parrish, who had always displayed a special understanding of childhood, as an expectant father took on a project that became particularly resonant in these terms: the illustration of Eugene Field's *Poems of Childhood.*

Published as a volume in the fall of 1904 by Charles Scribner's Sons, the project had originated with a series of drawings that appeared in the *Ladies' Home Journal* two years earlier. Unlike the magazine images, however, the book illustrations were the first of Parrish's to be reproduced in full color. As such, *Poems of Childhood* became one of his best-known volumes, with the image of *The Dinkey-Bird* (see page 142) serving as an icon of youthful abandon for a generation of readers.[125]

Again, critics used the occasion to celebrate Parrish's imaginative powers and to marvel at the unique blend of humor and poetry in his imagery. Emphasizing the artist's "illuminating interpretation" that went beyond merely illustrating Field's verses, William D. Moffat observed: ". . . there is in his work a classic simplicity and a largeness of idea that place his pictures among the enduring things of art. Each new work of his is in a way a new revelation, and it would be hard to fix the limit of his powers."[126]

The editors of *Collier's* appeared to agree, offering Parrish the six-year contract that would prove auspicious for both parties. In the first decade of the twentieth century, *Collier's* became a leader in high-quality color illustrations, recruiting such "stars" as Charles Dana Gibson, who was wooed away from *Life* in 1903, as well as other of Parrish's former Academy classmates, including William Glackens, Jessie Willcox Smith, and Everett Shinn. Despite this concentration of artistic talent and an emphasis on fiction and poetry (Rudyard Kipling, Frank Norris, and Frank L. Stanton were just a few of the publication's regular contributors), *Collier's* still promoted itself as a national weekly newspaper rather than an art (or literary) magazine, urging Parrish to be mindful of this when considering subjects and reproduction capabilities.[127]

Despite the artist's growing success as an independent agent, his arrangement with *Collier's* provided both greater artistic freedom and financial security, the latter no doubt welcome since the arrival of his first child. The magazine's format, larger than most periodicals, gave Parrish the opportunity to explore increasingly complex designs, more faithfully reproduced. Furthermore, by working for one magazine, the artist was able to pursue ideas in thematic series. The resulting covers attest to the success of this arrangement: *School Days (Alphabet)* (see page 72) and *The Idiot* (see page 73) were just two designs that revealed Parrish's ingenious experimentation with formal layering and optical effects.[128] Other important series commissioned by *Collier's* included *The Arabian Nights* (1906–7) and *Greek Mythology* (1908–9).[129]

Although Parrish terminated his contract with the magazine in 1910 in order to concentrate on mural commissions, *Collier's* continued to publish back designs for the next three years and, in 1936, invited the artist to contribute a cover image. Parrish, supposedly on the advice of his youngest daughter Jean, produced what would be both his last figurative work and magazine illustration. In yet another veiled self-portrait, the artist depicted himself as *Jack Frost,* working magic on a landscape with a paintbrush.[130]

1909: A Year to Remember

Throughout much of his career, Parrish displayed a breathtaking versatility in the kind and number of commissions he embraced. A particularly rich year was 1909, during which the artist saw the publication of his drawings for *The Arabian Nights* in a special volume; produced some of his strongest magazine covers; ventured into the realm of theater design; and completed two mural projects.

Parrish combined the fanciful and the "exotic" in his two series originally produced for *Collier's*—*The Arabian Nights* and *Greek Mythology*—that had lives elsewhere. In 1909, Charles Scribner's Sons published the artist's *Arabian Nights* illustrations with a text edited for young readers by Nora A. Smith and Kate Douglas Wiggin, author of *Rebecca of Sunnybrook Farm*.[131]

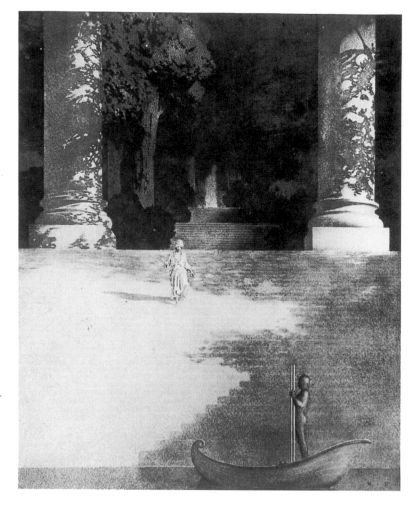

Landing of the Brazen Boatman. 1905. Oil on paper, 18 x 16" (46.15 x 41.02 cm). Location unknown. Photograph: Coy Ludwig, *Maxfield Parrish* (New York: Watson-Guptill Publication, 1973)

Many of the images from the *Greek Mythology* series were bought by Duffield and Company, in 1910, to illustrate a single volume of Nathaniel Hawthorne's *A Wonder Book and Tanglewood Tales*. This reuse of Parrish's art reinforced the interrelationships in the publishing industry as it ensured the artist's widespread circulation; numerous art prints of *The Arabian Nights* illustrations also were issued.

Parrish's original conception of these popular tales, so vividly colored and imaginatively realized, were an instant hit with both children and adults. Moreover, a number of the scenes anticipated future motifs for which the artist would become well known. *Princess Parizade Bringing Home the Singing Tree* (see page 130) marks the first appearance of Parrish's soon-to-be-ubiquitous "girl-on-the-rock" imagery. *Agib in the Enchanted Palace* features the artist's own garden design in New Hampshire, from the circular pool to the flowering bushes and classical urns. And *Landing of the Brazen Boatman,* though more fantastical in its architectural conception, suggests an elephantine, expanded version of the portico in *Daybreak.*

Landing of the Brazen Boatman proved to be one of the most acclaimed paintings in the series, winning the Beck Prize in the Pennsylvania Academy's 1908 watercolor annual and leading to one of

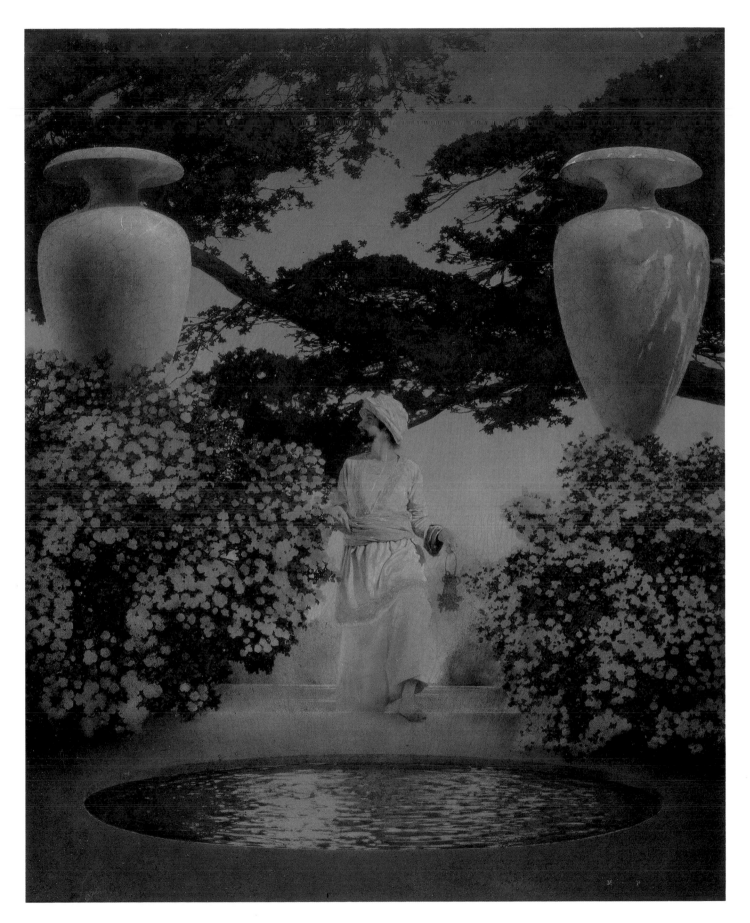

Agib in the Enchanted Palace. 1905. Glazed oil on paper, 18 x 16" (45.7 x 40.6 cm). Detroit Institute of Arts. Bequest of the Estate of Dollie May Fisher, widow of Lawrence P. Fisher

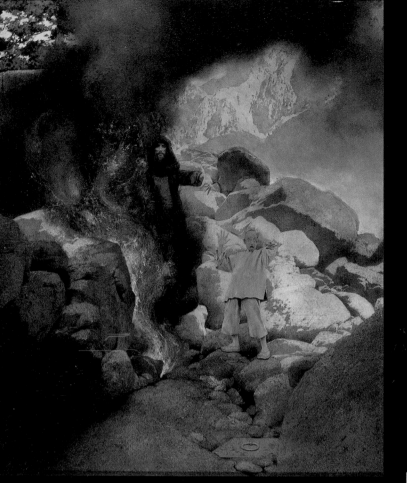

Aladdin and the African Magician. 1905. Glazed oil on
paper, 18 x 16" (45.7 x 40.6 cm). Detroit Institute of Arts.
Bequest of the Estate of Dollie May Fisher, widow of
Lawrence P. Fisher

Sinbad in the Valley of Diamonds.
1906. Glazed oil on paper, 18 x 16"
(45.7 x 40.6 cm). Detroit Institute
of Arts. Bequest of the Estate of
Dollie May Fisher, widow
of Lawrence P. Fisher

Parrish's earliest professional forays into the world of the theater. Apparently, the picture's cascade of stairs inspired the leading actress Maude Adams to incorporate the admittedly theatrical setting into her next play, J. M. Barrie's *A Kiss for Cinderella.* Although arranged through the artist's Cornish neighbor, Homer Saint-Gaudens—who happened to be Adams' manager—Parrish's lack of direct involvement in the set design affected its less than faithful realization.[132]

The impact of the tales' "exotic" subject matter on Parrish's art would be most apparent in a series of designs he produced for Crane's Chocolates between 1915 and 1918. No doubt inspired by the artist's *Arabian Nights* pictures, Clarence Crane commissioned Parrish to create gift-box decorations for the Christmas holiday in an effort to market his product to a more sophisticated clientele. Although the businessman suggested the subjects for all three boxes—*The Rubaiyat* (1916), *Cleopatra* (1917), and *Garden of Allah* (1918)—the interpretation was left to the artist.

Garden of Allah, the least "Orientalist" of the series, depicted three young women lounging by a reflective pool in a setting suggestive of an imaginative conflation of different aspects of Parrish's own garden at "The Oaks." The headdresses worn by two of the figures were the only indication of the picture's supposedly Eastern theme; even the costumes—a type of Grecian peplos with girdle favored by the artist— were more like those popularized by Parrish's contemporary, the dancer Isadora Duncan. Interestingly, the stagelike setting of the composition, dramatically lit and arranged, was inspired by a play of the subject Parrish had seen in New York, a production that imagined the scene as a "fairyland oasis somewhere in the Sahara."[133]

Girl by a Fountain (study for *Garden of Allah*). 1918. Crayon on paper, 11¼ x 9¹⁵⁄₁₆" (28.58 x 25.08 cm). Carnegie Museum of Art, Pittsburgh. American Artists' War Emergency Fund

Parrish's lifelong interest in the theater exerted a continuing influence on his art. From his 1895 decorations for the Mask and Wig Club, which marked the first appearance of his comic masks, dramatic references appeared in both literal and metaphoric forms. For example, an 1898 illustration for *Scribner's, At an Amateur Pantomime* (see page 13), incorporated two "players" and Parrish's signature masks amid a classical architectural setting.[134] Moreover, after his move to New Hampshire, amateur theatricals would become a favorite amusement of Parrish's, as they were for members of the Cornish colony in general. Popular staples of artists' gatherings in town and country, these performances, or masques, in which participants would enact *tableaux vivants* ("living pictures") and charades or humorously allegorical spectacles, were given each summer in Cornish and viewed as an essential "expression of community spirit."[135]

The most famous masque performed in the colony was the 1905 *A Masque of "Ours": The Gods and the Golden Bowl,* celebrating the twentieth anniversary of the Saint-Gaudenses' arrival in Cornish. In a pine grove on the Saint-Gaudens estate, Aspet, sixty-five members of the artists' colony and their children,

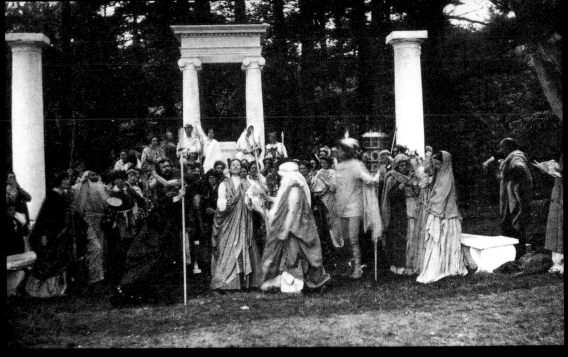

Above:
A Masque of "Ours."
1905. Photograph. U.S.
Department of the
Interior, National Park
Service, Saint-Gaudens
National Historic Site,
Cornish, NH

A Masque of "Ours."
1905. Autographed
playbill. U.S. Depart-
ment of the Interior,
National Park Service,
Saint-Gaudens National
Historic Site, Cornish,
NH

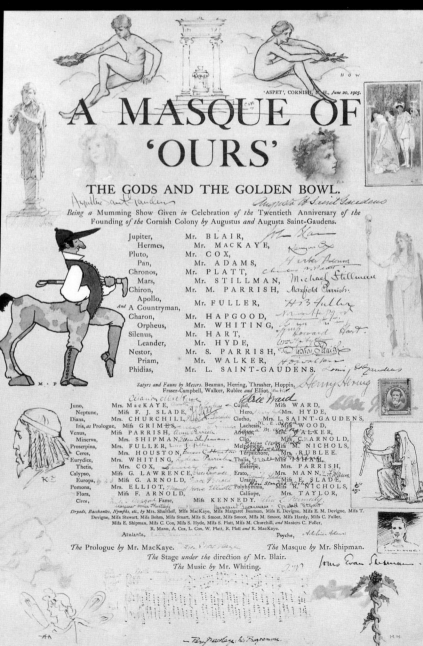

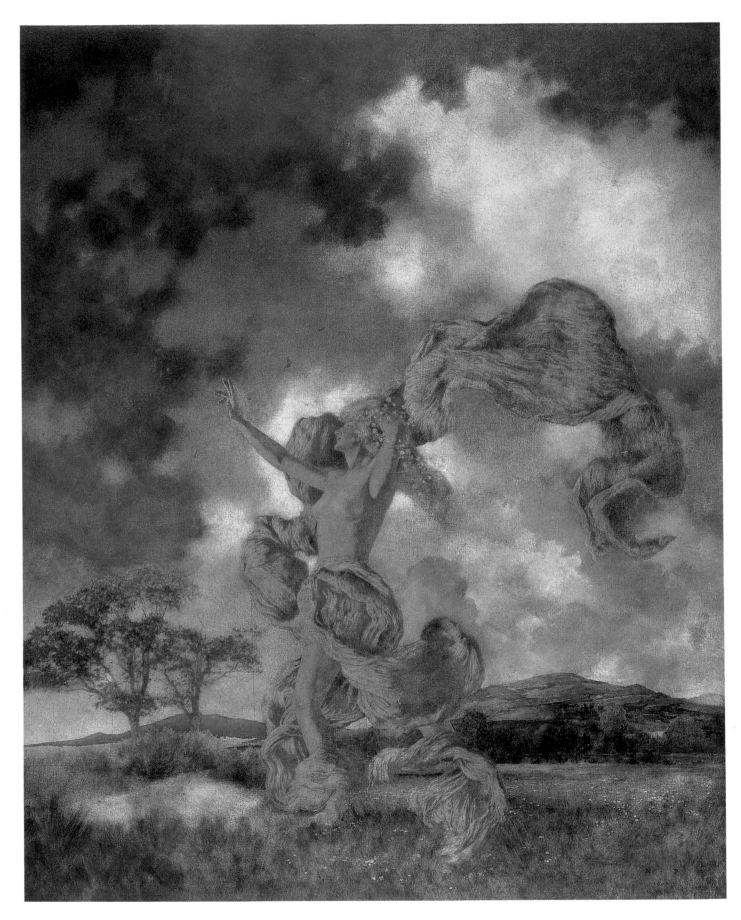

The Storm. 1907. Oil on canvas, 40 x 32" (101.6 x 81.28 cm). Addison Gallery of American Art, Phillips Academy, Andover, MA.
Gift of Mrs. Henry M. Sage

along with members of the Boston Symphony Orchestra, presented their tribute to the sculptor in the guise of a gathering of the gods, during which Jupiter announces his decision to abdicate. After much arguing about his replacement, Minerva calls upon Fame to decide. Bringing forth the golden bowl, the goddess reveals the "name of him most worthy"—Saint-Gaudens. Then, the bowl having been presented to the sculptor, he and his wife entered a chariot and joined the procession of "fauns, nymphs, and satyrs" to an outdoor banquet "spread under twinkling Japanese lamps."[136]

While reviewers of the *Masque* noted the poetic quality of Percy MacKaye's prologue honoring Saint-Gaudens' art and found the pagan burlesque an "agreeable nonsense," it was the set design, cos-

tumes, and overall visual effects that received the most praise (see page 83).[137] Unsurprisingly, Parrish played a major role in all departments. His gilded masks (see page 58) graced the curtain that opened onto a templelike setting, complete with freestanding Ionic and Doric columns (echoing the terraces of many local houses), laurel ropes, and flowers— all features that would appear in much of Parrish's later imagery. The artist also had a starring role in the production as Chiron, the Centaur—"the one frankly comic figure in the masque"—leading a group of "semi-nude faun children," his pupils. Parrish designed and constructed his complicated costume—depicted by the artist on the autographed playbill (see page 83)—a feat that impressed many as a "triumph of mechanical skill."[138]

According to his neighbors, the artist could not have been more appropriately cast. Homer Saint-Gaudens noted, in the year of the *Masque,* how Parrish "mastered the power of mingling work and play in the expression of his buoyant good humor. . . . Never did a man, his home, his amusements, and his vocation appear in happier accord."[139]

Deep Woods, Moonlight. 1916. Oil on masonite, 21¼ x 13¾" (53.98 x 34.93 cm). Private Collection. Photograph courtesy of Alma Gilbert

Another neighbor, Frances Grimes, in her 1950s reminiscences of life in Cornish, wrote of the "spirit of derision which was constantly woven with serious comment on art in the talk" of the colony, citing Parrish as one of the leading advocates of this playful social life.[140]

The artist's Cornish connections would lead to more theater work in 1907, when Parrish supposedly designed the temple scene in *Sappho and Phaon, A Tragedy* by the dramatist Percy MacKaye, the author of the prologue to *A Masque of "Ours."*[141] In 1916, Parrish was commissioned by his summer neighbor William Howard Hart, a New York stage designer and painter, to design the stage set for a production of *The Woodland Princess* in the Plainfield Town Hall, which that year had been equipped to serve as one of the colony's theatrical homes. (The production also may be related to Parrish's fairy and sprite imagery of the same year, for example, *Deep Woods, Moonlight* [see page 85]

Susan Lewin Posing for Djer-Kiss Cosmetics: Girl on Swing. ca. 1916. Modern print from original glass-plate negative, 10 x 8" (25.4 x 20.32 cm). Collection of Peter Smith and Alma Gilbert

and a series of photographs used as studies for his *Djer-Kiss* advertisements.[142]) For the set design, the artist produced a local sylvan scene with a waterside view of Mount Ascutney in the center, which local writer Adeline Adams dubbed "one of the finest expressions of his power in landscape."[143] Professional scene painters, under Parrish's direction, then reproduced the composition on the hall's stage backdrop, six wings, and three overhead drapes. With inventive stage lighting creating magical effects of daylight, dusk, and twilight, Plainfield gained the reputation of having "the most beautiful stage north of Boston"[144] (see pages 88 and 89).

Another Cornish theatrical connection led to one of Parrish's most important endeavors—his last book commission illustrating Louise Saunders' *The Knave of Hearts.* Saunders, another friend and summer neighbor of Parrish's and the wife of Maxwell Perkins, editor of *Scribner's,* wrote the manuscript as a play for children, which the artist likely saw performed in Cornish. In 1920, he wrote an enthusiastic letter to Charles Scribner's Sons (publisher of *Poems of Childhood* and *The Arabian Nights*), proposing an illustrated edition of the play: "The reason I wanted to illustrate *The Knave of Hearts* was on account of the bully

Djer-Kiss Cosmetics: Girl with Elves. 1918.
Lithograph on paper, 14⅛ x 9" (35.88 x 22.86 cm).
The Free Library of Philadelphia. Rare Book
Department

Djer-Kiss Cosmetics: Girl on Swing. 1916.
Lithograph on paper, 17 x 11" (43.18 x 27.94 cm).
Collection of Alma Gilbert

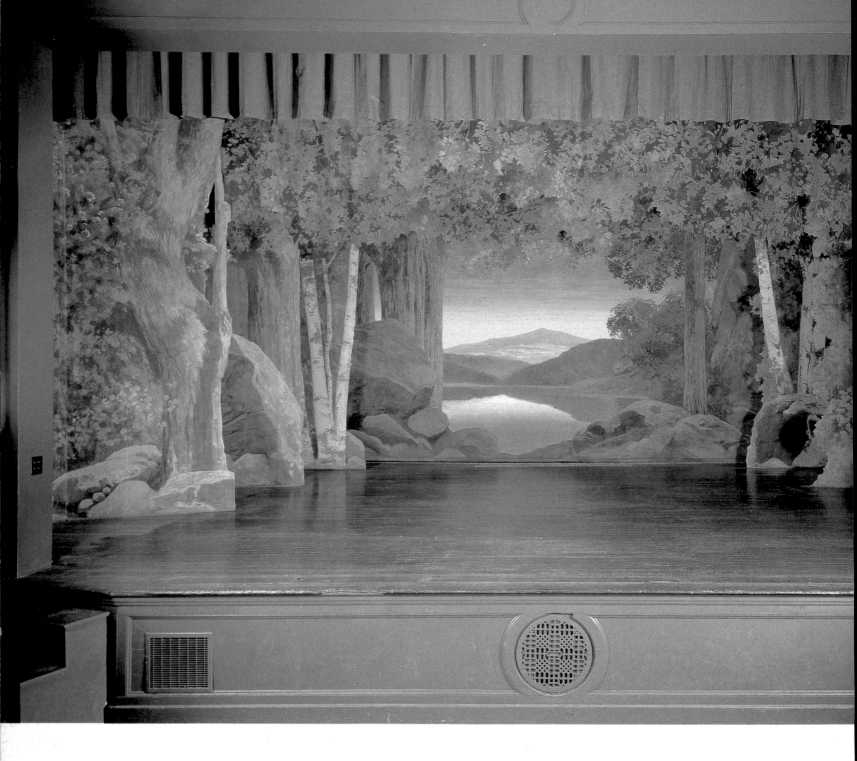

opportunity it gives for a very good time making the pictures. Imagination could run riot, bound down by no period, just good fun and all sorts of things."[145] By 1921, Parrish had prepared a mock-up of the book for approval, and over the next three years he executed twenty-six paintings. The book was published in 1925 in an oversized format with lush reproductions.

Many of the images in the book reflected the broad theatricality of the text as written for children, while others had little to do with the nursery-rhyme subject matter per se. For example, the painting used as the endpiece/cover lining for the book, *Romance* (see pages 90 and 91), did not illustrate any particular scene from the play but, rather, evoked the overall tone of Parrish's oeuvre to date. Significantly, it was one of the images from the book issued separately as a color reproduction suitable for framing.

Coinciding with the publication, a highly publicized exhibition of fifty paintings by the artist—

The End (The Knave of Hearts). 1923. Oil on board, 26 x 22" (66.04 x 55.88 cm). Private Collection

Stage Set for The Woodland Princess. 1916. Tempera on canvas, 14'6" x 28' (441.96 x 853.44 cm) main backdrop; 12' x 7'6" (365.76 x 228.6 cm) each wing. Plainfield Town Hall, NH

Two Pastry Cooks: Blue Hose and Yellow Hose. 1921. Oil on paper laid down on panel, 20⅛ x 16¼" (51.12 x 41.28 cm). Private Collection

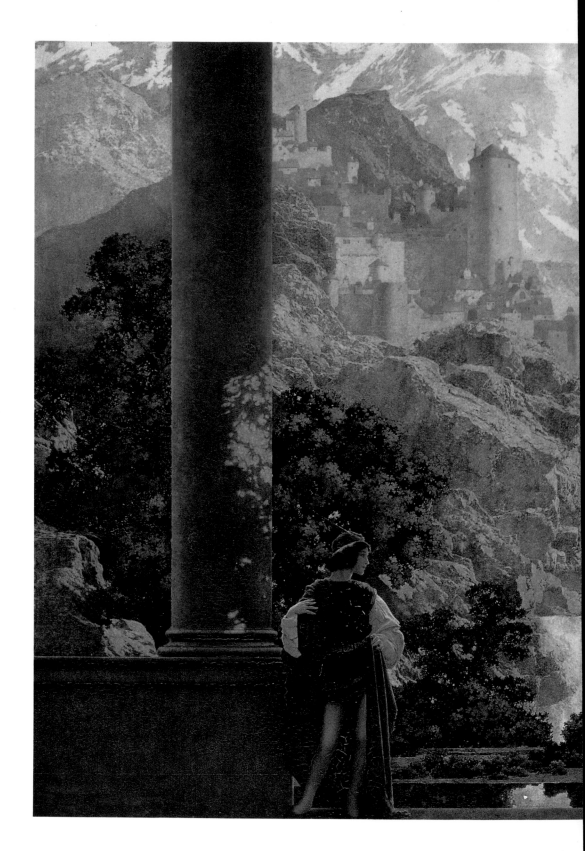

Romance. 1922. Oil on panel,
21¼ x 35" (53.98 x 88.9 cm).
Private Collection

including many from the *Knave* series—was held at the Scott and Fowles gallery in New York City. The exhibition was extraordinarily successful, with all the works selling for high sums. Indeed, three of Parrish's best-known paintings—*Garden of Allah, Daybreak,* and *Romance*—each went for ten thousand dollars, setting a record at the time for a living American artist. The financial return from the exhibition made up for the relatively poor sales of the book itself. With a price tag of ten dollars, at the time considered expensive for a children's book, and its oversized scale, *The Knave of Hearts* failed to attract many consumers.

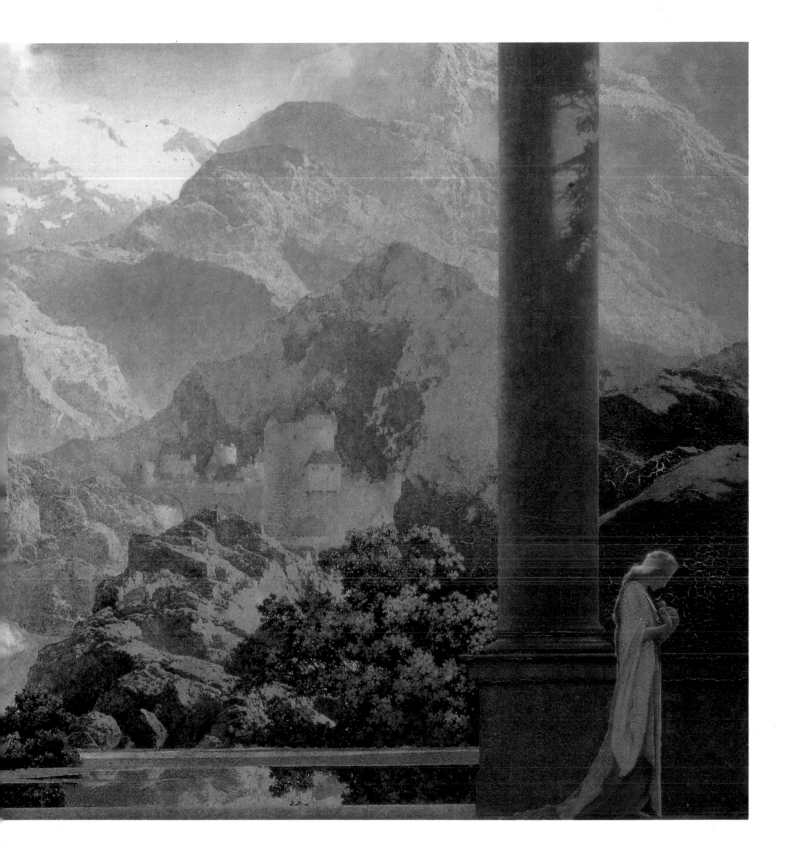

Nevertheless, it proved to be a highly remunerative project for both Parrish and Scribner's, spawning a host of spin-off products, from color reproductions and puzzles to a spiral-bound edition of the book marketed by different companies.[146]

Parrish also was involved in some larger theatrical ventures in New York. In 1909, he painted four scenes for Winthrop Ames' and Hamilton Bell's Broadway production of William Shakespeare's *The Tempest*. The Dodge Publishing Company later reproduced these elegantly spare landscapes as deluxe

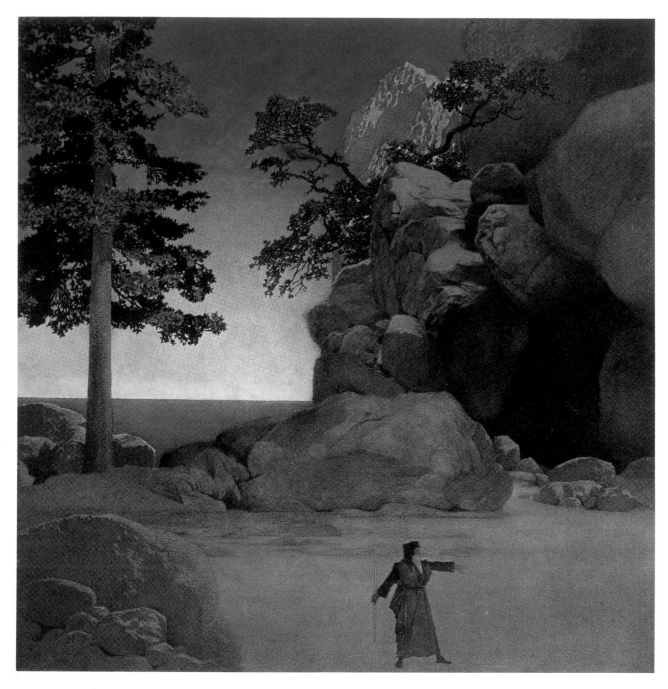

A Strong-Based Promontory (The Tempest). 1909. Lithograph on paper, 7 x 6¾" (17.78 x 17.15 cm). The Metropolitan Museum of Art, New York. Bequest of John O. Hamlin

framing prints. Interestingly, for this purpose, Parrish altered one of the original designs—*A Strong-Based Promontory*—adding a small figure for scale.

Parrish's last known involvement with the professional theater was the proposed circa 1917 production of Walter Wanger's *Snow White*. The artist painted backdrops, designed costumes, and built set models for the play—including the free-standing *Gnome*—before its cancellation due to America's entry into World War I.[147]

As both the theatrical and artistic center of the country, New York provided Parrish with many

professional opportunities in these years. Three years after his *Old King Cole* mural was installed in the Knickerbocker Hotel, the artist produced *Quod Erat Demonstrandum* (see page 94) for an overmantel in the Meeting House Club. Suggesting a conflation of Parrish's humorous style—by way of *Knickerbocker's History* and his interests in architectural and decorative design, the mural depicted two men sharing a book and refreshment from striking pewter tankards (likely from the artist's collection) in an eighteenth-century setting, with a snowy New Hampshire landscape incongruously glimpsed through latticed windows. (Parrish also produced a bookplate of the image for the Club.)

Both the Knickerbocker and Meeting House mural commissions suggest that the media image of Parrish as a plain Yankee or country bumpkin was a gross oversimplification. Located in the center of New York's theater district at Forty-second Street and Broadway, the luxurious Knickerbocker Hotel opened in 1906 with the slogan "a Fifth Avenue hotel at Broadway prices." What truly distinguished the establishment from others was its decorative program. Departing from the conventional use of Old Master reproductions, the operator James B. Regan commissioned a number of urbane, contemporary artists—in addition to Parrish, Frederic Remington and Frederick MacMonnies—to decorate the restaurants, grill, and bar. The *Real Estate Record and Guide* found Parrish's mural to be the most successful, noting that it "will do what very few works of art have ever done—it will pay its own way."[148]

Gnome (Snow White). ca. 1916. Painted figure cutout with jigsaw, 16½ x 5" (41.91 x 12.7 cm). American Precision Museum, Windsor, VT

THE BAR ROOM OF THE KNICKERBOCKER HOTEL, SHOWING THE PANEL, "OLD KING COLE."
Broadway and 42d Street, New York. (Photo by A. Patzig.) Bruce Price, } Associated.
 Marvin & Davis, } Associated.
 Trowbridge & Livingston, Architects.

"The Bar Room of the Knickerbocker Hotel, Showing the Panel *Old King Cole.*" 1906. Photograph: "The Knickerbocker Hotel: A Novelty in Decoration," *Architectural Record* 21 (January 1907)

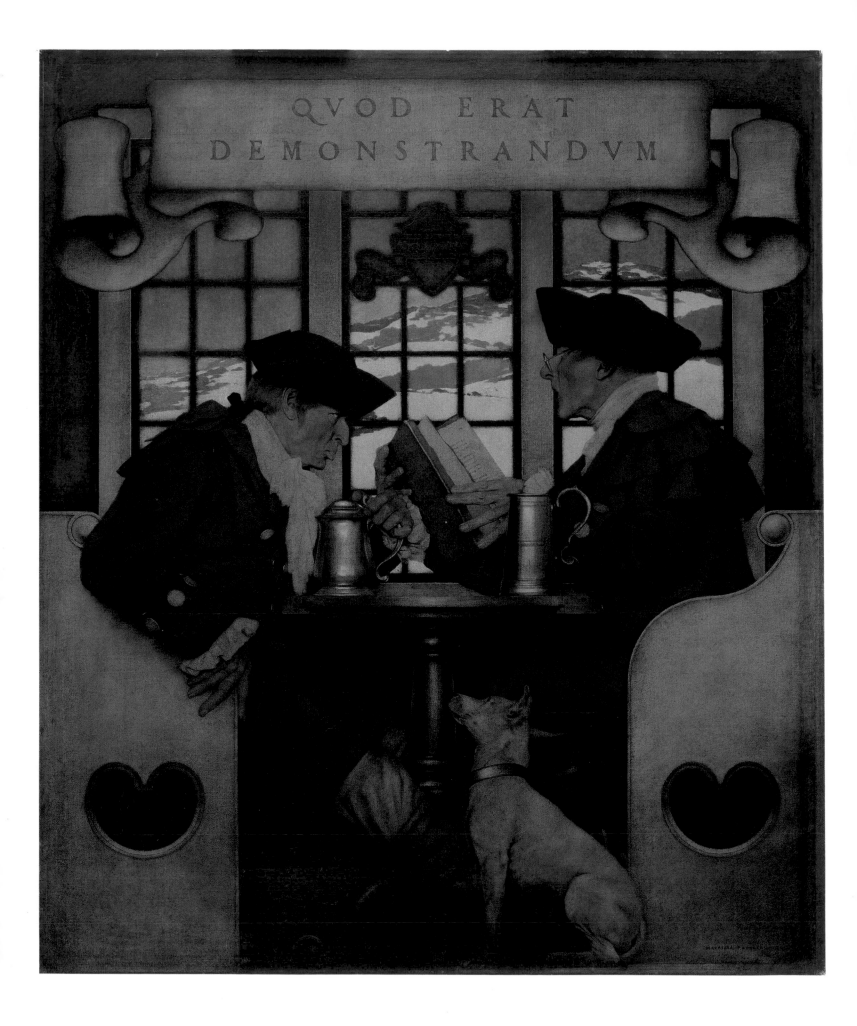

In addition to the Meeting House, a society of artists and collectors, Parrish maintained a membership in another New York club in these years, the Coffee House. Like the Meeting House, the club was a more intimate, less formal social organization, without its own architect-designed clubhouse, founded in 1915 by a group of literary and artistic types, including the writer Guy Lowell, the editor of *Vanity Fair* Francis Crowninshield, and the sculptor Paul Manship. Intended to be a refuge from the regulations and elitism of older social organizations—"a revolt against the marble palace idea . . . very simple and cheap"— the club membership favored cultural figures such as Robert Benchley, Douglas Fairbanks, Charles Dana Gibson, Childe Hassam, Charles Platt, Cole Porter, Owen Wister, and P. G. Wodehouse—all likely companions of a man such as Parrish—over "bankers and brokers."[149]

Adeline Adams, writing in 1918, noted that soon after the Meeting House commission, "some one was grumbling because in order to see a Parrish mural decoration, he had to go gayly to a bar, or sedately to a club."[150] And indeed, in 1909, three years after the *Old King Cole* mural was completed, the artist's *Pied Piper* mural was installed across the country, in the bar of San Francisco's Palace Hotel. Painted in Cornish using local young women and children as models—including Parrish's own sons, Dillwyn and Maxfield, Jr.— the mural suggested a metaphoric self-portrait in both local and national terms. While recalling the artist's

The Pied Piper. 1909. Lithograph on paper, 6¾ x 21¼" (17.15 x 56.5 cm). The Free Library of Philadelphia. Rare Book Department

Opposite:
Quod Erat Demonstrandum. 1909. Oil on canvas, 48 x 40" (121.92 x 101.6 cm). Collection of Beatrice W. B. Garvan

playful turn as the colony's Chiron, the Centaur, in the 1905 *Masque,* it also spoke to Parrish's reputation as a Peter Pan figure in the art world—captivating the "young at heart" of all ages. (Stephen Parrish noted how his son held a viewing of the mural for friends and neighbors before crating it for shipment: "P.M. drove over to see the decoration 'The Pied Piper of Hamlin'—for a San Francisco hotel—everybody there."[151])

From these commissions for all but masculine domains, Parrish expanded his mural painting repertoire in 1911 with, arguably, his most ambitious and significant venture to date—

Circus Bedquilt Design. 1904. Oil and collage on stretched paper, 23⅝ x 22¹³⁄₁₆" (60.01 x 58.10 cm). The Free Library of Philadelphia. Rare Book Department

the eighteen-panel *Florentine Fete* cycle for the new Curtis Publishing headquarters in Philadelphia. As early as 1905, Homer Saint-Gaudens observed that Parrish "makes no secret of his desire to leave illustrating. He progresses with a deliberate purpose and power that seems to aim at mural decoration with his taste for architectural effects."[152] To be sure, the artist's early architectural training gave him the requisite skills to establish himself as a fine muralist. As in the past, however, it was his talents as an illustrator that led to the Curtis commission.

Parrish's association with Edward W. Bok, the crusading editor of the *Ladies' Home Journal*, dated from 1896, when he designed his first color cover for the magazine. The 1901 commission to illustrate Eugene Field's *Poems of Childhood*, appearing in the magazine the following year, and his *Circus Bedquilt Design*, contributed to the growing popularity of Parrish's work with a female readership.[153] As the leading conservative general interest magazine for middle-class women, the *Ladies' Home Journal* set the pace for inexpensive and simple decoration in the early part of the twentieth century, reflecting Bok's modified Arts and Crafts philosophy.[154]

At the center of Philadelphia's publishing empire, the Curtis company occupied a majestic building on Independence Square, considered at the time to be the most beautiful and modern periodical plant in

Florentine Fete. 1916. Lithograph on paper, 8⅝ x 14⅛" (21.91 x 35.88 cm). The Free Library of Philadelphia. Rare Book Department

Ladies' Home Journal: Sweet Nothings.
1921. Lithograph on paper, 14 x 10¾"
(35.5 x 27.5 cm). The Free Library of
Philadelphia. Rare Book Department

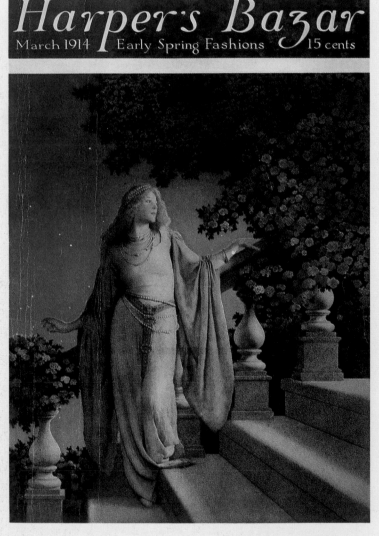

Harper's Bazar: Cinderella. 1914. Lithograph on
paper, 14¼ x 9¾" (36 x 25 cm). The Free Library
of Philadelphia. Rare Book Department

Susan Lewin in Velvet Dress Posing for Florentine Fete. ca. 1913. Modern print from original glass-plate negative, 10 x 8" (25.4 x 20.32 cm). Collection of the Brandywine River Museum, Chadds Ford, PA. Gift of the Maxfield Parrish Museum, Inc., Plainfield, NH. Courtesy of Alma Gilbert

the world. With its many young women employees in mind, the company planned a so-called "girls' dining room" for the top floor of its new building and commissioned Parrish to provide the decorations. For this site, with its narrow wall spaces between colonnade windows, the artist chose the theme of an Italian fete, or carnival, the same subject he was exploring in a mural cycle for the Long Island estate of the sculptor and art patron Getrude Vanderbilt Whitney. While one central painting depicted the fete itself (see page 97)—representing the artist's "aim to make it all joyous, a little unreal, a good place to be in, a sort of happiness of youth"—the narrow panels featured youths and maidens making their way to the festivities.[155]

More suggestive of contemporary masquerade than historical re-creation, the overall effect of the mural cycle was one of theatrical play, likely inspired by the artist's Cornish amusements.[156] Years later, when asked to explain the work, Parrish replied: "It doesn't mean an earthly thing, not even a ghost of an allegory: no science enlightening agriculture: nobody enlightening anything. The endeavor is to present a painting which will give pleasure without tiring the intellect: something beautiful to look upon."[157] As a mural artist who came of age during the American Renaissance, Parrish was almost unique in his eschewal of allegorical subject matter. By choosing nursery rhymes and costume dramas that appealed to a broad audience's individual desires, he distinguished himself from the elite cadre of muralists engaged in large civic and federal commissions; for example, Edwin Blashfield, who produced images that argued for a shared public culture of ideals and standards.[158]

Parrish's costumed frolic was critically and popularly acclaimed, not only in the pages of the *Ladies' Home Journal*, which ran an announcement for "the Most Beautiful Dining-Room in America" and

featured many of the panels on its cover (see page 98), but in such sophisticated art publications as the *International Studio*.[159] In a 1912 feature, the *Florentine Fete* murals were referred to as an "indescribable chromatic embroidery" that could be likened only to "a picture by Maxfield Parrish" and were declared to be "by far the finest thing he has ever done."[160]

Curiously, no one seemed troubled by the artist's rather formulaic depiction of the revelers. Susan Lewin, Parrish's beloved model, posed for all but two of the figures—female and male—in the cycle, in costumes of her own making (see page 99). Lewin, a native of Plainfield, first came to work for the Parrishes at the age of sixteen to help Lydia with their first child and to assist Annie Lewin, her sister, who cooked for the family. She soon began to model for Parrish, who preferred not to work with professionals as he felt they lacked the "innocence" that his work required. Increasingly, Lewin's role became that of muse, studio assistant, house-

Susan Lewin in Diaphanous Gown Posing for Florentine Fete. ca. 1913. Modern print from original glass-plate negative, 10 x 8" (25.4 x 20.32 cm). Collection of the Brandywine River Museum, Chadds Ford, PA. Gift of the Maxfield Parrish Museum, Inc., Plainfield, NH. Courtesy of Alma Gilbert

keeper, and, eventually, companion.[161] In 1911, in the midst of the Curtis commission, she moved with Parrish from the main house to his studio while Lydia and the children wintered at their home on Saint Simons Island, Georgia.[162]

A State of Mind: *Daybreak* as Cultural Nexus

Despite Parrish's growing national and international fame in the first two decades of this century, Cornish continued to be his creative base and inspiration. Unsurprisingly, even the cornerstone work of his career—*Daybreak* (see pages 14 and 15)—may be interpreted in very local terms.

In his introduction to Frances Grimes's *Reminiscences*, an account of life in the colony in the early decades of the twentieth century, John Dryfhout observed: "She speaks of Cornish as being a 'state of

mind'. She renders a rhythm and an artist's pictorial view, one scene fading softly into another, as the days of summer. It is a rare view of this 'cult of beauty,' the ideal these artists lived for in their work."[163] This statement eloquently evokes *Daybreak*'s quiet, tranquil air as it places it in a more personal context.

In his self-proclaimed "Magnum Opus," produced in Cornish over the fall and summer of 1922, Parrish depicted under a lush floral canopy, framed between large columns, two young girls: one, Kitty Owen, granddaughter of William Jennings Bryan, dressed in a Grecian outfit and languorously reclining on a portico; and the other, Parrish's youngest child, Jean, androgynously nude and modestly bending over her older friend. The breaking dawn bathes the foreground figures and the background landscape in golden light and purple shadows, rousing the smiling adolescent and the fantastical lake and mountains from their slumbers.

Both the classical setting of the portico and the models' dress (and lack thereof) speak to Cornish's "atmosphere of modern antiquity"—dramatized in the 1905 *Masque*—that so impressed visitors. Moreover, the colony's "cultish" fascination with its mountain scenery—one summer resident likened Ascutney to Italy's Etna and Japan's Fuji—as well as its young women suggests a broader cultural reading of Parrish's "great painting."[164]

In a revealing and rare discussion of contemporary gender politics, Frances Grimes described Cornish as a "place where the men were acknowledged to be more important than the women, where the men talked and the women listened." One could add to this statement John Berger's more recent formulation of "men act/women appear," expanding on Grimes' observation that Cornish was home to a number of women of "unusual beauty," eminently paintable. It was this cult of idealized beauty—realized in the female form as well as in architecture—that united the work of the Cornish residents, from Thomas Wilmer Dewing (see page 102) to Henry Brown Fuller (see page 103) to Maxfield Parrish. In these paintings, Cornish appears as a kind of arcadian paradise that liberated the imagination, uncovering, in Parrish's case, a tension between an intensified reality and a pastoral dream.[165]

The classical ideal was not merely limited to Parrish's choice of subject matter in these years but shaped his entire approach to composition. *Daybreak*'s highly symmetrical construction, with its broad vertical and horizontal framing device and interlocking forms, revealed Parrish's use of "dynamic symmetry," a theoretical formulation based on Jay Hambidge's study of Greek art and architecture, *Dynamic Symmetry of the Greek Vase* (1920). Applying Hambidge's notion that patterns of natural growth could be adapted to artistic production, Parrish produced compositions in which precise formal arrangements permitted "every feature of the picture to be a harmonious part," including individual components such as urns and columns, which themselves embodied principles of dynamic symmetry. The artist continued to employ this technical formulation throughout his later career, in the end applying it to figureless, panoramic vistas.[166]

Daybreak was the first painting produced by Parrish as part of his reproduction and distribution arrangement with the House of Art, the New York and London–based firm that had been marketing his Crane's Chocolates prints since 1919.[167] While it was Crane who first convinced the artist of the mass-market potential of his work—particularly in the area of color reproductions suitable for the middle-class home—it was

Thomas Wilmer Dewing. *The Days*. 1887. Oil on canvas, 43 ¼ x 72" (109.86 x 182.88 cm). Wadsworth Atheneum, Hartford. Gift from the Estates of Louise Cheney and Anne W. Cheney

Parrish's contract with the House of Art that finally liberated him from advertising art, leading to the exclusive production of his first love, landscape painting, in the 1930s.[168] (As Michele Bogart has pointed out, it was Parrish's willingness to work in a newly expansive art world firmly aligned with consumer culture—"small companies, large corporations, print and lithography businesses, and artists' agents," who both commissioned work from Parrish and marketed it to a mass audience—that accounted for his tremendous success.[169])

Anticipating Komar and Melamid's "most wanted" painting survey by more than seventy years, *Daybreak* may be seen as a collaborative commodity in both conception and reception, a phenomenon of the growing consumer culture of the 1920s. The House of Art owners, A. E. Reinthal and Stephen L. Newman, advised Parrish on how to make the work more salable, suggesting a format and dimensions (horizontal, 15 x 30") best suited for domestic decoration. They even asked Parrish to submit a written statement to accompany the work, something he refused to do:

> *Alas, you have asked the very one thing that is entirely beyond me, to write a little story of* Daybreak, *or, in fact, of any other picture. I could do almost anything in the world for you but that. I know full well the public want a story, always want to know more about a picture than the picture tells them but to my mind if a picture does not tell its own story, it's better to have the story without the picture. I couldn't tell a single thing about* Daybreak *because there isn't a single thing to tell: the picture tells all there is, there is nothing more.*[170]

Henry Brown Fuller. *Illusions.* Before 1901. Oil on canvas, 70⅜ x 45⅛"
(27.71 x 114.63 cm). National Museum of American Art, Smithsonian
Institution. Gift of William T. Evans

Although the artist's surprisingly modernist stance may have been a bit disingenuous, it proved to be a shrewd one, allowing viewers to project their own meanings onto *Daybreak.* This strategy, which probably accounted in large measure for the work's appeal, continued to be successful with Parrish's future work.

Calculated to appeal to a broad audience, the popular success of the *Daybreak* prints far exceeded both the artist's and the marketer's expectations. According to Coy Ludwig:

College students decorated their rooms with them, people gave them as wedding gifts, hotels exhibited them in their lobbies, housewives placed them over the mantels—in short, Daybreak *became the decorating sensation of the decade. Whenever color reproductions were placed in windows of department stores and frame shops, crowds gathered to admire.*[171]

In seeking explanations for the extraordinary appeal of an image that apparently crossed gender, class, generational, and geographic boundaries—Parrish wrote of fan letters he had received from as far away as South Africa and remarked on hearing of a "business man who carries a large sized framed print with him on his journeys to and from New York and the West. I wish there was some way to reach him and suggest that he buy two"—it becomes necessary to move beyond Parrish's own description of *Daybreak* as antinarrative.[172]

In national terms, the composition's classical symmetry and balanced harmony seem to have evoked in viewers feelings of calm and well-being, perfectly matched to the booming economy of the 1920s. However, the dreamy nostalgia and transcendence simultaneously connoted by the classical

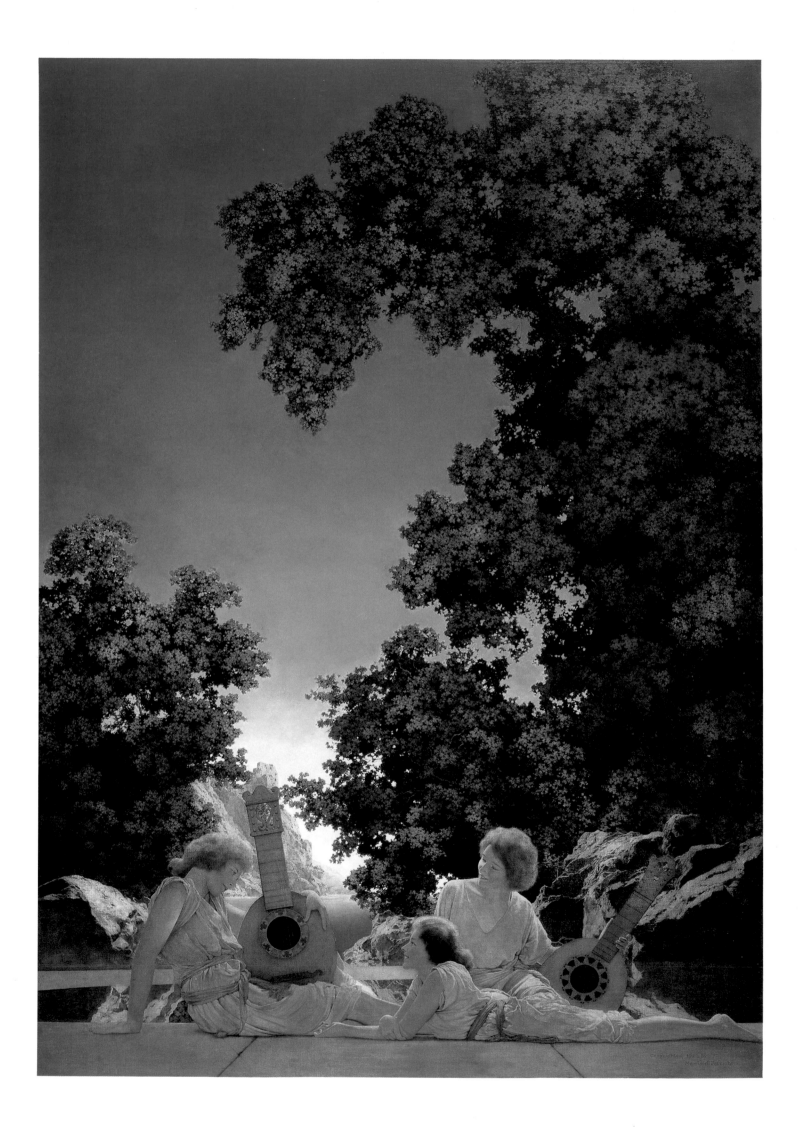

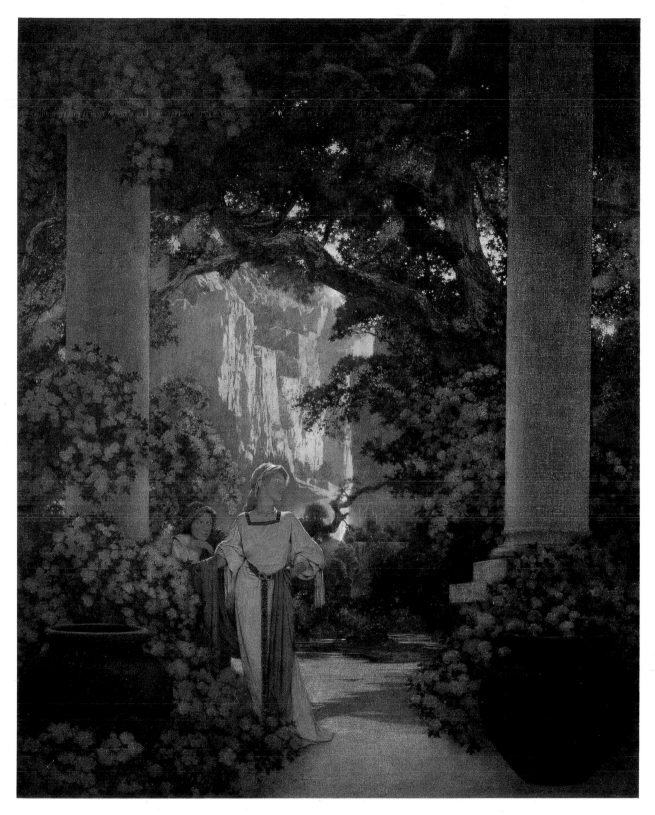

Land of Make Believe. 1905. Oil on canvas laid down on board, 40 x 32" (101.6 x 81.28 cm). Private Collection

Opposite:
Interlude (The Lute Players). 1922. Oil on canvas, 6'11" x 4'11" (210.82 x 149.86 cm). The Memorial
Art Gallery of the University of Rochester, NY. Lent by the Eastman School of Music

associations of this ideal image, realistically rendered, may have offered reassurance in the face of the decade's growing social tensions. Masking the artifice of his subject matter with a hyperrealistic style, Parrish offered viewers a believable, if highly theatrical, utopian paradise.[173]

The appeal of the work's erotic innocence, moreover, should not be understated. As Bogart has observed, Parrish frequently presented preadolescents—both male and female—as objects of desire, reflecting a popular if complex cultural trope of the period. By merging images of childhood and femininity in *Daybreak,* Parrish tweaked adult sexual anxieties at a time of increased cultural freedoms—both titillating and calming viewers with an ideal of naked innocence and youthful abandon.[174] (Parrish's photographic study of his eleven-year-old daughter Jean, posing nude for *Daybreak,* recalls the work of the late twentieth-century artist Sally Mann, whose photographs of her children have created a controversy that would have been foreign to Parrish's culture.[175])

While Parrish never fully acknowleged the sexual appeal of his art, what Nina Auerbach has described as the "power and erotic energy within a dream of purity" surely played a key part in the popularity of works such as *Daybreak.*[176] When efforts to repeat the startling success of the picture with similar images of "girls on rocks"—for example, *Stars* of 1926—failed, the artist described to Reinthal in a revealing letter that merits quoting at length the futility of seeking blueprints for public taste:

Jean Parrish Posing for Daybreak. 1922. Photograph. Dartmouth College Library, Hanover, NH. Special Collections

Opposite:
Stars. 1926. Oil on panel, 35¾ x 22¼" (90.81 x 56.52 cm). Private Collection

> *This whole question of pictures made to order is a darn peculiar form of merchandise. . . . I think I know more than I did, but there are a lot of things to consider in making a picture that is as good a work of art as you know how to produce and at the same time be popular to the public at large. I have gone about, in this connection, and kept my ears open, proposing mild questionnaires, and I confess to being somewhat at sea still. They all seem to like the tiresome M.[axfield] P.[arrish] blue, for one thing, and girls having a pleasant chat, for another. They must look pleasant, like* Garden of Allah *and* Daybreak. *The contemplative kind, such as* Hilltop, *not so popular. . . . You know, and I know, that what people like is a beautiful setting with charming figures, clothed or*

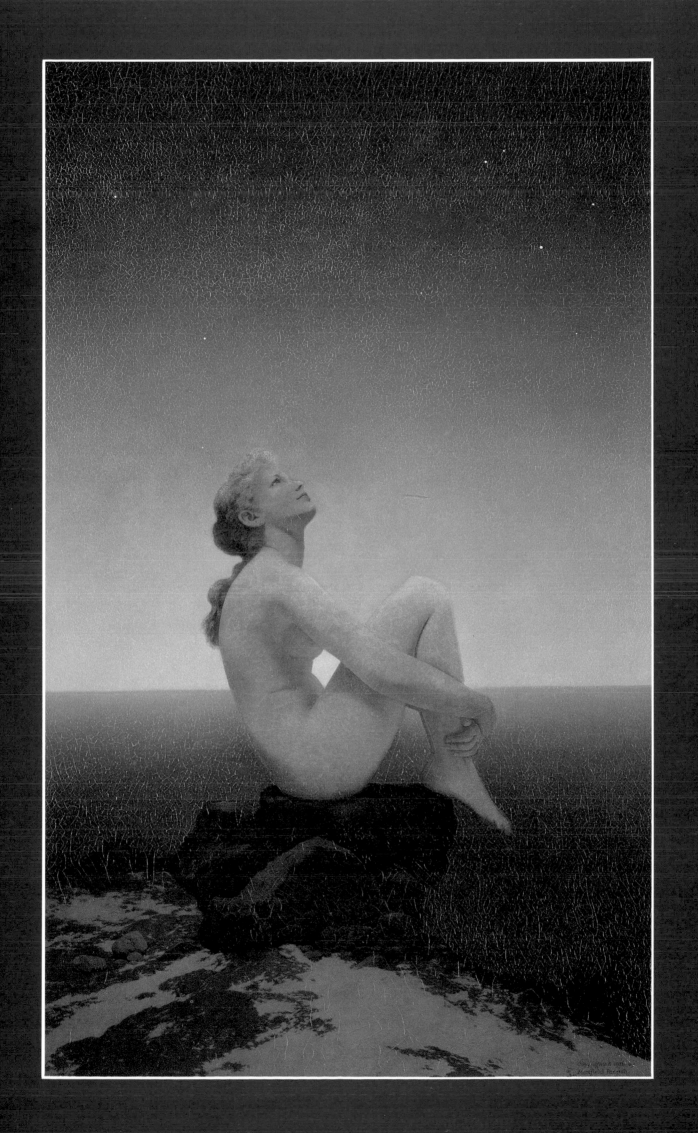

otherwise, and probably no one special feature. Whatever it is, it's elusive. . . . Needless to say the good art quality has no particular appeal; that is only for those who know. . . . There are countless artists whose shoes I am not worthy to polish whose prints would not pay the printer. . . . The question of judgement is a puzzling one. I am beginning to doubt my own. I'd rather have the cook's opinion concerning popularity than my own.[177]

In the final analysis, the irony of *Daybreak*'s success lay not only in the fact that an artist, formerly known for his narrative skills, failed to find his largest audience until he had left that realm—belying the notion that popular art requires a straightforward storyline—but, in the consequences this windfall had for Parrish's artistic reputation in general.

Commercial Perils

Although the 1920s was a decade that witnessed a celebration of popular culture, from comic strips to jazz, and a synergy between "low" and "high" art forms, it also experienced a backlash to this cultural invasion, resulting in a strengthening of hierarchies and divisions of production.[178] In the public and critical imagination of the interwar decades, Parrish— that "businessman with a brush"—became increasingly associated with commerical art and its place in middlebrow culture. This assessment derived from the artist's lucrative contract with the Edison Mazda Lamp Division of General Electric, for which he submitted an annual calendar image from 1918 to 1934, as well as the popular success of his House of Art color reproductions—both of which he viewed as falling somewhere between fine and commercial art.[179]

Parrish had produced calendars as forms of advertising before—the first in 1907 for *Collier's*—yet his association with General Electric would prove to be uniquely

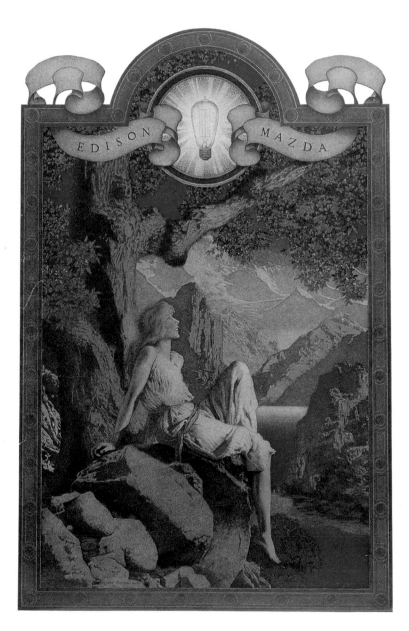

Edison Mazda Lamps Calendar: Night Is Fled (Dawn). 1918. Lithograph on paper, 14 5/8 x 9 1/2" (37.15 x 24.13 cm). The Free Library of Philadelphia. Rare Book Department

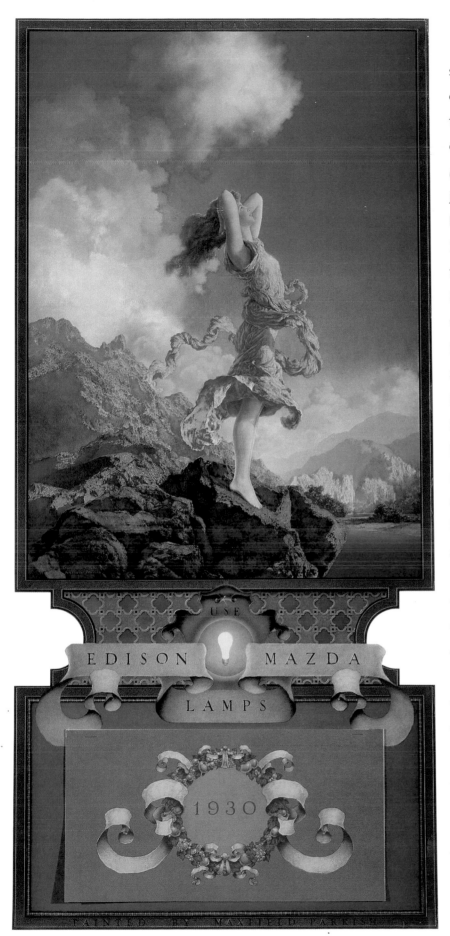

Edison Mazda Lamps Calendar: Ecstasy. 1930. Lithograph on paper, 33 ⅞ x 15 ⅜" (86.04 x 39.05 cm). The Free Library of Philadelphia. Rare Book Department

satisfying, beginning with his acceptance of the high sum of two thousand dollars for the design of the 1918 Edison Mazda Lamps calendar.[180] In this image, *Night Is Fled (Dawn),* Parrish first fully developed a subject that increasingly would be linked with Edison Mazda Lamps and the artist himself in American popular culture—the "girl-on-the-rock." Over the next sixteeen years, Parrish explored this theme in numerous variations, becoming a household commodity through the widespread distribution of advertising products. (J. L. Conger, General Electric's art director, estimated in 1931 that Parrish's calendar series had reached "each home in the United States nearly 300 times," noting, "Parrish's work, we have found, appeals to vast numbers of people who are left emotionally unmoved by the work of others."[181])

Parrish's iconographic updating of the art-historical Andromeda theme, in which evil and danger have been banished from the arcadian landscape, proved to be very popular with the general public, particularly women. His seemingly liberated female figures—New Women-cum-Flappers in classical garb—perched on precipices in characteristic Parrish landscapes, have broken free of their chains and achieved unlimited access to nature, if not culture. These American dreamers struck a chord with viewers who surely responded to their almost orgasmic claims of freedom and joy. Many women apparently framed the prints once the calendar year was through.

Conger discussed how the distinctive charm of Parrish's work—"almost instantly identifiable, even by the layman"—coupled with the company's willingness to maintain "unity of artist and technique" and to spare no expense in both design and reproduction, "created an advertising engine whose power dwarfs that of many a vehicle more pretentious," in effect, admitting the middlebrow appeal of the calendars.[182]

Intended for private consumption, the Edison Mazda Lamps images also embodied the successful prescription outlined in a later discussion on "creative illustration" by Andrew Loomis: "calendar pictures may be those which provide an escape from the monotonous routine of life into fanciful dreaming"—a rather

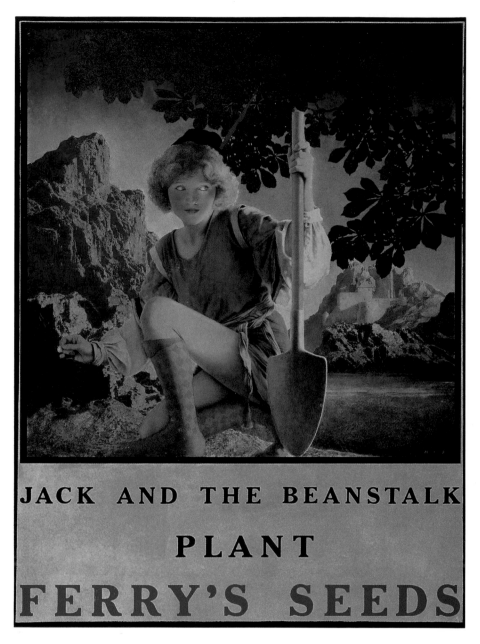

Ferry's Seeds: Jack and the Beanstalk. 1923. Oil on board, 29 x 21⅝" (73.66 x 54.94 cm). Department of Special Collections, University of California Library, Davis

ironic goal of a vehicle that tracks time. Loomis remarked on the psychological component of successful commercial art, noting that most people live in two worlds—"as it is and . . . as we would like it to be. . . . Make a picture a man or woman can dream in, or escape into, and you can hardly miss." In his view, it was this quality of escapism that explained the popularity of Parrish's calendars, as well as the artist's ability to "make the fancy real."[183]

Significantly, when producing advertisements for more widespread public consumption—billboards or magazines—Parrish chose, instead, his ever-popular nursery-rhyme formula, guaranteed to evoke universal nostalgia rather than personal escape. Such commissions for Fisk Rubber Company and the D. M. Ferry Seed Company were heralded in both the popular and critical press as "artistic," and his Fisk billboards, in

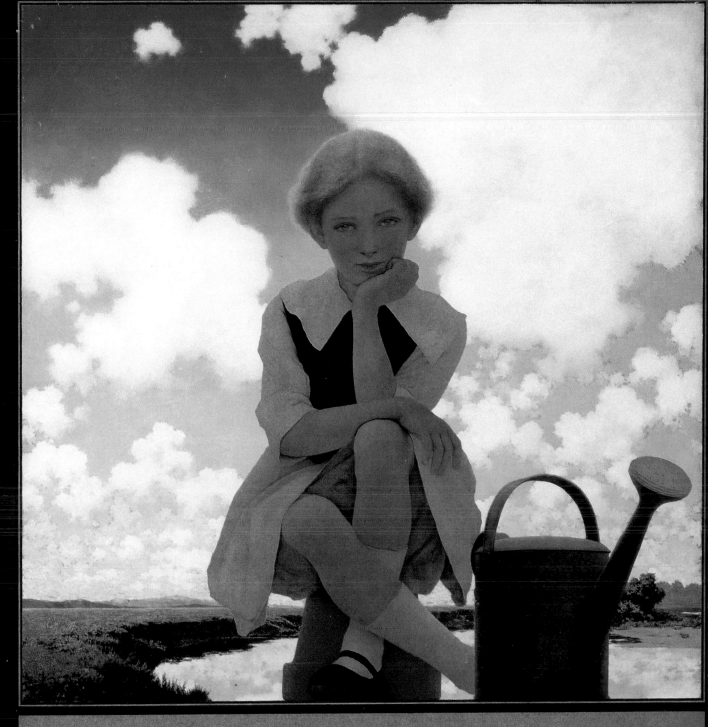

Ferry's Seeds: Mary, Mary Quite Contrary. 1921. Oil on board, 27 x 20" (68.58 x 50.8 cm). Department of Special Collections, University of California Library, Davis

Cobble Hill. 1931. Oil on panel, 11½ x 13" (29.21 x 33.02 cm). Collection of the Brandywine River Museum, Chadds Ford, PA. Gift of Amanda K. Berls

particular, were viewed by many as "mural art" at a time when this form of advertising elicited much controversy over the commercial intrusion of public space. Parrish himself participated in this debate, apparently, taking on the Fisk commission in an effort to "do his bit toward raising the standard of billboard advertising," and he approached the projects seriously, with characteristic concern for qualitative and creative control.[184] This is evident in a 1917 letter written to his advertising "agent," Rusling Wood, in which Parrish discussed his ideas for the Fisk campaign:

> There seems to be a move in advertising to show the ends and not particularly the means in motoring. All tires look alike and all cars resemble each other much more than they did, so that delightful places to visit and delightful means of getting there are about the only thing left with which to tell the story. The background in the enclosed could be made most interesting, with a kind of romantic, ideal landscape, with all that gives joy in nature: water-falls and castles and mountains and a rocky shore, etc.[185]

By the end of the decade that brought him the greatest public success, Parrish unequivocally described himself as a commercial artist. Yet, more and more, he seemed to go beyond that label, into the realm of self-expressive painting. To this end, his ideal landscape moved from the background to the foreground until it dissolved the demarcation completely. While advertisers continued to seek Parrish's services for a variety of products, in the early 1930s the popularity of the Edison Mazda Lamps calendars began to falter. The artist himself predicted the slump in a 1929 letter to Reinthal: "This particular vein of mine may be petering out. It wouldn't be surprising. Maybe the public knows before the artist does."[186] In 1932, soon before painting his last calendar image for General Electric, Parrish gave a revealing interview to the Associated Press, declaring he was "done with girls on rocks":

> I've painted them for thirteen years and I could paint them and sell them for thirteen more. That's the peril of the commercial game. It tempts a man to repeat himself. It's an awful thing to get to be a rubber stamp. I'm quitting my rut now while I'm still able. Magazine and art editors—and the critics, too—are always hunting for something new, but they don't know what it is. They guess at what the public will like, and, as we all do, they guess wrong about half the time. My present guess is that landscapes are coming in for magazine covers, advertisements and illustrations. . . . There are always pretty girls on every city street, but a man can't step out of the subway and watch the clouds playing with the top of Mount Ascutney. It's the unattainable that appeals. Next best to seeing the ocean or the hills or the woods is enjoying a painting of them.[187]

Thus, at the age of sixty, Parrish increasingly turned to painting the "joys of nature" with an "unattainable" verisimilitude, producing his last figurative composition—*Jack Frost*—in 1936.[188] Having reached a point in his career when he was no longer tied to product endorsement, this truly public artist still opted

Early Autumn, White Birch. 1936. Oil on panel, 31 x 25" (93.98 x 63.5 cm). Haverford College Library, PA. Special Collections

Daniel's Farm. 1937. Oil on panel, 9 x 12" (22.86 x 30.48 cm). Collection of Mr. and Mrs. Donald Caldwell

Dusk. 1942. Oil on Masonite, 13¼ x 15¼" (33.66 x 38.74 cm). Lent by the New Britian Museum of American Art, CT. Charles F. Smith Fund

Maxfield Parrish '42

Swiftwater (*Misty Morn,* Brown & Bigelow title). 1953. Oil on panel, 23 x 18½" (58.42 x 46.99 cm).
Collection of Joseph Zicherman. © Brown & Bigelow, Inc.

to paint largely on commission in the interest of artistic independence and popular success. In 1936, after parting company with General Electric, Parrish entered into what would be a twenty-seven-year contract with the Minnesota-based calendar and greeting card company Brown and Bigelow. For the first five years of the association, Parrish produced one landscape annually for use in both of its two lines. Thereafter, he provided an additional annual winter scene.

Parrish's turn to landscape painting—always a critical part of his practice—at a time of increased nationalism reveals the acute market awareness of the artist. While the conflation of southwestern and New England vistas had always given his work a simultaneously regional and national appeal, the connotations of Americanness resonated more deeply during a time of economic hardship and social upheaval. The popularity of these images of domestic comfort amid peaceful, idyllic settings—truly fantasies for many struggling through the Great Depression—proved the artist's statement that "it's the unattainable that appeals."[189]

Once again, Parrish's production stood apart from other artists' of the period. While his work's nonfigurative and nonpartisan qualities would seem to separate it from that of the Social Realists and Regionalists, arguably, it may still be read as "political" in its claims of national purity and stability—signified by the glow of a New England autumn morning or winter twilight (see page 114). Many of the latter scenes, produced during World War II (see page 128), convey the cheerful sentiment that permeated American popular culture at the time, from song ("I'll Be Home for Christmas") to film (*Holiday Inn*). Well into the 1950s, Parrish continued to produce landscapes for Brown and Bigelow that were increasingly cinematic in scope and optimistic in outlook, expressing the country's spectacular postwar prosperity and the deeply held belief in the idea of a perfect place.[190]

The impact of Parrish's art on American culture during the first three decades of the twentieth century is evidenced by its frequent referencing by the media. While F. Scott Fitzgerald positively analogized the "color of Maxfield Parrish moonlight" to the reflection in a restaurant window in his 1920 short story "May Day," by the mid-thirties such a reference had become the stuff of jokes and clichés.[191] In the 1935 movie *Top Hat,* when Fred Astaire's character described another's black eye as resembling "a sunrise by Maxfield Parrish," the response was "Ohhh. Oh . . . that's *terrible.*" (As Michele Bogart has pointed out, the line is somewhat ambiguous: Is it the eye that's terrible or its Parrish-like qualities?—though the first meaning seems more likely.[192]) Even the dreamworld of *The Wizard of Oz,* which so excited moviegoers in 1939, reveals a debt to the artist's fanciful constructions.

While Parrish's art in these years was known to the majority of Americans through reproduction, a 1936 exhibition at New York's Ferargil Gallery—his first in a decade—afforded certain viewers and critics an opportunity to assess his current standing in the larger art world. *Time* used the occasion to comment on Parrish's status as one of the three most reproduced artists in the world, while noting the artist's particular appeal to a less sophisticated public. However, the critical establishment did not completely ignore this exhibition of mostly landscapes. No less a figure than Royal Cortissoz, a staunch defender of traditional artistic values, expressed the "same qualifications of the same admiration" that he had felt on viewing

Parrish's last exhibition, especially regretting the absence of the artist's figurative work, which he described as "humorous, fanciful, and altogether adorable." Asking whether or not it was fair to expect creative breadth from an artist who had remained "sturdily faithful to his own hypothesis," Cortissoz saluted Parrish's originality, which, though he found it technically impressive, left him cold emotionally:

> In carrying out the given picture he uses a fantastically accurate draughtsmanship and a touch of the brush that is, in its mechanistic way, fairly magical. His art is a curious phenomenon. It stands, as I have indicated, alone, and it has its charm. Yet it is as unimpassioned as a photograph.[193]

And with this assessment, shared by most mainstream art critics in these years, Parrish entered the dark ages—continuing to appeal to a mass audience through his calendars, yet all but forgotten by an art world committed to modernist self-expression. The leading critic associated with the rise of Abstract Expressionism, Clement Greenberg, had what may be understood as the last word regarding Parrish's standing at the time when, in his seminal 1939 essay "Avant-Garde and Kitsch," he firmly placed the artist's work in the enemy camp. Parrish's particular brand of "hallucinatory high-octane realism," with its brushless surfaces, could only have been reviled when compared to the aggressive mark-making of painters such as Jackson Pollock and Willem de Kooning. But, as the fifties gave way to the sixties and the inevitable cycle of action and reaction continued to advance, Parrish would again attract attention for work that had earned its place as a significant cultural artifact of the twentieth century.[194]

In 1961, at the age of ninety-one, Parrish painted his last picture—a small uncommissioned landscape he titled *Getting Away from It All*. In a strikingly synthetic mountain landscape, a single light shines through a lone snow-covered cabin, incongruously sheltered by a diminutive oak tree—a fitting finale to a life well spent. As one later writer rather painfully observed, however, the American public was not quite ready to "let its Maxfield perish."[195] In 1964, Lawrence Alloway—then a curator at the Guggenheim Museum—and the abstract painter Paul Feeley organized the first major retrospective of Parrish's work at Bennington College, an exhibition that traveled to the Gallery of Modern Art, Columbus Circle, New York. Featuring more than fifty oils, drawings, and prints (drawn mainly from the holdings of the late Austin Purves, a Philadelphia businessman who once owned the "biggest and best" collection of the artist's work), "Maxfield Parrish: A Second Look" seriously reconsidered Parrish in the context of Pop Art—a term coined by Alloway himself—and sought to "account for the discrepancy between Parrish's original fame and his present neglect."[196]

As the advent of Pop Art had signaled a turn from the high formalism of abstraction to representation and had sparked a playful examination of the relationships between art and commerce, "high" and "low" cultural forms, the time could not have been more opportune for a reappraisal of the artist's work.[197] (Andy Warhol was an avid collector of Parrish's art.[198]) Moreover, the cultural politics of the period—particularly the theatricality and eroticism of the youth movement—provided a newly receptive context for this appreciation.[199]

Getting Away from It All. 1961. Oil on board, 12 x 14" (30.48 x 35.56 cm). Private Collection

In a review of the Parrish exhibition for the *New York Times*, John Canaday—someone, like many Americans of a certain age, who had grown up with a reproduction of *Garden of Allah* hanging in his living room—applauded Alloway's respectful tribute to the ninety-four-year-old artist, calling it the "most unexpected revival of modern times." Testing the current thesis "that no artist can be re-examined without the hope of finding a lineage for contemporary reputations," he then described Parrish's *Penmanship* as "Proto-Pollock" and compared *The Idiot* to the Op Art of Victor Vasarely and *Arithmetic* to the wordplay of Stuart Davis and Jasper Johns.[200]

Other reviewers were not as receptive, describing the artist's palette as a "blend of Kodachrome and candy-box wrapping" and arguing that the "phenomenon of Parrish is a proof of the well known fact that the relationship of real art to taste is extremely marginal."[201] The artist himself was somewhat stupefied by the renewed interest in his work: "I'm hopelessly commonplace. . . . How can these avant-garde

Joan Nelson. *Untitled No. 432 (After Painting by Maxfield Parrish)*. 1997. Acrylic with oil on wood panel, 59¾ x 59⅞" (151.77 x 152.10 cm). Robert Miller Gallery, New York

Virgil Marti. *Untitled*. 1996. Novajet print on resin-coated paper in anaglyphic 3-D, 35½ x 50½" (90.17 x 128.27 cm). Courtesy of the Artist

people get any fun out of my work?" He wryly added that he found the "current appreciation of his work a bit 'highbrow.' I've always considered myself strictly a 'popular' artist."[202]

The success of the exhibition—and the wave of mass nostalgia that it generated—led to a second retrospective of the artist's work held at the George Walter Vincent Smith Art Museum in Springfield, Massachusetts, in the winter of 1966. The ninety-five-year-old Parrish passed away at "The Oaks" on March 30, just ten days after the close of the exhibition. He had lived long enough to witness an extraordinary revival of his art that surprised even himself.[203] A few months later, in a belated tribute, the *Boston Herald* acknowledged Parrish's mainstream appeal:

> Today . . . Parrish is "IN," but this only means that he is back in vogue with the current batch of intelligentsia and a group of tastemakers who are busy creating tastes for each other. He has never been "OUT" with the public. If you grew up keeping cool with Coolidge, there was probably a Maxfield Parrish somewhere in your home. But if you're a mod teenager today there may be a Parrish around, too. He appeals to practically everybody. He was probably the last of his kind.[204]

This posthumous interest in the artist as a unique product of American culture has continued unabated for the last three decades as new generations of viewers seek a Parrish for their age—locating different meanings in his work at different times. In the 1970s, artists associated with the New Realism and Photorealism focused their attention on Parrish's technique—finding a strict formality in his work that

anticipated their own—while the public at large continued to view the theatricality and erotic undertones of the artist's production through a lens of the decade's robust and playful consumer culture.[205] (Significantly, the major Parrish exhibition of the seventies—"Maxfield Parrish: Master of Make-Believe," organized by the Brandywine River Museum in Chadds Ford, Pennsylvania—used the artist's technique as its interpretive framework.[206])

Parrish's reputation in the 1980s rested primarily on the aggressive promotion of his art by the New York auction houses and select private dealers, who found ready buyers in the entertainment industry in particular.[207] While the market for the artist's work had begun to strengthen in the mid-seventies, largely due to the ongoing sale of his estate by Boston's respected Vose Galleries and to the publication of Coy Ludwig's impressive monographic study, the overall inflation of art prices during the decade of excessive spending and investing greatly impacted the value of a Parrish. Moreover, the artist's lavishly optimistic vision of America as a "grand good place" surely struck a chord in the feel-good climate of Reaganomics.[208]

As auction prices for Parrish's work continued to soar into the 1990s, a traveling retrospective, organized by New York's American Illustrators Gallery, once again brought the artist to the attention of the art world. Ken Johnson, writing in *Art in America*, found the later landscapes in particular to be "quietly miraculous . . . works of mystic pantheism." Describing their aura of artificiality, Johnson added, "If you discovered them unlabeled in the right contemporary gallery, you might mistake them for essays in postmodern duplicity."[209] And, indeed, a number of artists today—from the landscape painter Joan Nelson to the installation artist Virgil Marti—have referenced Parrish's work in both form and concept.[210] At a time in which the recent critical success of the portraitist Chuck Close caused one writer to marvel at the "ascendancy of what might be called Friendly Art," Parrish's ongoing rediscovery seems perfectly apt.[211]

Despite the art world's tentative, at times ironic, embrace of Parrish, the clearest indication of his art's continuing resonance for our own visual age can be found vis-à-vis the collective memory of popular culture. Appropriated in CD design by the New Age–Celtic singer Enya; Michael Jackson videos; Mia Farrow movies; and Kamel cigarettes advertising, "our" Parrish for the nineties represents everything from nostalgic longing to sexual availability. His imagery can chart your months, mark your book, secure your grocery list, and shelter you from the rain. One can even use a figureless *Daybreak* as currency by way of personal checks titled "Maxfield."

Will Parrish's art continue to resonate in both "high" and "low" forms for future viewers? Will Bill Gates install Parrish next to Winslow Homer on virtual and actual walls? Komar and Melamid's project participants and the nearly seventy thousand visitors to a particular Parrish web site would seem to indicate an affirmative response. For, as Lawrence Alloway posited in 1964, "Behind a screen of high technique, Parrish is master of the cliché, of the image of the moment"—whatever that moment may bring.[212]

"FRANK IMAGINATION, WITHIN
The Painting Methods of

Hunt Farm. 1948. Oil on board, 23 x 18⅞" (58.42 x 47.94 cm). Hood Museum of Art, Dartmouth College, Hanover, NH.
Gift of the Artist, through the Friends of the Library

A BEAUTIFUL FORM"
Maxfield Parrish

Mark F. Bockrath

Maxfield Parrish's phenomenal success owed much to his unusual working methods. His paintings are unique in their combination of an exactitude in drawing with a bold use of design and color, lending a sense of realism and familiarity to scenes that, in fact, transcend reality and the familiar. This quality inspired the admiration not only of millions of Americans, who incorporated his imagery into popular culture, but also of artists such as John La Farge, who wrote in 1910, "I know of no artist today, no matter how excellent, with such a frank imagination, within a beautiful form, as is the gift of Mr. Parrish."[1]

Despite Parrish's gifts as a draughtsman and his extraordinary imagination, the artist's methods were far from spontaneous. His inspiration found its realization in paintings only by arduous study and meticulous planning. This preparation involved making photographic studies of models and miniature landscapes and then painstakingly constructing his compositions from these disparate elements.

Parrish's Working Methods

Although many artists since the latter part of the nineteenth century had frequently employed photography as a source of imagery for their works, Parrish was unusual in the extent to which he used the medium. A number of passages in his paintings were literally copied from their photographic sources. With characteristic concern for quality control in his photographic studies, Parrish did all of his own laboratory work, including shooting and printing his negatives; set up the models or himself in the required poses; and built rocky landscapes or models of buildings on a table in his studio, lighting them dramatically (see page 124). Parrish also made cutouts of traced images in order to transfer them to his compositions. An example of such a cutout is the graphite pencil on paper study, *The Stage Manager* (see page 124). Both the castle model and cutout were utilized in the artist's last major book commission, *The Knave of Hearts*.

Parrish's practice of projecting a photographic image onto his painting supports and tracing it before applying paint calls to mind the methods of the Photorealists of the 1960s and 1970s, whose work also was closely tied to the use of photography. In the aesthetic of these painters, however, the wealth of detail found in photographic images is utilized in an attempt to reproduce a literal and objective view of their often mundane subjects, whereas Parrish used the verisimilitude of the photograph to add an eerie sense of reality to otherwise fantastic or nearly surreal scenes.

Early in his career, Parrish frequently made illustrations in the form of black-and-white drawings

done in pen and ink or lithographic crayon. *Concerning Witchcraft*, one of Parrish's illustrations for Washington Irving's *Knickerbocker's History of New York*, was executed on a sheet of smooth cream-colored wove paper that the artist stretched over a wooden frame. At first glance, this meticulously detailed drawing appears to be a mezzotint print, with its carefully graded gray tones comprised of tiny dots of ink; but closer examination reveals that the myriad dots are drawn with pen and ink rather than mechanically printed. The light pencil underdrawing used by Parrish to plan the work is still visible in his inscription in the lower-left corner, which reads, "Book V. Chapter VII. concerning witchcraft."

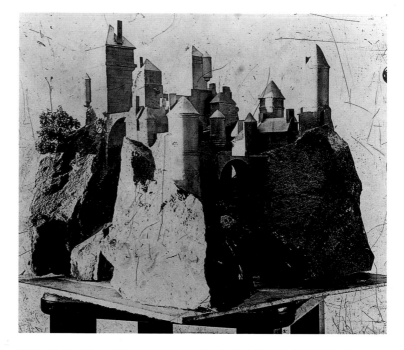

Parrish combined watercolor, ink, gouache, and graphite in *Old King Cole* (see pages 32 and 33), a work on paper done as a preparatory study for the 1895 mural for the University of Pennsylvania's Mask and Wig Club in Philadelphia. This complex and detailed work contains areas of exposed cream-colored paper, transparent watercolor washes, ink and graphite lines, and opaque gouache highlights. Fine pencil lines create details in many passages, such as the decorative wall patterns and the fiddlers' lace cuffs. Parrish layered paint to achieve colors in some areas; red glazes over a yellow underlayer create the king's orange shoes. He made corrections by pasting cutouts of paper over many elements in the design, and then repainting them. These corrections include both of the chef's shoes; the bowl held by the chef; his blue bag; the green vest of the boy near the chef; the upturned ends of the carpet on the steps to the throne; the pitchers near the throne; the tiny watch fob of the fiddler on the left; and the green linings of the jackets of all three fiddlers. The

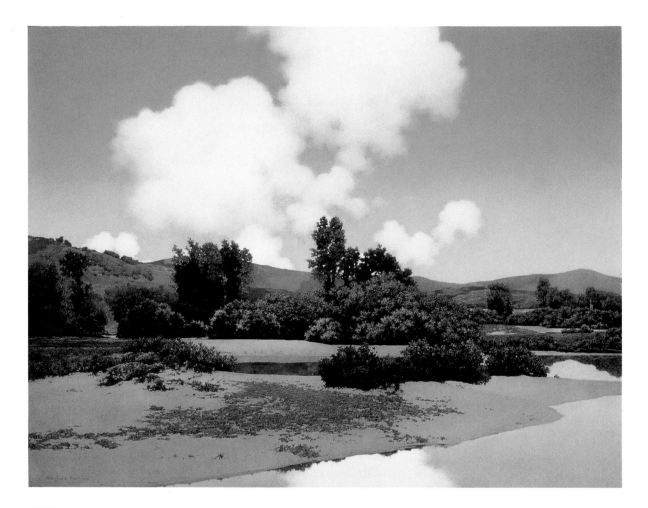

Little Sugar River at Noon. ca. 1922–24. Oil on panel, 15½ x 19¾" (39.3 x 50.2 cm). Virginia Museum of Fine Arts, Richmond. Gift of Langbourne M. Williams

Dreaming/October. 1928. Oil on board, 32 x 50" (81.28 x 127 cm). Private Collection

decorative edge of the chef's bowl and the diamond patterns on the linings of the fiddlers' jackets consist of additional cutout details that Parrish pasted to larger cutouts he had previously applied. The floor's checkered pattern extends underneath the scrolled inscription along the bottom of the design. The entire scroll is another overlaid and pasted cutout, suggesting that its addition was an afterthought on the part of the artist.

The same precise method used in the construction of these drawings is found in Parrish's oil paintings. His usual technique in oil involved the application of thin layers of transparent glazes over underpaintings of monochrome ink or paint layers. The artist generally used supports of stretched paper, canvas, or panels made of composition boards such as Masonite or Vehisote. The composition boards appear from the 1920s until the end of Parrish's career. Sometimes the artist prepared panels by gluing paper to composition board.[2] The paper and panels were coated with several layers of varnish to seal them before application of the priming, or ground layer. The glazes of oil color were then carefully stippled on with stencil brushes in multiple layers to achieve an even application and gradation of tone. Sometimes, stencils were used by Parrish to ensure precise paint application. The thin glazes were separated from each other with multiple thin films of natural resin varnishes, which the artist applied as the work progressed, allowing the paint to dry between layers. The extended drying time needed for this methodical layering process necessitated that Parrish work on several paintings at a time in his studio; he would accelerate the drying time by placing the paintings in sunlight or by heating them with lamps.[3]

Before the glazes were applied by the artist, underpaintings were done in various colors to serve as a tonal understructure. The underpaintings varied from pencil, crayon, and ink washes in gray tones to colored washes in blue or brown. In the unfinished painting *Dreaming/October*, passages of both blue and gray underpaintings are present within the same work.[4] Moreover, several stages of the artist's process are represented by the blue underpainting of the tree at right, surrounded by blank white priming; the yellow glazes over the gray underpainting of the tree in the lower left; and the orange foliage of the completed trees at left.

Parrish discussed using an underpainting of raw umber and white lead for his 1906 mural, *Old King Cole*, originally located in New York's Knickerbocker Hotel and later moved to the St. Regis Hotel in the same city.[5] The brown-and-white combination described by the artist implies a certain opacity in contrast to his usual transparent underpaintings. For example, the white ground of *Moonlight Night: Winter* (see page 128), is coated with a monochrome blue underpainting over pencil lines and gray ink washes. The artist sometimes simply colored a drawing with oil glazes directly on the paper, but more commonly, and especially in his later works, Parrish primed the paper or panels with oil grounds of lead or zinc white. However, no priming is present in the 1899 painting *Stormbearers of the Norsemen* (see page 129).

With the exception of his mural projects, Parrish generally worked in a small format, with most paintings measuring less than forty inches. The monumentality of many of his compositions, even when seen in reproduction, is often surprising compared to the small size of the actual work. Moreover, the strong graphic quality of the design allows the images to retain their impact even when reduced in reproductions.

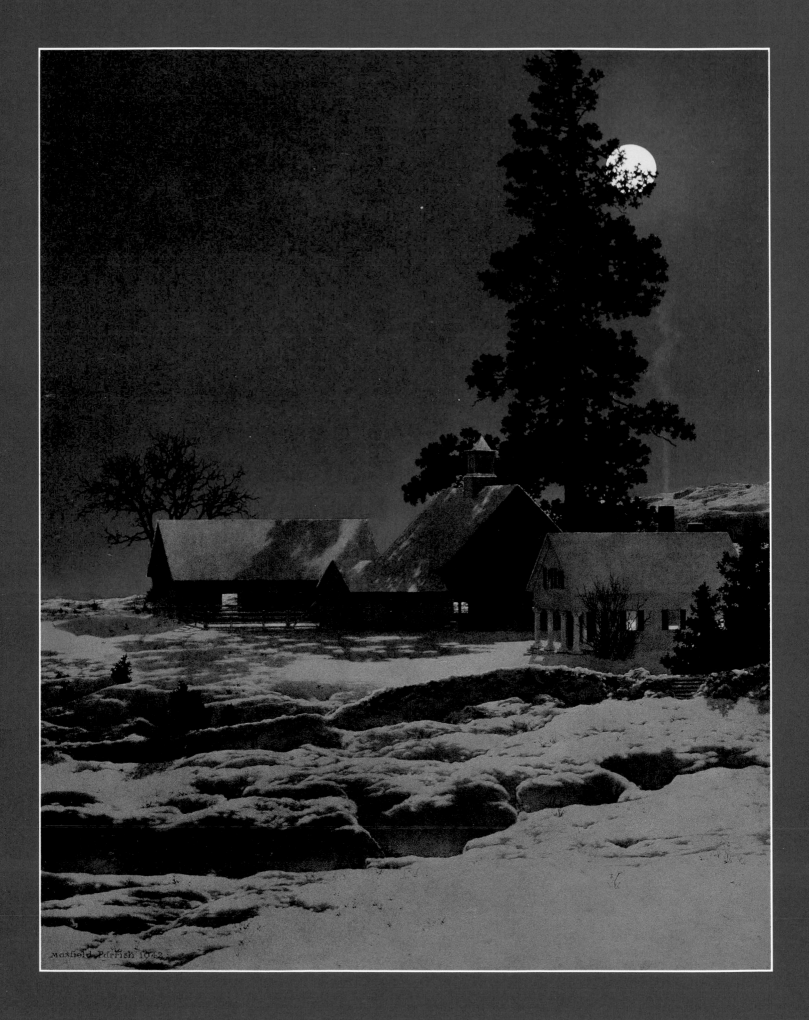

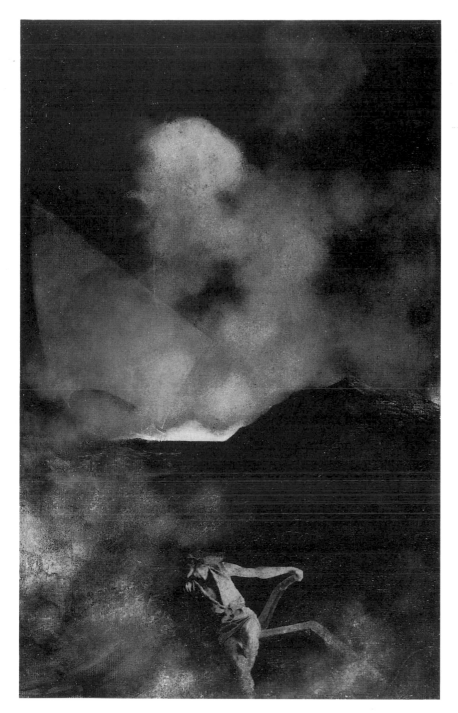

Stormbearers of the Norsemen. 1899. Oil on paper, 16½ x 10¼" (42 x 26 cm).
The Free Library of Philadelphia. Rare Book Department

Opposite:
Moonlight Night: Winter. 1942. Oil on
board, 19¹⁵⁄₁₆ x 15¾" (49.21 x 40.01 cm).
The Free Library of Philadelphia. Rare
Book Department

Technical Examination of the Paintings

Examination of Parrish's work in the conservation laboratory can yield interesting insights into his painting methods. Several paintings were examined by the author and other conservators at the Pennsylvania Academy of the Fine Arts using a variety of analytical methods, including a binocular microscope; ultraviolet and infrared light; optical microscopy of pigments; and cross sections of paint films.

Infrared photography can be useful in showing underlayers in a painting, especially when the upper layers of paint are thin and transparent and the underlayers contain black media on a white, reflective ground. Since so many of Parrish's paintings employ transparent glazes over black ink and crayon underdrawings on a white ground, infrared photography is ideally suited to the examination of his work.

When *Princess Parizade Bringing Home the Singing Tree* (see page 130) is viewed in infrared, the various materials used by the artist in the underdrawing are readily evident. The black ink washed into gray tones that Parrish used to establish the tonal relationships in the design is visible throughout the painting (see page 131). This monochrome underdrawing was then colored with glazes of blue, deep red, and yellow. The gray washes of the underdrawing establish the shadows in the deep colors of the design; and in the golden

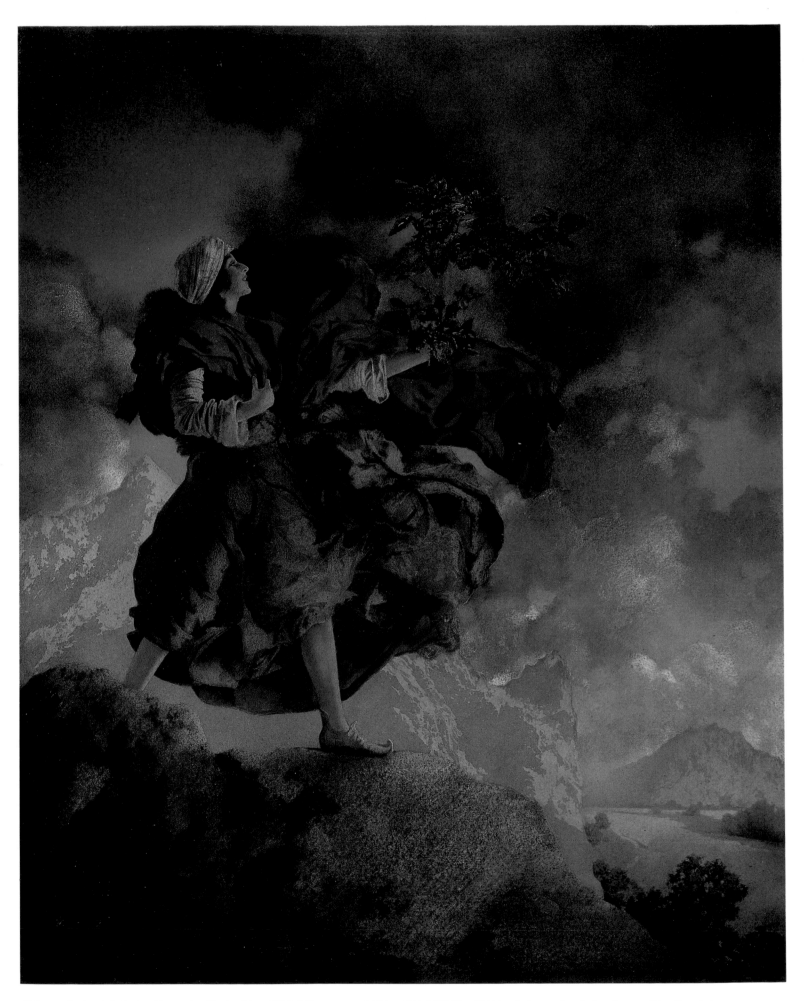

Princess Parizade Bringing Home the Singing Tree. 1906. Oil on paper, 20 1/16 x 16 1/16" (50.95 x 40.97 cm). Pennsylvania Academy of the Fine Arts.
Gift of Mrs. Francis P. Garvan

*Princess Parizade Bringing
Home the Singing Tree*. Detail

*Princess Parizade Bringing Home the
Singing Tree*. Infrared view of above detail

mountains, the yellow glaze creates bright yellow highlights over exposed white paper and olive-yellow shadows when the yellow tints the underlying gray ink wash.

Parrish's precise underdrawing in pencil lines and ink washes for the farm buildings in *Moonlight Night: Winter* is easily seen in infrared examination. The precision of line and exact perspective in the buildings call to mind the artist's early training and lifelong interest in architecture. Parrish probably made models of the buildings and photographed them to aid in drawing them onto the panel, a practice that he employed in other paintings with architectural elements.[6] While many of the details revealed in infrared photography may be somewhat discernible by careful naked-eye examination, others appear that would otherwise be obscured by the upper paint layers. In *Hermes,* for example, the lower portion of the painting now

Moonlight Night: Winter. Overall infrared view of painting

consists of almost undifferentiated brown rocks. Infrared examination of the work, shown here before conservation treatment in 1998, reveals Greek pottery vessels, cut stones, and a box that were painted out by Parrish when he changed his original design (see page 134).

Tiny samples of paint were taken from the edges of *Princess Parizade Bringing Home the Singing Tree* in order to determine which pigments were used by the artist in this painting. Samples of red, blue, and yellow colors were examined by polarized light microscopy. In this instance, the "Parrish blue" of the sky was found to be ultramarine. The orange glazes of the rocky landscape were found to contain an organic red lake, such as rose madder or alizarin crimson. Other pigments found by microscopy included white lead, ivory black, and red, yellow, and brown earth colors such as siennas, ochers, and umbers.

Other tiny paint samples, in the form of cross sections containing multiple layers of paint and ground, were taken from *Hermes* in order to study Parrish's complex layering of color in this image. *Hermes* was painted in 1909 on a finely woven linen canvas, as are a number of the artist's works from this period. The lowest layer of ground is a white lead priming. Cross sections taken from several locations show that the artist applied a dark brown film over the white ground throughout the painting. In the cross section of the sky (see page 135), it is evident that Parrish underpainted the carefully applied transparent

Moonlight Night: Winter. Detail

Moonlight Night: Winter. Infrared view of above detail

Hermes. Overall infrared view of painting before conservation treatment

Hermes. 1909. Oil on canvas, 28⁷⁄₈ x 15⁵⁄₁₆" (73.34 x 39.05 cm). The Free Library of Philadelphia. Rare Book Department

blue glazes of the uppermost paint layer with a bright, opaque layer of turquoise.[7] Presumably, this bright, opaque interlayer was necessary to blot out the underlying dark brown layer before the final deep blue glazes were applied. Parrish abandoned the dark brown underlayer in his later works, preferring to paint with transparent glazes directly over the white ground.

Hermes. Microscopic view of cross section of paint in sky showing paint layers, normal light

Ultraviolet light examination of Parrish's paintings reveals other technical information. Some pigments and varnish resins characteristically fluoresce with a bright coloration when the paintings are illuminated with ultraviolet light. Most paintings by the artist are varnished with films of natural resin varnishes such as damar. Damar and copal resin varnish films also were used by Parrish to isolate glaze layers as he painted. Aged damar films fluoresce a bright yellow-green when exposed to ultraviolet light. This enables the examiner to identify such coat-

Hermes. Microscopic view of cross section of brown paint at bottom edge showing bright fluorescence of varnish layers in paint structure, ultraviolet light

ings on the surfaces of Parrish's paintings. Fluorescing layers of natural resin varnishes can be seen between paint layers in cross sections of *Hermes* when they are viewed in ultraviolet light.[8]

The deep transparent red pigment rose madder fluoresces a strong orange color when viewed in ultraviolet light. Such an orange fluorescence is seen in the dark green trees of *Moonlight Night: Winter,* suggesting that the artist glazed a green underlayer in the trees with rose madder. This glazing of a contrasting color over the green underlayer would have the effect of intensifying the brilliance of color and transparency in the trees. This passage illustrates Parrish's discussion of glazing green trees with rose madder in a

letter of 1950 to art supplier F. W. Weber, which describes his painting techniques: "One does not paint long out of doors before it becomes apparent that a green tree has a lot of red in it . . . when the green is dry and a rose madder glazed over it you are apt to get . . . a richness and glow of one color shining through the other, not to be had by mixing."[9]

The Glazing Technique

In 1895 Parrish traveled to Europe, where he studied works by Old Master painters and marveled at their techniques. At the Louvre, the artist was enchanted by Titian. "That great Titian, *La Mise au Tombeau* simply haunts me," he wrote to his wife. "I dream about beautiful reds and greens and glorious whites. The color in that picture is pure magic."[10]

The Venetian master's use of rich, transparent color struck a chord with the young artist. Titian, Tintoretto, and other painters of the sixteenth century "Venetian School" were innovative in their use of oil paint, creating surfaces that varied from heavily textured impasto to smooth, transparent glazes. A typical method of painting for these artists was to build up a monochrome underpainting of white and warm gray tones over a dark red or brown ground, followed by layers of thin transparent glazes of color. Areas of thicker opaque paint also were used, but it was the oil-rich films of glazing that lent a distinct richness and brilliance of color to Venetian paintings. In this "indirect" method of painting, color is produced by light passing through the colored glazes and reflecting off the white ground or underpainting, producing an effect akin to light passing through stained glass. This is a very different effect than that created by a direct application of opaque color, in which light reflects off the surface of the color only. For example, a medium shade of red produced by glazing a deep red over a white underpainting will appear much more transparent and brilliant than if the same red is mixed directly with white to produce an opaque medium red of similar value to the glazed color.

Despite Parrish's admiration for the Venetians, his methods of glazing differed from theirs in some very fundamental ways. The Venetian painters painted on brushmarked white lead underpaintings rather than on the smooth primed boards and paper supports used by Parrish. Therefore, the glazes in the Old Master paintings reflect the texture variations of these lower layers. Parrish's glazes, however, were applied with stencil brushes in a stippling motion that produced flawless, even films of color on his smooth white grounds. The Venetian painters preferred dark grounds. Parrish's peculiar insistence on isolating his glazes with films of natural resin varnish also does not follow the earlier technique. The artist rarely used opaque paint in combination with his glazes. In *Moonlight Night: Winter,* for example, the only passages of opaque color are in the bright yellows of the moon and the windows of the farm buildings. The Venetian painters freely juxtaposed passages of directly applied paint with glazed color in their works. Parrish's methods were singular and of his own invention and, in fact, have more to do with color printing processes than with Titian.

Paintings in Reproduction

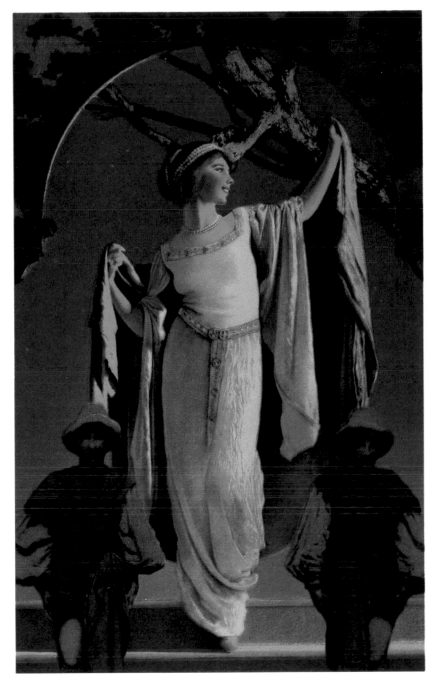

Edison Mazda Lamps Calendar: Spirit of the Night. Detail. 1919. Lithograph on paper, 19 x 8½" (48.72 x 21.78 cm). Collection of the Brandywine River Museum, Chadds Ford, PA

Parrish himself alluded to the relationship between his painting method and printing processes when he wrote to F. W. Weber in 1950: "You ask for a description of my technique? . . . It is somewhat like the modern reproductions in four color half tone, where the various gradations are obtained by printing one color plate over another on a white ground of paper."[11] In the case of paintings such as *Princess Parizade Bringing Home the Singing Tree* this was especially true; the glazes of deep red, blue, and yellow over a monochrome black underdrawing closely correspond to the magenta, cyan, yellow, and black tones used in color printing.

Parrish was very interested in the quality of tone and color in reproductions of his work and was able to exercise a great deal of creative control as his career progressed and printing methods improved. Some of the highest quality images were made by the Forbes Lithograph Manufacturing Company for the reproduction of Parrish's paintings in the Edison Mazda Lamps calendars. The 1919 calendar image, *Spirit of the Night*, for example, was lithographed with twelve different colors.[12]

Parrish anticipated the dulling effect of reproduction on the colors in his paintings and adjusted them accordingly. In a 1916 letter to Clarence Crane, who commissioned him to paint *The Rubaiyat* for reproduction on a Christmas candy gift box, Parrish compared the color scheme of the original to his intentions for the color in the reproduction:

*In making this design I have tried to keep in mind the fact that the final result will be much
smaller, probably not over ten inches long, and the scheme I had in view was one of rich jewel-
like brilliancy. Therefore the original, to my thinking, is a bit too brilliant, if the result is to be
considered for a picture the size of the original. We all know how, in the process of reproduction
and the reduction of size, this life and brilliancy is lost . . . [so] I have made the design stronger in
this respect than would be warranted if this were painting pure and simple, not intended for
reproduction.*[13]

Parrish also could exercise some control over reproductions by working with lithographers on
proofs of the prints. His attention to detail in this respect is evident in his 1923 comments to the Brett
Lithographing Company, the printers of *Daybreak:* "I would suggest that the teeth in the reclining figure are
much too white: it is a white spot that jumps right out at you. . . . It would be better, too, if the water was
not quite so intense a blue; it looks a little out of color scheme."[14]

Thus, Parrish was able to ensure that the prints of his paintings closely reproduced the brilliant
colors of the originals. This was not the case for many other contemporary illustrators who used a direct
painting technique with thicker layers of impastoed paint textures and less glazing, such as N. C. Wyeth
and Frank Schoonover. Book illustrations by these artists are often very different in color from the origi-
nals, and their textured surfaces are, of course, only suggested in reproduction. The smooth texture of
Parrish's paintings makes the replication of his brushwork less important. N. C. Wyeth contrasted his great
satisfaction with his illustrations for James Fenimore Cooper's *The Last of the Mohicans* with his disap-
pointment in their reproductions in a 1919 letter: "The bitter part of it all came afterward, when the N.Y.
engravers practically ruined the colorplates, so that there is very slight resemblance to the original
canvases."[15] Wyeth's use of a variety of opaque colors in his paintings made them difficult to reproduce.

The Artist as Craftsman

Parrish's interest in quality control in his paintings extended even to their reverse sides. His Masonite panels
are painted and varnished on their reverse sides to provide a moisture barrier that reduces the possibility
of warpage. A layer of aluminum paint coats the screen pattern on the back of the Masonite support for
Moonlight Night: Winter.

The color and design of his frames also concerned Parrish, who disliked bright gold or white next
to his paintings. The frame on *Moonlight Night: Winter* was almost certainly made by the artist and is rep-
resentative of a type he used on many of his later landscapes (see page 140).[16] The frame consists of wide
strips of Masonite mounted to a wooden substrate and carefully butt-jointed at the corners. The surface
of the frame is coated with a brown stain over a gold underlayer, imparting a dark bronze patination to a
simplified Arts and Crafts–style design.

Winter. 1906. Oil on paper mounted on board, 19 x 19" (48.72 x 48.72 cm). Collection of Joan Purves Adams

Parrish also lavished attention on his shipping crates, which he made himself in his workshop. The crate for *Circus Bedquilt Design* was probably made by the artist in the 1940s, when he shipped the work from his New England studio to Sydney Gross in Philadelphia. With its beautifully lettered inscriptions and precisely fitted interior, the crate shows Parrish's attention to detail even in the last phase of his artistic process, the final shipment of the work itself.

Conservation of Parrish's Paintings

The use of multiple layers of colored glazes separated by natural resin varnish films, which were then coated overall with a final natural resin varnish film, makes Parrish's paintings especially susceptible to condition problems that are commonly associated with these materials. Natural resin varnishes, such as

Moonlight Night: Winter. Detail of frame

damar, yellow markedly with time, in addition to becoming more opaque. These films also develop fine crackle patterns as they age, further reducing their clarity and transparency. Sometimes, these films can become so dark and opaque that they greatly obscure the color and detail in the underlying paint layers. In addition to these problems, the fast drying of these spirit varnishes can cause slower drying oil paint layers below them to crack. This effect is seen in many paintings by Parrish in which the upper layers of varnish, as well as the multiple isolating layers, have caused the slow-drying oil glazes to crack, revealing the typically white ground layers. This has occurred despite the artist's careful attempts to allow proper drying time between layers of paint.

Due to these inherent problems with Parrish's technique, many of his paintings have yellowed with time and cracked through glassy varnish and glaze layers, which have a perceptible thickness. As some of the yellowing occurs within the paint layers due to their varnish content, the discoloration is irreversible. Furthermore, it is impossible, in most cases, to safely remove a discolored layer of aged natural resin varnish from paint films that contain varnish. Conservators, therefore, often cannot clean the paintings to remove the final varnish layer. As a result, many of Parrish's paintings appear somewhat yellow and mottled in coloration, compromising his originally brilliant color.

Crate for *Circus Bedquilt Design*. Plywood.
The Free Library of Philadelphia. Rare
Book Department

*Princess Parizade Bringing Home
the Singing Tree*. Detail of paint
crackle before conservation
treatment

The Dinkey-Bird. 1904. Oil on paper, 21¼ x 15½" (53.98 x 39.37 cm). Charles Hosmer Morse Museum of American Art, Winter Park, FL

Notes

DREAM DAYS: THE ART OF MAXFIELD PARRISH
by Sylvia Yount

1. JoAnn Wypijewski, ed., *Painting by Numbers: Komar and Melamid's Scientific Guide to Art* (New York: Farrar Straus Giroux, 1997). For an important study of the development of elite and popular culture in America, see Lawrence W. Levine, *Highbrow/Lowbrow: The Emergence of Cultural Hierarchy in America* (Cambridge and London: Harvard University Press, 1988).

2. Alma Gilbert, *Maxfield Parrish: The Masterworks*, 2nd ed. (Berkeley: Ten Speed Press, 1995), 164.

3. Wypijewski, *Painting by Numbers*, 13.

4. See "Parrish's Magical Blues," *Literary Digest* 121 (February 22, 1936): 24–25; and ibid. Like Komar and Melamid's survey, *Daybreak* attracted fans from as far away as South Africa; see Coy Ludwig, *Maxfield Parrish* (New York: Watson-Guptill Publications, 1973), 143.

5. "Domesticated Colors," *Time* 27 (February 17, 1936): 34. A later article, published on the occasion of the 1964 retrospective of the artist's work, stated: "Parrish uses a universal language, couched in simple terms, that can be understood by the most illiterate; and, on the other extreme, it is subject to the profound respect of those who have attempted to create comparable effects." See G. Elizabeth Gillett, "His Skies Are Blue: Maxfield Parrish at Ninety-Three," *Saturday Review* 47 (March 4, 1964): 130.

6. In May 1996, *Daybreak*, which originally sold for ten thousand dollars in 1925—at the time, a record for a living American artist—sold at Sotheby's for another record price of $4.3 million.

7. While Parrish has enjoyed a veritable cottage industry of popular coffee-table books in the past two decades—specifically aimed at the collector—no substantive body of literature exists, with the exception of the 1973 monograph by Coy Ludwig, *Maxfield Parrish*, drawn from his doctoral dissertation, and a recent critical analysis within a larger study by Michele H. Bogart, *Artists, Advertising, and the Borders of Art* (Chicago and London: University of Chicago Press, 1995), 234–43.

8. Lawrence Alloway, "The Return of Maxfield Parrish," *Show* 4 (May 1964): 62–67.

9. As Bogart has pointed out, nineteenth-century American artists, in particular, had always sought a market for their pictures, working on commission for private patrons or art unions; see Bogart, *Artists, Advertising, and the Borders of Art*, 10.

10. According to James B. Carrington, Parrish held the "creed that the man's work is himself, and his own work bears the mark of sincerity and directness that belongs to the man." See James B. Carrington, "The Work of Maxfield Parrish," *Book Buyer* 16 (April 1898): 224.

11. See Ludwig, *Maxfield Parrish*, 171; *Stephen Parrish, 1846–1938* (Boston: Vose Galleries, 1982); "Maxfield Parrish as a Mechanic," *Literary Digest* 77 (May 12, 1923): 42; and Maxfield Parrish to George Eastman, November 23, 1922; quoted in Ludwig, *Maxfield Parrish*, 21.

12. For the classic treatment of the epoch, see *The American Renaissance, 1876–1917* (Brooklyn: Brooklyn Museum, 1979).

13. The American Renaissance was given its clearest expression in the 1893 Columbian Exposition. Dubbed the "White City," Chicago's fairgrounds inspired many artists, including Parrish, who, having gone primarily to see the fine art exhibitions, was most impressed with the "conception of the whole thing . . . these stupendous architectural groupings could scarcely be surpassed in fairy tales without becoming absurd. . . . It seems more fairy like when one knows it is all to come down in a few months." Quoted in Ludwig, *Maxfield Parrish*, 13.

14. For a discussion of the Quaker character, see James Walvin, *The Quakers: Money and Morals* (North Pomfret, VT: John Murray/Trafalgar Square, 1998).

15. Adeline Adams, "The Art of Maxfield Parrish," *American Magazine of Art* 9 (January 1918): 101.

16. See *Stephen Parrish, 1846–1938*, 5; and John Goodspeed Stuart, *Young Maxfield Parrish* (Aurora, CO: Aurora Public Schools, 1992), 12.

17. Christian Brinton, "A Master of Make-Believe," *Century Illustrated Monthly Magazine* 84 (July 1912): 340–42.

18. Stuart, *Young Maxfield Parrish*.

19. Brinton, "A Master of Make-Believe," 342.

20. Maxfield Parrish, "Inspiration in the Nineties," *Haverford Review* 2 (Autumn 1942): 14.

21. One biographical account notes that Parrish applied for a job in an architect's office—perhaps Wilson Eyre's—after leaving Haverford but was advised to strengthen his art training first; see M. K. Wisehart, "Maxfield Parrish Tells Why the First Forty Years Are the Hardest," *American Magazine* 104 (May 1930): 30.

22. Brinton, "A Master of Make-Believe," 345.

23. These works were included in the "architectural drawings" section of the Academy's annual exhibitions of 1892 and 1893, with the artist's name given as F. M. Parrish; see *Annual Exhibition Record of the Pennsylvania Academy of the Fine Arts*, vol. 2 (Madison, CT: Sound View Press, 1989), 370. Also see Stuart, *Young Maxfield Parrish*, 132.

24. "Academy Students' Work," *Philadelphia Press*, May 24, 1895; Archives of the Pennsylvania Academy of the Fine Arts (PAFA).

25. Fraser's lectures were titled "Pencil and Graver in American Books for 200 Years" (February 10) and "Illustration: What It Is and How to Draw for It" (February 17). See Archives of the PAFA. Parrish worked regularly for *Century* from 1898 to 1917, producing some of his most important magazine illustrations.

26. *Howard Pyle: The Artist and His Legacy* (Wilmington: Delaware Art Museum, 1987), 11.

27. See Ludwig, *Maxfield Parrish*, 14; and Gilbert, *The Masterworks*, 16.

28. Minutes of the Committee on Instruction, May 17 and 29, 1895; Archives of the PAFA.

29. Maxfield Parrish to Daisy Evangeline Deming, undated letter and October 6, 1892; Collection of Alma Gilbert.

30. Parrish to Deming, September 3, 1893; Collection of Alma Gilbert.

31. Ibid.

32. Ibid.

33. See *City Life Illustrated, 1890–1940* (Wilmington: Delaware Art Museum, 1980); and *James M. Preston: Pennsylvania Post-Impressionist* (Greensburg, Penn.: Westmoreland Museum of Art, 1990).

34. Parrish would have been very familiar with his cousin's collection of Pre-Raphaelite paintings. In 1908, when Bancroft purchased *The Tramp's Dinner*, the artist wrote: "How are your Rossetti's [*sic*] going to like it? It sure is breaking into high society. Indeed I wish I could get down to Wilmington someday. You have no doubt many more pictures since I was last there"; quoted in Ludwig, *Maxfield Parrish*, 153. Interestingly, Howard Pyle also could claim Samuel Bancroft as a cousin, in his case, by marriage; see *Howard Pyle*, 10.

35. A later discussion of Parrish's tremendous popularity, in relation to calendar art, noted the artist's talent for making "fancy real"; see Andrew Loomis, *Creative Illustration* (New York: Viking Press, 1947), 259.

36. Quoted in *Revisiting the White City: American Art at the 1893 World's Fair* (Washington, D.C.: National Museum of American Art and National Portrait Gallery, 1993), 185. Like most art students, Parrish admired Sargent's bravura technique and later singled out his *Portrait of Ada Rehan* in an 1895 exhibition he saw in London as "a stunner"; quoted in Ludwig, *Maxfield Parrish*, 17.

37. "Great Paintings Caricatured," *Philadelphia Inquirer*, March 4, 1894; Archives of the PAFA.

38. Ibid.

39. First prize went to Parrish's classmate John Sloan, one of the future members of the Ashcan group of artists, for his caricature of Sargent's work. "Lady McBroth" imagined the actress holding a bowl of tomato soup, rather than a crown, that flowed streams of "steaming soup," in place of her auburn braids; see ibid., and *Philadelphia Evening Bulletin*, March 19, 1894; Archives of the PAFA.

40. "A Caricature Exhibition," *Philadelphia Times*, February 21, 1895; Archives of the PAFA.

41. "Art Notes," *Philadelphia Inquirer*, March 3, 1895; Archives of the PAFA. In fact, the poster was not purchased by the Academy.

42. Quoted in Ludwig, *Maxfield Parrish*, 13. See also endnote 13.

43. Minutes of the Committee on Instruction, January 1924; Archives of the PAFA.

44. Brinton, "A Master of Make-Believe," 351, 348.

45. The artist's stance was apparent during his 1895 European trip, during which he found a number of so-called naturalist paintings at the Paris Salon "frightful"; see Ludwig, *Maxfield Parrish*, 15. Throughout his career, Parrish adhered to the belief that nature should inspire the artist—rather than provide a blueprint—and always be mediated by a touch of idealism.

46. In a letter to the author, Patrick Connors remarked on Parrish's unusual interest in producing a study of linear perspective at the turn of the century, as the advent of the camera had all but done away with this technical skill: "For the sensitive artist, linear perspective made sense of the busy flatness of the photograph. Parrish's wonderfully resolved paintings show how well he understood both the distortions of linear perspective and those of the photograph." See Patrick Connors to Sylvia Yount, April 6, 1998; Archives of the PAFA.

47. Brinton, "A Master of Make-Believe," 351.

48. Ibid., and Adams, "The Art of Maxfield Parrish," 91.

49. Helen Henderson, "The Artistic Home of the Mask and Wig Club," *House and Garden* 5 (April 1904): 168–74. Henderson was a former Academy classmate of Parrish's and art critic for the *Philadelphia Inquirer*.

50. Brinton, "A Master of Make-Believe," 349.

51. Before its installation at the St. Regis, the mural hung for a time at the Racquet Club on Park Avenue. See Christopher Gray, "Beaux-Arts Facade and 'Old King Cole' in the Bar," *New York Times*, February 16, 1997, 7.

52. The Architectural Exhibition, held from December 15, 1894, to February 5, 1895, ran concurrently with the Academy's Sixty-fourth Annual but was not organized by the institution. That

the board purchased a work from this show—the *Old King Cole* study was bought for one hundred dollars—was highly unusual, as few acquisitions were made from special exhibitions. Parrish also displayed his Mask and Wig ticket window design in the exhibition. See Archives of the PAFA.

53. Thomas Hastings, "The Architectural League of New York Exhibition," *Harper's Weekly* 39 (March 2, 1895): 197. Between 1895 and 1900, Parrish produced covers for five different Harper and Brothers periodicals: *Harper's Bazar, Harper's Weekly, Harper's Monthly, Harper's Round Table,* and *Harper's Young People;* see Ludwig, *Maxfield Parrish,* 209–10.

54. Parrish referred to all his advertising designs as "posters" despite their final reproductive form. See Nancy Finlay, "American Posters and Publishing in the 1890s," in *American Art Posters of the 1890s* (New York: Metropolitan Museum of Art, 1987), 52.

55. See *Annual Report* (1894) and *Circular* (1895–96), School of Industrial Art of the Pennsylvania Museum; Archives of the University of the Arts.

56. Ludwig, *Maxfield Parrish,* 15–17.

57. Brinton, "A Master of Make-Believe," 342, 344; Carrington, "Work of Maxfield Parrish," 224.

58. See *Exhibition of Posters* (Philadelphia: Pennsylvania Academy of the Fine Arts, 1896), 4–5; Archives of the PAFA.

59. Although Sloan and Parrish were apparently on good terms during their student days at the Academy—they entered the same year—the relationship did not last. In a 1905 letter to Robert Henri, Sloan bemoaned the rejection of two of his drawings by *Scribner's,* caustically noting the continuing popularity of Parrish's *Collier's* covers; see Bennard B. Perlman, ed., *Revolutionaries of Realism: The Letters of John Sloan and Robert Henri* (Princeton: Princeton University Press, 1997), 99.

60. *Exhibition of Posters,* 3. A later article identified 1896 as the year in which "the fine frenzy regarding posters . . . raged in America"; see Percival Pollard, "American Poster Lore," *Poster* 2 (March 1899): 123.

61. Harrison Morris, *Confessions in Art* (New York: Sears Publishing Company, 1930), 20. For a general discussion of the poster's appeal at the turn of the century, see Neil Harris, "American Poster Collecting: A Fitful History," *American Art* 12 (Spring 1998): 11–19.

62. Harrison Morris to Maxfield Parrish, April 25, 1899; Archives of the PAFA.

63. Ibid.

64. Maxfield Parrish to Harrison Morris, April 28, 1899; Archives of the PAFA.

65. In 1913, Parrish declined a position as head of the art department at Yale University for the same reasons he had given the Academy; see Ludwig, *Maxfield Parrish,* 23.

66. Harrison S. Morris, "Philadelphia's Contribution to American Art," *Century Illustrated Monthly Magazine* 69 (March 1905): 729–31.

67. John Trask to Maxfield Parrish, December 19, 1905; Archives of the PAFA. Trask was particularly keen to have work by Parrish for this exhibition celebrating the Academy's centennial. As the artist was willing, the Academy included thirty-six of his works. Three other illustrators also were given large showings: Elizabeth Shippen Green, Jessie Willcox Smith, and Violet Oakley. Almost all other artists were represented by just one work in the exhibition.

68. These decorations, so surprising in light of the artists' later work, suggest the seminal influence of the French painter Puvis de Chavannes, famous in America for his decoration of the Boston Public Library. Commissioned before the Columbian Exposition, the Boston murals, which included designs by John Singer Sargent and Edwin Austin Abbey, were not completed until 1895. Another influential mural cycle of the time was for the Library of Congress in Washington, D.C., a project that involved some nineteen artists and was unveiled in 1897. Sloan's decoration for the Academy was one of his earliest experiments in oil painting and suggests his other concurrent production—art posters in a vaguely Art Nouveau style designed for such magazines as *Gil Blas* and *Moods.*

69. "The Academy's Lecture Room," *Public Ledger,* April 16, 1897; Archives of the PAFA.

70. Years later, in a particularly effusive burst of local pride, John Trask claimed Parrish as a celebrated native son: "I think you are the one man in the country from whom the number of things we would receive [for an exhibition] is unlimited. Perhaps you did not know it, but you have become almost an object of veneration in Philadelphia. We 'point with pride' to William Penn, Benjamin Franklin, and you. . . ." See John Trask to Maxfield Parrish, October 12, 1909; Archives of the PAFA.

71. In 1902, Parrish repainted the picture at the request of its owners, who found the work too dark for domestic display. This second version was later reproduced in both *Century* (October 1905) and *St. Nicholas* (November 1910) magazines; see Ludwig, *Maxfield Parrish,* 208.

72. Carrington, "Work of Maxfield Parrish," 222. In response to a letter from Morris seeking information for an Academy catalogue, Parrish included the SAA honor along with his birth date and years of Academy enrollment; see Maxfield Parrish to Harrison Morris, September 23, 1897; Archives of the PAFA.

73. For more on the Gilders' artistic circle, see Sylvia Yount, "'Give the People What They Want': The American Aesthetic Movement, Art Worlds, and Consumer Culture, 1876–1890" (Ph.D. diss., University of Pennsylvania, 1995), 135–77.

74. Pollard, "American Poster Lore," 127.

75. Interestingly, Vedder himself had won an important commercial competition in the 1880s: Louis Prang's contest for the design of Christmas cards. That project encouraged Vedder to pursue other decorative work, not unlike Parrish, making him one of the key players in New York's Aesthetic culture.

76. *Poster* 1 (March 1896): 32.

77. In Parrish's first year at the Academy, controversy swirled around the *Ariadne*. A pressure group of leading Philadelphia Quakers, dubbing themselves the Social Purity Alliance, protested the permanent display of the Vanderlyn, calling for the latter's removal on "moral grounds." See February 1891 circular; Archives of the PAFA.

78. For Baum's mercantile career, see William Leach, "Strategists of Display and the Production of Desire," in Simon J. Bronner, ed., *Consuming Visions: Accumulation and Display of Goods in America, 1880–1920* (New York and London: W. W. Norton & Company, 1989), 106–10.

79. Ludwig, *Maxfield Parrish*, 25.

80. Carrington, "Work of Maxfield Parrish," 221.

81. Iona and Peter Opie, eds., *The Oxford Dictionary of Nursery Rhymes* (Oxford and New York: Oxford University Press, 1997), 3–4.

82. Ibid., 40–43. Perhaps the use of Parrish's nursery-rhyme themes for advertising purposes, in the teens, was intended to appeal directly to consumers' own memories of the artist's earlier work: Having grown up with it as children, they may have been predisposed to respond positively to it as adults. The selection of such subjects for hotel-bar murals suggests an analogy with the late-nineteenth-century popularity of trompe l'oeil still lifes, particularly the work of William Michael Harnett, in men's saloons. Both themes resonated with larger cultural narratives—in Parrish's case, nostalgia; in Harnett's, mastery. See Paul J. Staiti, "Illusionism, Trompe l'Oeil, and the Perils of Viewership," in *William M. Harnett* (Fort Worth and New York: Amon Carter Museum and the Metropolitan Museum of Art, 1992), 32–34.

83. Ruth Boyle, "A House that 'Just Grew': Maxfield Parrish's Home in New Hampshire," *Good Housekeeping* 88 (April 1929): 44–45.

84. "The Oaks" was officially completed in 1906, but Parrish continued to tinker; see Philip Zea and Nancy Norwalk, eds., *Choice White Pines and Good Land: A History of Plainfield and Meriden, New Hampshire* (Portsmouth, NH: Peter E. Randall Publisher), 357.

85. According to Parrish, "the place has been photographed so much that the corners are getting rounded"; quoted in Boyle, "A House that 'Just Grew,'" 44. See also "The House of Mr. Maxfield Parrish," *Architectural Record* 22 (October 1907): 272.; and Brinton, "A Master of Make-Believe," 345–46.

86. Boyle, "A House that 'Just Grew,'" 44.

87. Homer Saint-Gaudens, "Maxfield Parrish," *Critic* 46 (June 1905): 517, 515.

88. See Boyle, "A House that 'Just Grew,'" 44; and "The House of Mr. Maxfield Parrish," 276.

89. Ibid. This picturesque construction of an architectural setting suggests the earlier design work of the landscape painter Frederick Edwin Church, whose "Olana" of the 1870s embodied the domesticated "exoticism" of the Aesthetic era.

90. Saint-Gaudens, "Maxfield Parrish," 215. Similarly, Brinton described "The Oaks" as Parrish's "most typical creation"; see Brinton, "A Master of Make-Believe," 346.

91. "The House of Mr. Maxfield Parrish," 276.

92. Brinton, "A Master of Make-Believe," 345. Although "The Oaks" was officially in the township of Plainfield, New Hampshire, and its mailing address given as Windsor, Vermont, the community at large was generally referred to as "Cornish, New Hampshire." See "An Artist Colony," *New York Sunday Tribune*, August 11, 1907; quoted in *A Circle of Friends: Art Colonies of Cornish and Dublin* (Durham: University Art Galleries, University of New Hampshire, 1985), 58.

93. For an enlightening account of Parrish's daily routine, see Betty Skillen, "Sue Lewin Colby—My Aunt Sue," unpublished manuscript, 1997; Archives of the PAFA.

94. See "An Artist Colony," 58.

95. For a comprehensive study of the Cornish colony, see *A Circle of Friends*.

96. "An Artist Colony," 58. Referring to themselves as the "Chicadees," the group of year-round Cornish residents included, in addition to Maxfield and Lydia Parrish, Stephen Parrish and his niece Anne, the painters Henry and Lucia Fuller, the dramatist and landscape architect Louis and Ellen Shipman, and, after 1900, Saint-Gaudens' family and studio assistants. See John H. Dryfhout, "The Cornish Colony," in *A Circle of Friends*, 50.

97. Ludwig, *Maxfield Parrish*, 28.

98. See J. H. Irvine, "Professor von Herkomer on Maxfield Parrish's Book Illustrations," *International Studio* 29 (July 1906): 35–43.

99. Ibid., 35–36, 43.

100. In 1904, *The Golden Age* was reissued as a companion volume to *Dream Days*, using a new black-and-white photogravure process far superior to the halftone method that had been employed in the reproduction of the first edition of the book; see Ludwig, *Maxfield Parrish*, 29.

101. Irvine, "Professor von Herkomer on Maxfield Parrish's Book Illustrations," 42.

102. "Parrish and Dream Days," *Everbody's Magazine* 13 (August 1905): 283.

103. Adams, "The Art of Maxfield Parrish," 86–87.

104. Augustus Saint-Gaudens to Maxfield Parrish, December 5, 1901; Maxfield Parrish Papers, Dartmouth College Library.

105. Maxfield Parrish to Augustus Saint-Gaudens, December 21, 1901; Maxfield Parrish Papers, Dartmouth College Library. In a later letter, Saint-Gaudens again expressed acute interest in buying one of Parrish's original drawings: "Whisper, how many hundred thousand million dollars is the price of what I covet, and please name not one cent less than what you have in mind, no matter who the purchaser may be"; see Augustus Saint-Gaudens to Maxfield Parrish, November 2, 1904; Maxfield Parrish Papers, Dartmouth College Library.

106. See Bogart, *Artists, Advertising, and the Borders of Art*, 238.

107. Maxfield Parrish to Augustus Saint-Gaudens, December 21, 1901.

108. Ludwig, *Maxfield Parrish*, "Chronology."

109. Between 1894 and 1912, Parrish participated in eight of the Academy's annual exhibitions and, from 1908 to 1933, in four of the Philadelphia Water Color Club's annuals (cosponsored by the Academy). His work also was featured in exhibitions of original designs circulated nationally by various magazines, namely *Collier's*, one of which came to the Academy in the winter of 1905/6; see Maxfield Parrish to John Trask, December 22, 1905; Archives of the PAFA.

110. "Should Museums Form Collections of Illustrations? *New York Herald*, December 1, 1907.

111. Ibid.

112. Nancy F. Allyn, "The Illustrations of William Glackens," in *William Glackens: Illustrator in New York, 1897–1919* (Wilmington: Delaware Art Museum, 1985).

113. William D. Moffat, "Maxfield Parrish and His Work," *Outlook* 78 (December 3, 1904): 839.

114. Ibid.

115. "Maxfield Parrish's Western Pictures," *Century Illustrated Monthly Magazine* 64 (July 1902): 486.

116. "The Southwest in Color," *Century Illustrated Monthly Magazine* 65 (November 1902): 160–61. In a 1930 interview, M. K. Wisehart offered Parrish a narrative of the importance of his southwestern experience: "Today when you paint a landscape, you are always thinking of Arizona. Specifically, you are thinking of the bare ruggedness of that part of Arizona which is sixty miles beyond Phoenix where the desert joins the Bradshaw Mountains, where there are great distances, where the world's first color was made, and where silence was born"; see Wisehart, "Maxfield Parrish Tells Why . . . ," 30.

117. "Maxfield Parrish's Western Pictures," 486.

118. For a discussion of the outdoors movement and personal health, see John Higham, "The Reorientation of American Culture in the 1890's," in *The Origins of Modern Consciousness* (Detroit: Wayne State University Press, 1965), 26–27; see also "The Southwest in Color," 160.

119. T. J. Jackson Lears, *No Place of Grace: Antimodernism and the Transformation of American Culture, 1880–1920* (Chicago and London: University of Chicago Press, 1981), 223.

120. In 1897, Edith Wharton and the architect–decorator Ogden Codman, Jr., published the influential *The Decoration of Houses* (New York: Charles Scribner's Sons), a book that revealed Wharton's taste for European—specifically eighteenth-century French—design.

121. In 1905, Parrish exhibited the Italian drawings, along with his illustrations for Eugene Field's *Poems of Childhood*, in the Academy's annual exhibition; *Villa Gamberaia* was sold. See Maxfield Parrish to Harrison Morris, March 3, 1905; Archives of the PAFA.

122. "Pen and Pencil in Italy," *Critic* 66 (February 1905): 166–67. The Century Company was so pleased with Parrish's work that it offered to send him to any place he wished to paint, but the artist preferred to remain in New Hampshire; see Ludwig, *Maxfield Parrish*, 74.

123. Soon after the artist's return from Italy, the editor of *Century*, Richard Watson Gilder, commissioned writer Frances Duncan to prepare an article on the gardens of Cornish, including those of the senior and junior Parrishes; see Dryfhout, "The Cornish Colony," 48.

124. Adams, "The Art of Maxfield Parrish," 88.

125. In discussing *The Dinkey-Bird*, Moffat argued, "It seems to us that Mr. Parrish has made no illustration more exquisitely charming than this, in color, in composition, and in poetic feeling"; see Moffat, "Maxfield Parrish and His Work," 841.

126. Ibid.

127. Under the editorship of Parrish's Cornish neighbor Norman Hapgood (1902–12), *Collier's* became one of the leading muckrakers of the Progressive era; see Frank Luther Mott, *A History of American Magazines*, vol. 4 (Cambridge: Harvard University Press, 1968 [1938]), 453–79. See also Ludwig, *Maxfield Parrish*, 35.

128. According to his Cornish neighbor Frances Grimes, Parrish was very interested in lettering and used an adaptation of Albrecht Dürer's alphabet in his work, remarking to others frequently on the "beauty of individual letters in that alphabet with enthusiasm." See Frances Grimes, "Reminiscences," reprinted in *A Circle of Friends*, 69.

129. One of the paintings from the *Greek Mythology* series considered too dark by *Collier's*—Hermes—later appeared on the September 1912 cover of *Heart's Magazine*. Presumably, this depiction of the ancient Greek patron of trade—"a messenger . . . and a wily trickster"—would have held particular appeal for the media tycoon William Randolph Hearst; see Susan Strasser, *Satisfaction Guaranteed: The Making of the American Mass Market* (Washington, D.C., and London: Smithsonian Institution Press, 1989), 124.

130. The cover appeared on October 24, 1936; see Ludwig, *Maxfield Parrish*, 88.

131. Smith and Wiggin's retelling sanitized this collection of ancient Persian–Indian–Arabian tales, orginally written in Arabic and arranged around 1450.

132. In a letter to the artist, John Trask noted that the Academy's Beck Prize, awarded to the exhibition's best work in color, could have been given to any one of the fifteen featured *Arabian Nights* paintings and continued: "I hope that you will not consider that in making this award we are carrying coals to Newcastle to an unwelcome degree but that it will serve to show you the esteem in which you and your work are still held here, even though you do not send regularly to our exhibitions nor favor us anymore with your welcome presence." John Trask to Maxfield Parrish, December 4, 1908; Archives of the PAFA. For an unfootnoted account of the Maude Adams story, see Ludwig, *Maxfield Parrish*, 34.

133. Just as *The Rubaiyat of Omar Khayyam* had seduced the Anglo-American imagination of the late nineteenth century, the Garden of Allah theme became a favorite in early-twentieth-century popular culture. The play Parrish saw in New York was likely based on Robert Hichens' widely read novel of 1904; see Ludwig, *Maxfield Parrish*, 135–36. The influence of Lawrence Alma-Tadema (1836–1912), the Dutch-born Victorian painter, who also designed stage sets, props, costumes, and furniture and whose Grecian fantasies were once the rage of Aesthetic London, also is apparent in the work.

134. Grace Goodale, "At an Amateur Pantomime," *Scribner's* 24 (November 1898): 528.

135. For a discussion of this collaboration between amateurs and professionals—including the actors William Gillette and Ethel Barrymore—see Dryfhout, "The Cornish Colony," 52. See also Percy MacKaye, "American Pageants and Their Promise," *Scribner's* 66 (July 1909): 28–33.

136. MacKaye, "American Pageants," 32.

137. Kenyon Cox, "An Outdoor Masque in New England," *Nation* 180 (June 29, 1905): 519–20. In addition to reviewing the performance, Cox played the role of Pluto.

138. Ibid., and Ludwig, *Maxfield Parrish*, 21. The costume consisted of a rib cage made of barrel staves and wooden hind legs on wheels, connected to the artist's own body by steel rods that followed his movements.

139. Saint-Gaudens, "Maxfield Parrish," 519.

140. Grimes, "Reminiscences," 62, 68–69.

141. Dryfhout, "The Cornish Colony," 54.

142. The production also may have been connected to the artist's so-called "Once Upon a Time" scenery design; see Ludwig, *Maxfield Parrish*, 216. For the larger Anglo-American fairy phenomenon during these years, see *Victorian Fairy Painting* (London: Royal Academy of Arts, 1997), and Lears, *No Place of Grace*, 170–71. Susan Strasser discussed how many American businesses used fairies and elves in their advertisements in these years to imply the "magic" of mass production; see *Satisfaction Guaranteed*, 115–17.

143. Adams, "The Art of Maxfield Parrish," 91.

144. One of the few known sets designed by a professional artist and still in use today, Parrish's contribution to the larger Cornish community remains an important local landmark; see "Parrish in Plainfield" brochure. The artist's other gift to the colony was a sign for the Cornish teahouse depicting "in delicately ironic vein a pair of lovers at tea . . . [and] painted with the same enthusiasm that he would give to a monumental decoration." Ibid., 91, 93.

145. Quoted in Ludwig, *Maxfield Parrish*, 48.

146. Ibid., 48–53; and Gilbert, *The Masterworks*, 52, 164.

147. Ludwig, *Maxfield Parrish*, 216. The *Gnome* is an interesting example of Parrish's translation of his penchant for two-dimensional paper cutouts to a three-dimensional wooden object. The figure later reappeared in some of the artist's Hires Root Beer and Fisk Rubber Company advertisements, as well as on his last *Collier's* cover as Jack Frost; see Carrie Brown, *Maxfield Parrish: Machinist, Artisan, Artist* (Windsor, VT: American Precision Museum, 1995).

148. Gray, "Beaux-Arts Facade and 'Old King Cole' in the Bar."

149. For more on the Coffee House club, see Deborah S. Gardner, "Charles A. Platt in New York, 1900–1933," in *Shaping an American Landscape: The Art and Architecture of Charles A. Platt* (Hanover and London: University Press of New England, 1995), 101.

150. Adams, "The Art of Maxfield Parrish," 9.

151. Quoted in Zea and Norwalk, "Plainfield and the Cornish Colony," 359.

152. Saint-Gaudens, "Maxfield Parrish," 521.

153. For one of the few how-to designs ever published by the artist, see Maxfield Parrish, "A Circus Bedquilt," *Ladies' Home Journal* Bridal Number 22 (March 1905): 11.

154. See Mott, *A History of American Magazines*, 536–55; and Salme Harju Steinberg, *Reformer in the Marketplace: Edward W. Bok and Ladies' Home Journal* (Baton Rouge and London: Louisiana State University Press, 1979).

155. Ludwig, *Maxfield Parrish*, 163.

156. An announcement that ran in the *Ladies' Home Journal* noted, "the ingenious designs are destined to set the fashions for years to come in masquerade costuming"; see "A Girls' Dining Room of Maxfield Parrish Paintings," undated clipping, Maxfield Parrish artist file; Library of the PAFA. Similarly, a writer for the *International Studio* applauded Parrish for his "wizardry of a master of stagecraft, who has planned a faultless *ensemble* for the rise of the curtain"; also see "A Note on Some New Paintings by Maxfield Parrish," *International Studio* 47 (August 1912): 26.

157. Quoted in Ludwig, *Maxfield Parrish*, 163.

158. Bogart, *Artists, Advertising, and the Borders of Art*, 234.

159. Upon completion, the dining room became a popular tourist attraction in Philadelphia, attracting hundreds of visitors on a weekly basis. The Curtis Publishing Company was so pleased with the artist's work that, after the untimely death of Edwin Austin Abbey, who was working on a mural for the building's lobby, Bok persuaded Parrish to take over the project. The decision was made to translate one of his earlier landscape designs into a mural of Favrile glass, executed by the Tiffany Studios. The 15 x 49' *Dream Garden* was installed in the east lobby in 1915, where it remains today; see Ludwig, *Maxfield Parrish*, 166–67.

160. "A Note on Some New Paintings by Maxfield Parris," 26.

161. For more on Lewin, who remained Parrish's loyal companion for nearly fifty-five years, see Ludwig, *Maxfield Parrish*, 200; Alma Gilbert, *The Make Believe World of Maxfield Parrish and Sue Lewin* (San Francisco: Pomegranate Books, 1990); and Skillen, "Sue Lewin Colby—My Aunt Sue."

162. Eventually, Parrish used the studio as his year-round residence while Lydia spent the winters traveling abroad or at her cottage in Georgia. There, she became engrossed in the local African-American Gullah culture, particularly its music and dance traditions. In 1942, she published *Slave Songs of the Georgia Sea Islands*; see Ludwig, *Maxfield Parrish*, 21. For an account of the Parrishes' early married life, see Grimes, "Reminiscences," 67–68.

163. Dryfhout, *A Circle of Friends*, 59.

164. See *A Circle of Friends*, 58; and Mrs. Daniel Chester French, *Memories of a Sculptor's Wife* (Boston and New York: Houghton Mifflin Company, 1928), 184.

165. See Grimes, "Reminiscences," 63–4; and John Berger, *Ways of Seeing* (London: BBC and Penguin Books, 1972), 47.

166. Brown, *Maxfield Parrish: Machinist, Artisan, Artist*.

167. Clarence Crane had arranged for the House of Art to handle the reproduction and distribution of Parrish's designs, even placing his son, the future poet Hart Crane, in the sales department. Parrish's dissatisfaction with his partnership with Crane led to his contract with the House of Art; see Ludwig, *Maxfield Parrish*, 138.

168. In a February 5, 1923 letter to Rusling Wood, owner of a New York lithography firm that arranged many of the artist's commissions, Parrish wrote of his desire to move from advertising work into the print business: "A successful print is a pretty good thing all round. In the first place I can paint exactly what I please, and then, if it's successful it means an income, a pretty big one, for a number of years. I have just finished an ambitious painting [*Daybreak*] for Reinthal and Newman, of whom I have a high opinion, and I'll wait and see what the picture is going to do for me." Ibid., 122.

169. Bogart, *Artists, Advertising, and the Borders of Art*, 234.

170. Ibid., 143. Frances Grimes discussed Parrish's interests in matters of form over content in his pictures: "What has interested him most in them has not been the subject, but some arrangement, pattern, juxtaposition of colors. Once when I had praised a picture he said, 'People like the sentiment of that,' but what had interested him was painting the white fabric in shadow so it would look like white in shadow, and not a gray fabric." See Grimes, "Reminiscences," 68.

171. Ludwig, *Maxfield Parrish*, 143. By the end of 1923, after the print had only been on the market for a few months, the artist's royalties totaled almost twenty-five thousand dollars; in 1925, his reported income, before taxes, exceeded ninety-two thousand dollars—equivalent to more than seven hundred thousand dollars today. See Bogart, *Artists, Advertising, and the Borders of Art*, 235.

A song popular with upperclasswomen at Wellesley College, in 1924, included the verse, "Oh they're a-hanging Maxfield Parrish in the village," referring to the freshmen's middlebrow tastes; the "college cognoscenti" had already moved on to the prints of Rockwell Kent; see John Canaday, "Maxfield Parrish, Target Artist," *New York Times*, June 7, 1964, 21.

172. Quoted in Ludwig, *Maxfield Parrish*, 143.

173. For a discussion of *Daybreak* in terms of classical dreams of democracy, see Judy Larson, "The Power of the Image as Narrative," unpublished manuscript; Archives of the PAFA.

174. This reading of *Daybreak* as a metaphor for "budding sexuality" and an expression of the 1920s obsession with youth explains its popular rediscovery by the 1960s counterculture. See Bogart, *Artists, Advertising, and the Borders of Art*, 238–39, 328; Lears, *No Place of Grace*, 144–51, 223, 249–50; and Bram Dijkstra, *Idols of Perversity: Fantasies of Feminine Evil in Fin-de-Siecle Culture* (New York and Oxford: Oxford University Press, 1986), 188–95.

175. As she became older, Jean and other local girls chose to no longer pose nude for Parrish, a situation repeated in Mann's practice.

176. Nina Auerbach, *Romantic Imprisonment: Women and Other Glorified Outcasts* (New York: Columbia University Press, 1986), 168.

177. Maxfield Parrish to A. E. Reinthal, February 15, 1929; Maxfield Parrish Papers, Dartmouth College Library.

178. See Bogart for a discussion of a number of American modernists'—Walter Pach, Stuart Davis, Rockwell Kent—involvement with commercial art at this time; *Artists, Advertising, and the Borders of Art*, 221–33, 243–55. For an analysis of the 1920s fusion of elite and popular culture, see Ann Douglas, *Terrible Honesty: Mongrel Manhattan in the 1920s* (New York: Farrar, Straus and Giroux, 1995).

179. Joan Shelley Rubin links the twentieth-century growth of

middlebrow culture to the popularization of literature in *The Making of Middlebrow Culture* (Chapel Hill and London: University of North Carolina Press, 1992).

180. See Ludwig, *Maxfield Parrish*, 214. For a study of the developing relationship between advertising and magazines at the turn of the century, see Ellen Gruber Garvey, *The Adman in the Parlor: Magazines and the Gendering of Consumer Culture, 1880s to 1910s* (New York and Oxford: Oxford University Press, 1996).

181. J. L. Conger, "Maxfield Parrish's Calendars Build Sales for Edison Mazda Lamps," *Artist & Advertiser* 2 (June 1931): 35, 4. The calendars were generally produced in two sizes: a large format for "intraorganization" use and a smaller one for public distribution; pocket calendars and playing cards also were issued. For a detailed discussion of the artist's arrangement with General Electric, see Ludwig, *Maxfield Parrish*, 123–28.

182. Conger, "Maxfield Parrish's Calendars," 35. For a discussion of advertising art directors' use of "art-art" as a key marketing tool during the 1920s and 1930s, see Bogart, *Artists, Advertising, and the Borders of Art*, 9, 125–70.

183. Loomis, *Creative Illustrations*, 259. Conger concurred, noting that Parrish's inimitable appeal lay in his extraordinary ability to make the painting look like a more attractive version of the "real thing" through his detailed photographic technique and use of coloring; see Conger, "Maxfield Parrish's Calendars," 5.

184. See Bogart, *Artists, Advertising, and the Borders of Art*, 110–24, 220; Strasser, *Satisfaction Guaranteed*, 91; and "Offensive Billboards," *Nation* 105 (December 6, 1917): 629.

185. Maxfield Parrish to M. Rusling Wood, February 1, 1917; Maxfield Parrish Papers, Dartmouth College Library.

186. Maxfield Parrish to A. E. Reinthal, February 15, 1929; Maxfield Parrish Papers, Dartmouth College Library.

187. "Maxfield Parrish Will Discard 'Girl-on-Rock' Idea in Art," *Associated Press*, April 27, 1931; quoted in Ludwig, *Maxfield Parrish*, 129.

188. Parrish explained his highly theatrical approach to landscape painting in 1952: "My theory is that you should use all the objects in nature, trees, hills, skies, rivers and all, just as stage properties on which to hang your idea. . . . 'Realism' of impression, the mood of the moment, yes, but not the realism of things. The colored photograph can do that better. That's the trouble with so much art today, it is factual, and stops right there." Quoted in Ludwig, *Maxfield Parrish*, 185.

189. Interestingly, the artist's landscapes never approached the fame of his "girl-on-the-rock" imagery. Brown and Bigelow continued to capitalize on the "American" qualities of Parrish's landscapes in future decades by issuing portfolios of his calendar images, namely, *Our Beautiful America*, in the early forties, and *My Homeland* in 1964. Ibid. 216.

190. Although one can assume Parrish supported the Regionalists' advocacy for a dynamic national art based on indigenous values and experiences—an art that supposedly rejected the influence of European modernism—their means of expression were quite different. For example, artists such as Thomas Hart Benton, who worked for a time in the advertising industry, clearly shared Parrish's popular belief in the "power of mass communication to produce community," but their stance was more self-consciously ideological. For a discussion of the Associated American Artists, a marketing body that promoted the nationwide sale of five-dollar prints by mostly Regionalist painters—including Benton and John Stuart Curry—see Erika Doss, *Benton, Pollock, and the Politics of Modernism: From Regionalism to Abstract Expressionism* (Chicago and London: University of Chicago Press, 1991), 156–67.

191. Cited by Ludwig, *Maxfield Parrish*, 201. In a short story that appeared in a 1942 issue of the *Saturday Evening Post*, characters described a view from a boat as looking "exactly like the paintings a—a man I can't remember the name of makes for children. Only you don't ever expect to see anything like the paintings. . . . Maxfield Parrish. Yes. Same blue colors. Same pink cities floating, because of the mirage. . . . Like having a job in heaven." See Philip Wylie, "Three-Time Winner," *Saturday Evening Post* 214 (May 2, 1942): 52.

192. Bogart, *Artists, Advertising, and the Borders of Art*, 242.

193. Royal Cortissoz, "Recent Work by Maxfield Parrish," *New York Herald Tribune*, February 16, 1936, 10.

194. See Clement Greenberg, "Avant-Garde and Kitsch," in *Art and Culture: Critical Essays* (Boston: Beacon Press, 1961), 13; Adam Gopnik, "The Power Critic," *New Yorker* (March 16, 1998): 70. This low regard was mutual as Parrish considered the abstractionists to be "scribblers"; see "Maxfield Parrish, Painter and Illustrator, Dies at 95," *New York Times*, March 31, 1966.

195. John R. MacKay, "Maxfield Parrish. Again," *Philadelphia Inquirer Today* (Sunday) magazine, February 10, 1974, 18.

196. Alloway, "The Return of Maxfield Parrish," 66.

197. In its review of the exhibition, *Time* magazine caustically noted, "the pop art of 50 years ago had an attribute not shared by the pop art of today: it was popular," citing Parrish as the "most popular of the artists of that time." See "Grand-Pop," *Time* 83 (June 12, 1964): 76.

198. For the four works by Parrish sold from Warhol's estate in 1988, see *The Andy Warhol Collection*, vol. 5: *Americana and European and American Paintings, Drawings, and Prints* (New York: Sotheby's, 1988), lots 2828–2831.

199. For a historiographic examination of "high" culture's ambivalent relationship to "mass" culture, see Jackson Lears, *Fables of Abundance: A Cultural History of Advertising in America* (New York: Basic Books, 1994).

200. Canaday, "Maxfield Parrish, Target Artist," 21.

201. Charlotte Lichtblau, "20 Parrish Paintings in 'Commercial' Vein," unidentified, undated clipping, Maxfield Parrish artist file, Library of the PAFA. Another article—more of a popular interest story on the artist himself rather than a review of the exhibition—warned that "to discount the able, perceptive expression of a man such as Parrish . . . because his work does not follow current fads in technique, composition, and subject matter is a mistake . . . history will prove it so." See Gillett, "His Skies Are Blue," 130.

202. "Bit of a Comeback Puzzles Parrish," *New York Times,* June 3, 1964. In the same article, Parrish expressed his admiration for the work of Andrew Wyeth, at the time the artistic inheritor of his crown of national celebrity.

203. For the artist's obituary, see "Maxfield Parrish, Painter and Illustrator, Dies at 95."

204. Robert Taylor, "Maxfield Parrish Is In," *Boston Herald,* May 24, 1966; quoted in Gilbert, *The Masterworks,* 214.

205. As one writer noted in 1974, "Last year saw a sudden, startling renewal of interest in Maxfield Parrish and his work. Three lavish books on Parrish were published; his work began to appear on the walls of coffee houses and art galleries. In recent years American popular culture has fallen in love with the mysterious and romantic, and now it is looking back at pictures by an old friend"; MacKay, "Maxfield Parrish. Again," 17.

206. *Maxfield Parrish: Master of Make-Believe* (Chadds Ford, PA: Brandywine River Museum, 1974).

207. See Gilbert, *The Masterworks,* 183–97. Apparently, George Lucas, among other Hollywood collectors, has been drawn to the art of Parrish as well as to Norman Rockwell—"another unironic American image-maker"; see John Seabrook, "Letter from Skywalker Ranch: Why Is the Force Still With Us?" *New Yorker* 72 (January 6, 1997): 43. Today, the mania surrounding the lucrative merchandising of Parrish's art continues to reach Machiavellian proportions—a phenomenon this painter of pleasures would surely have found to be decidedly ironic.

208. Parrish used the phrase to describe what he intended his landscapes to represent; quoted in Ludwig, *Maxfield Parrish,* 175.

209. Ken Johnson, "Kitsch Meets the Sublime," *Art in America* 84 (March 1996): 81–83.

210. The philosophy of the conceptual/performance artist Stephen Keene, whose populist project "History for Sale" created a stir in Philadelphia during the fall of 1997, also suggests an affinity to Parrish: "I don't create art for artists in a walled-up little fort. I'm more interested in everyday life and people." See Jennifer Darr, "A Keene Eye," *Philadelphia City Paper,* December 12–18, 1997, 11; Steve Lopez, "Assembly-Line Picasso," *Time* 150 (December 1, 1997): 4; and Edward J. Sozanski, "A One-Man Show Proves Singularly Popular," *Philadelphia Inquirer,* January 4, 1994, F10.

211. Deborah Solomon, "The Persistence of the Portraitist," *New York Times Magazine,* February 1, 1998, 24.

212. Alloway, "The Return of Maxfield Parrish," 67.

"FRANK IMAGINATION, WITHIN A BEAUTIFUL FORM": THE PAINTING METHODS OF MAXFIELD PARRISH
by Mark F. Bockrath

1. Coy Ludwig, *Maxfield Parrish* (New York: Watson-Guptill Publications, 1973), 201.

2. Ibid., 190.

3. Ibid., 191.

4. Ibid., 190.

5. Ibid., 149.

6. Ibid., 200.

7. Rikke Foulke, condition report, January 28, 1997, Pennsylvania Academy of the Fine Arts, Philadelphia.

8. Ibid.

9. Ludwig, *Maxfield Parrish,* 193.

10. Ibid., 16.

11. Ibid., 191.

12. Ibid., 85.

13. Ibid., 133.

14. Ibid., 143.

15. Betsy James Wyeth, ed., *The Wyeths: The Letters of N. C. Wyeth, 1901–1945* (Boston: Gambit, 1971), 631; letter from N. C. Wyeth to Sidney M. Chase, October 25, 1919.

16. Ludwig, *Maxfield Parrish,* 177.

Exhibition Checklist

PAINTINGS

Old King Cole, 1895
Oil on canvas
44 x 132"
Private Collection

Stormbearers of the Norsemen, 1899
Oil on paper
16½ x 10¼"
Rare Book Department, The Free Library of
Philadelphia

Milkmaid, 1901
Oil on paper
25 x 18"
Private Collection

Phoebus on Halzaphron, 1901
Oil on paper
5¾ x 7½"
Charles Hosmer Morse Museum of
American Art, Winter Park, FL

Poet's Dream, 1901
Oil on paper
25 x 18"
Private Collection

Cowboys, Hot Springs, Arizona, 1902
Oil mixed with melted wax on cardboard
mounted on wood
17 x 14 ³⁄₁₆"
Museum of Art, Rhode Island School of
Design, Providence

Villa Gamberaia, Settignano, 1903
Oil on canvas
28½ x 18½"
Lent by the Minneapolis Institute of Arts,
Bequest of Margaret B. Hawkes

The Dinkey-Bird, 1904
Oil on paper
21¼ x 15½"
Charles Hosmer Morse Museum of
American Art, Winter Park, FL

The Rawhide, 1904
Oil on panel
16¼ x 12¼"
Collection of Mr. and Mrs. Thomas Davies

Saint Valentine, 1904
Tempera on gesso panel
20 x 16"
National Academy Museum, New York

Agib in the Enchanted Palace, 1905
Glazed oil on paper
18 x 16"
Detroit Institute of Arts. Bequest of the
Estate of Dollie May Fisher, widow of
Lawrence P. Fisher

*"Ah never in this world were there such
roses,"* 1905
Oil on stretched paper
16 x 14"
The Memorial Art Gallery of the Univer-
sity of Rochester, NY

Aladdin and the African Magician, 1905
Glazed oil on paper
18 x 16"
Detroit Institute of Arts. Bequest of the
Estate of Dollie May Fisher, widow of
Lawrence P. Fisher

Architectural Study, ca. 1905
Oil on composition board
26¾ x 63"
Collection of the Brandywine River
Museum, Chadds Ford, PA. Gift of the
Maxfield Parrish Museum, Inc., Plainfield,
NH. Courtesy of Alma Gilbert

Land of Make Believe, 1905
Oil on canvas laid down on board
40 x 32"
Private Collection

The Tramp's Dinner, 1905
Charcoal, oil, and pastel on cardboard
adhered to wood panel
21 x 16"
Delaware Art Museum. Samuel and Mary
R. Bancroft Memorial

*The History of Codadad and His Brothers
(The Pirate Ship)*, 1906
Glazed oil on paper
18 x 16"
Detroit Institute of Arts. Bequest of the
Estate of Dollie May Fisher, widow of
Lawrence P. Fisher

*Princess Parizade Bringing Home the
Singing Tree*, 1906
Oil on paper
20¹⁄₁₆ x 16¹⁄₁₆"
Pennsylvania Academy of the Fine Arts.
Gift of Mrs. Francis P. Garvan

*Queen Gulnare of the Sea Summoning Her
Relations*, 1906
Oil on board
20 x 16⅛"
Frances Lehman Loeb Art Center,
Vassar College, Poughkeepsie, NY. Gift of
Mrs. Francis P. Garvan

Sinbad in the Valley of Diamonds, 1906
Glazed oil on paper
18 x 16"
Detroit Institute of Arts. Bequest of the
Estate of Dollie May Fisher, widow of
Lawrence P. Fisher

Winter, 1906
Oil on paper mounted on board
19 x 19"
Collection of Joan Purves Adams

Sinbad Plots against the Giant, 1907
Oil on cardboard
20⅛ x 16⅛"
Philadelphia Museum of Art. Centennial
gift of Mrs. Francis P. Garvan

The Storm, 1907
Oil on canvas
40 x 32"
Addison Gallery of American Art, Phillips
Academy, Andover, MA. Gift of Mrs. Henry
M. Sage

April Showers, 1908
Oil on paper
22 x 16"
Private Collection

Dream Castle in the Sky, 1908
Oil on canvas
6' x 10'11"
Lent by the Minneapolis Institute of Arts.
The Putnam Dana McMillan Fund

School Days (Alphabet), 1908
Oil on board
22 x 16"
Collection of Joan Purves Adams

The Artist, Sex, Male, 1909
Oil on paper
19¾ x 16"
Collection of the Brandywine River
Museum, Chadds Ford, PA. Gift of Mrs.
Andrew Wyeth

Hermes, 1909
Oil on canvas
28⅞ x 15⁵⁄₁₆"
Rare Book Department, The Free Library of
Philadelphia

Quod Erat Demonstrandum, 1909
Oil on canvas
48 x 40"
Collection of Beatrice W. B. Garvan

A Strong-Based Promontory (The Tempest), 1909
Oil on paper mounted on panel
16 x 16"
High Museum of Art, Atlanta

Thanksgiving, 1909
Oil on paper
22 x 16"
Private Collection

Errant Pan, ca. 1910
Oil on canvas
40 x 32"
The Metropolitan Museum of Art. George
A. Hearn Fund

The Idiot, 1910
Oil paint over graphite and ink on
stretched paper
22 x 16"
The Fine Arts Museums of San Francisco,
Achenbach Foundation for Graphic Arts.
Bequest of Arthur W. Barney

The Forest Scene for "Once Upon a Time,"
1916
Oil on canvas mounted on board
32 x 40"
Robert Miller and Betsy Wittenborn Miller

Ferry's Seeds: Mary, Mary Quite Contrary,
1921
Oil on board
27 x 20"
Department of Special Collections,
University of California Library, Davis

*Two Pastry Cooks: Blue Hose and Yellow
Hose*, 1921
Oil on paper laid down on panel
20⅛ x 16¼"
Private Collection

Daybreak, 1922
Oil on panel
26 x 45"
Private Collection

Interlude (The Lute Players), 1922
Oil on canvas
6'11" x 4'11"
The Memorial Art Gallery of the University of Rochester, NY. Lent by the Eastman
School of Music

Little Sugar River at Noon, ca. 1922–24
Oil on panel
15½ x 19¾"
Virginia Museum of Fine Arts, Richmond.
Gift of Langbourne M. Williams

Romance, 1922
Oil on panel
21¼ x 35"
Private Collection

The End (The Knave of Hearts), 1923
Oil on board
26 x 22"
Private Collection

Ferry's Seeds: Jack and the Beanstalk, 1923
Oil on board
29 x 21⅝"
Department of Special Collections,
University of California Library, Davis

Wild Geese, 1924
Oil on board
19¾ x 14¾"
Collection of Dr. Ronald Lawson

*The Gardener Wheeling Vegetables (The
Knave of Hearts)*, 1925
Oil, watercolor, and graphite with varnish
on panel
9⅜ x 20¹⁄₁₆"
Philadelphia Museum of Art. Gift of the
Philadelphia Water Color Club

Stars, 1926
Oil on panel
35¾ x 22¼"
Private Collection

Cobble Hill, 1931
Oil on panel
11½ x 13"
Collection of the Brandywine River
Museum, Chadds Ford, PA. Gift of Amanda
K. Berls

Early Autumn, White Birch, 1936
Oil on panel
31 x 25"
Haverford College Library, PA. Special
Collections

Jack Frost, 1936
Oil on board
25 x 19"
Haggin Museum, Stockton, CA

Daniel's Farm, 1937
Oil on panel
9 x 12"
Collection of Mr. and Mrs. Donald
Caldwell

Dusk, 1942
Oil on Masonite
13¼ x 15¼"
Lent by the New Britain Museum of
American Art. Charles F. Smith Fund

Moonlight Night: Winter, 1942
Oil on board
19⁵⁄₁₆ x 15¾"
Rare Book Department, The Free Library
of Philadelphia

Hunt Farm, 1948
Oil on board
23 x 18⅞"
Hood Museum of Art, Dartmouth College,
Hanover, NH. Gift of the Artist, through
the Friends of the Library

Hill Top Farm, Winter, 1949
Oil on masonite
13½ x 15½"
Museum of Fine Arts, Boston. Gift of
Katherine H. Putnam, by exchange

Arizona, 1950
Oil on board
20½ x 17"
Phoenix Art Museum. Bequest of Thelma
Kieckhefer

Swiftwater, 1953
Oil on panel
23 x 18½"
Collection of Joseph Zicherman

Getting Away from It All, 1961
Oil on board
12 x 14"
Private Collection

GRAPHICS

Man with Cigarette and Cane
Pen and ink drawing on paper
8 x 5½"
Haverford College Library, PA. Special
Collections

Untitled (Blue Tones)
Watercolor on board
5⅛ x 4⅛"
Collection of the Brandywine River
Museum, Chadds Ford, PA. Gift of the
Maxfield Parrish Museum, Inc., Plainfield,
NH. Courtesy of Alma Gilbert

Dragon, 1877
Pen and ink on paper
4½ x 7¾"
Haverford College Library, PA. Special
Collections

Calendar, 1887
Etching on paper
14½ x 12"
Private Collection

*Haverford Classbook: Class Poet; Glee
Club; Ukulele Player; Historian,* 1889
Pen and ink on paper
4½ x 4½" each
Haverford College Library, PA. Special
Collections

*Hotel Bellevue Menu Cards: Balloon Man;
Nutty; Infant Scientist,* 1891
Pen, ink, and watercolor on paper
7½ x 4½" each
Haverford College Library, PA. Special
Collections

Untitled (Susan Walker), 1891
Pencil and watercolor on paper
11 x 5⅞"
Rare Book Department, The Free Library of
Philadelphia

Men's Day Life, 1892–94
Charcoal and pencil on paper
24⅝ x 19⅛"
Pennsylvania Academy of the Fine Arts.
Acquired by exchange through the gift of
Mrs. Morris Fussell

Old King Cole, 1894
Ink, graphite, watercolor, gouache, and
collage on wove paper
13½ x 32"
Pennsylvania Academy of the Fine Arts.
Gilpin Fund Purchase

Book News, 1895
Lithograph on paper
12¼ x 10"
Delaware Art Museum. Gift of Mrs. J.
Marshall Cole

Moonrise, 1895
Watercolor on paper
10 x 14"
Collection of Alma Gilbert

The Century Midsummer Holiday Number,
1896
Lithograph on paper
19¹⁵⁄₁₆ x 13⁹⁄₁₆"
The Metropolitan Museum of Art. Leonard
A. Lauder Collection of American Posters.
Gift of Leonard A. Lauder

No-To-Bac, 1896
Lithograph on paper
44¾ x 31⅛"
Philadelphia Museum of Art. The William
H. Helfand Collection

*Poster Show: Pennsylvania Academy of
the Fine Arts, Philadelphia,* 1896
Silkscreen on paper
37½ x 27⅞"
Pennsylvania Academy of Fine Arts. Asbell
Fund Purchase and Gift of Dr. Edgar P.
Richardson

Wanamaker's Goods & Prices, No. 40, 1896
Printed catalogue
10 x 7"
Historical Society of Pennsylvania

The Adlake Camera, 1897
Lithograph on paper
11 x 17"
Haverford College Library, PA. Special
Collections

The Bartram's New Year Greeting, 1897
Mixed media on paper
25¾ x 18¼"
Collection of the Brandywine River
Museum, Chadds Ford, PA. Gift of Bertha
Bates Cole, in memory of Bertha Corson
Day Bates

Blacksheep, Blacksheep, 1897
Lithographic crayon and black ink on white
paper
12¼ x 10⅜"
Fogg Art Museum, Harvard University Art
Museums. Gift of Charles B. Hoyt

Figure, 1897
Watercolor, black ink, black chalk, varnish
and cutout paper on off-white wove
paper
11¼ x 11⁹⁄₁₆"
The Metropolitan Museum of Art. Gift of
A. E. Gallatin

Free to Serve, 1897
Lithograph on paper
18⅜ x 12⁹⁄₁₆"
The Metropolitan Museum of Art. Leonard
A. Lauder Collection of American Posters.
Gift of Leonard A. Lauder

Humpty Dumpty, 1897
Ink and collage on woven paper mounted
on board
16¾ x 12¾"
Courtesy of the Syracuse University Art
Collection

Little Jack Horner, 1897
Pen and ink on paper
12½ x 10½"
Collection of Jim and Judi Kaiser

Scribner's Fiction Number, 1897
Lithograph on paper
19¹³⁄₁₆ x 14⅜"
The Metropolitan Museum of Art. Leonard
A. Lauder Collection of American Posters.
Gift of Leonard A. Lauder

Wond'rous Wise Man, 1897
Pen and ink on paper with pasted and
printed (Benday®) overlays
11¼ x 10"
Collection of Justin G. Schiller

At an Amateur Pantomime, 1898
Wash, ink, pencil, crayon, and lithographic
crayon on Steinbach® paper
27⅜ x 18½"
Museum of Fine Arts, Boston. Gift of Mrs.
J. Templeman Coolidge

Alarums and Excursions, 1899
Pen and India ink, India wash drawing with
Chinese white over pencil on paper
11 x 7"
Cleveland Museum of Art. Bequest of
James Parmelee

Blacksmiths, 1899
Pen and ink on paper
16 x 12"
Private Collection

*Bookplate Design for John R. and Ethel
Morrison Van Derlip,* 1899–1900
Pen, brush, India ink, and white heightening
on paper
18⅝ x 12¾"
Lent by the Minneapolis Institute of Arts.
Bequest of John R. Van Derlip in memory
of Ethel Morrison Van Derlip

Concerning Witchcraft, 1899
Pen and ink on paper
11¹³⁄₁₆ x 8⅝"
Rare Book Department, The Free Library of
Philadelphia

What They Talked About, 1899
Pencil, charcoal, pen and ink, and ink wash
on paper mounted on paperboard
11⅝ x 7½"
National Museum of American Art, Smith-
sonian Institution. Bequest of Olin Dows

Harper's Weekly, National Authority on Amateur Sport, 1900
Halftone on paper
20 x 15"
Delaware Art Museum. Gift of Mrs. J. Marshall Cole

Untitled (Outing cover design), 1900
Pen, ink, and watercolor on paper
12 3/16 x 12 3/16"
Rare Book Department, The Free Library of Philadelphia

Untitled (Scribner's cover design), 1900
Pen, ink, and watercolor on paper
11 x 7 11/16"
Rare Book Department, The Free Library of Philadelphia

Desert without Water (Cowboys), 1902
Lithograph on paper
9 1/2 x 6 1/2"
Collection of Louis Sanchez

Water on a Field of Alfalfa, 1902
Lithograph on paper
9 1/2 x 6"
Collection of Louis Sanchez

Untitled (Sketch of Entry to a Garden), 1904
Watercolor and ink on paper
5 5/8 x 3 7/8"
Collection of the Brandywine River Museum, Chadds Ford, PA. The Jane Collette Wilcox Collection

An Odd Angle of the Isle (The Tempest), 1909
Lithograph on paper
7 x 6 3/4"
The Metropolitan Museum of Art. Bequest of John O. Hamlin

As Morning Steals upon the Night (The Tempest), 1909
Lithograph on paper
7 x 6 3/4"
The Metropolitan Museum of Art. Bequest of John O. Hamlin

The Phoenix Throne (The Tempest), 1909
Lithograph on paper
7 x 6 3/4"
The Metropolitan Museum of Art. Bequest of John O. Hamlin

A Strong-Based Promontory (The Tempest), 1909
Lithograph on paper
7 x 6 3/4"
The Metropolitan Museum of Art. Bequest of John O. Hamlin

The Pied Piper, 1909
Lithograph on paper
6 3/4 x 21 1/4"
Rare Book Department, The Free Library of Philadelphia

Thanksgiving, 1909
Lithograph on paper
15 x 10 3/4"
Private Collection

Sing a Song of Sixpence, 1910
Lithograph on paper
8 5/8 x 20 7/8"
Rare Book Department, The Free Library of Philadelphia

Young King of the Black Isles, 1910
Lithograph on paper
11 x 8 3/4"
Rare Book Department, The Free Library of Philadelphia

Cinderella (Enchantment), 1914
Lithograph on paper
21 7/8 x 13 3/4"
Rare Book Department, The Free Library of Philadelphia

Harper's Bazar: Cinderella, 1914
Lithograph on paper
14 1/4 x 9 3/4"
Rare Book Department, The Free Library of Philadelphia

Florentine Fete, 1915
Lithograph on paper
21 1/2 x 25 1/4"
Collection of Creston Tanner

Italian Villas, 1915
Lithograph on paper
19 3/4 x 13"
Rare Book Department, The Free Library of Philadelphia

Djer-Kiss Cosmetics: Girl on Swing, 1916
Lithograph on paper
17 x 11"
Collection of Alma Gilbert

Florentine Fete, 1916
Lithograph on paper
8 5/8 x 14 1/8"
Rare Book Department, The Free Library of Philadelphia

Djer-Kiss Cosmetics: Girl with Elves, 1918
Lithograph on paper
14 1/8 x 9"
Rare Book Department, The Free Library of Philadelphia

Edison Mazda Lamps Calendar: Night Is Fled (Dawn), 1918
Lithograph on paper
14 5/8 x 9 1/2"
Rare Book Department, The Free Library of Philadelphia

Fisk Tires: Fit for a King, 1918
Lithographic window card
9 x 20"
Collection of Jason Karp and Sandra Lake

Garden of Allah, 1918
Lithograph on paper
15 x 30"
Collection of Mr. and Mrs. Michael L. Crippen

Girl by a Fountain (study for Garden of Allah), 1918
Crayon on paper
11 1/4 x 9 15/16"
Carnegie Museum of Art, Pittsburgh. American Artists' War Emergency Fund

Fisk Tires: Mother Goose, 1919
Lithograph billboard panel
40 x 60"
The Metropolitan Museum of Art. Museum Accession

Jell-O, 1921
Lithograph on paper
7 7/8 x 11 1/4"
Rare Book Department, The Free Library of Philadelphia

Ladies' Home Journal: Sweet Nothings, 1921
Lithograph on paper
14 x 10 3/4"
Rare Book Department, The Free Library of Philadelphia

Daybreak, 1922
Lithograph on paper
16 x 22"
The Metropolitan Museum of Art. Bequest of John O. Hamlin, 1976

Edison Mazda Lamps Calendar: Egypt, 1922
Lithograph on paper
16 7/8 x 13 3/8"
Rare Book Department, The Free Library of Philadelphia

Edison Mazda Lamps Calendar: Dreamlight, 1925
Lithograph on paper
23 5/8 x 15"
Rare Book Department, The Free Library of Philadelphia

Collier's Magazine: The Knave of Hearts,
1929
Lithograph on paper
14 x 10⅝"
Rare Book Department, The Free Library of
Philadelphia

Edison Mazda Lamps Calendar: Ecstasy,
1930
Lithograph on paper
33⅞ x 15⅜"
Rare Book Department, The Free Library
of Philadelphia

The Glen, 1936
Lithograph on paper
22½ x 17¾"
Rare Book Department, The Free Library of
Philadelphia

Sunup, 1945
Lithograph on paper
16 x 12"
Collection of Creston Tanner

Study for Valley of Enchantment, ca. 1946
Watercolor on board
8⅞ x 7¼"
Collection of the Brandywine River
Museum, Chadds Ford, PA. Gift of the
Maxfield Parrish Museum, Inc., Plainfield,
NH. Courtesy of Alma Gilbert

BOOKS

[L. Frank Baum]
Mother Goose in Prose, 1897
Printed book
11⅜ x 9½"
Chicago and New York: George M. Hill
Company
Rare Book Department, The Free Library of
Philadelphia

The Lantern, 1898
Printed journal
9⅜ x 7¾"
Bryn Mawr College Archives

[Kenneth Grahame]
The Golden Age, 1899
Printed book
8⅛ x 6¼"
London and New York: John Lane: The
Bodley Head
Rare Book Department, The Free Library of
Philadelphia

[Washington Irving]
Knickerbocker's History of New York, 1900
New York: R. H. Russell
12⅞ x 9¼"
Collection of the Brandywine River Mu-
seum, Chadds Ford, PA. Uncatalogued Gift
of the Maxfield Parrish Museum, Inc.,
Plainfield, NH. Courtesy of Alma Gilbert

[Kenneth Grahame]
Dream Days, 1902
Printed book
8¼ x 6½"
London and New York: John Lane: The
Bodley Head
Rare Book Department, The Free Library of
Philadelphia

Haverford Verse, 1904
Printed book
8½ x 6½"
Haverford College Library, PA. Special Col-
lections

[Edith Wharton]
Italian Villas and Their Gardens, 1904
Printed book
10¾ x 7¼"
New York: The Century Company
Art Department, The Free Library of
Philadelphia

[Eugene Field]
Poems of Childhood, 1904
Printed book
9½ x 7½"
New York: Charles Scribner's Sons
Rare Book Department, The Free Library of
Philadelphia

[Kate Douglas Wiggin and Nora A. Smith,
eds.]
*The Arabian Nights, Their Best-Known
Tales*, 1909
Printed book
9½ x 7½"
New York and London: Charles Scribner's
Sons
Rare Book Department, The Free Library of
Philadelphia

[Louise Saunders]
The Knave of Hearts, 1925
Printed book
14⅛ x 11¾"
New York: Charles Scribner's Sons
Rare Book Department, The Free Library of
Philadelphia

PHOTOGRAPHS

Potpourri: Maxfield Parrish Posing, 1904
Gelatin silver print
10 x 8"
The Memorial Art Gallery of the Univer-
sity of Rochester, NY

Villa Caprarola, 1904
Painted photograph
12 x 10"
Collection of Peter Smith and Alma
Gilbert

Homage to Susan Lewin
Photographic collage
Collection of the Brandywine River Mu-
seum, Chadds Ford, PA. Gift of the Max-
field Parrish Museum, Inc., Plainfield, NH.
Courtesy of Alma Gilbert (original gift of
Harold Knox)

Susan Lewin Posing for The Idiot, ca. 1910
Modern print from original glass-plate
negative
10 x 8"
Collection of the Brandywine River Mu-
seum, Chadds Ford, PA. Gift of the Max-
field Parrish Museum, Inc., Plainfield, NH.
Courtesy of Alma Gilbert

*Susan Lewin in Diaphanous Gown Posing
for* Florentine Fete, ca. 1913
Modern print from original glass-plate
negative
10 x 8"
Collection of the Brandywine River Mu-
seum, Chadds Ford, PA. Gift of the Max-
field Parrish Museum, Inc., Plainfield, NH.
Courtesy of Alma Gilbert

Susan Lewin in Velvet Dress Posing for Flo-
rentine Fete, ca. 1913
Modern print from original glass-plate
negative
10 x 8"
Collection of the Brandywine River Mu-
seum, Chadds Ford, PA. Gift of the Max-
field Parrish Museum, Inc., Plainfield, NH.
Courtesy of Alma Gilbert

Susan Lewin Posing for Reveries, ca. 1913
Modern print from original glass-plate
negative
10 x 8"
Collection of the Brandywine River Mu-
seum, Chadds Ford, PA. Gift of the Max-
field Parrish Museum, Inc., Plainfield, NH.
Courtesy of Alma Gilbert

Susan Lewin Posing as The Mad Hatter, ca. 1914
Modern print from original glass-plate negative
10 x 8"
Collection of the Brandywine River Museum, Chadds Ford, PA. Gift of the Maxfield Parrish Museum, Inc., Plainfield, NH. Courtesy of Alma Gilbert

Susan Lewin Posing for Djer-Kiss Cosmetics: Girl on Swing, ca. 1916
Modern print from original glass-plate negative
10 x 8"
Collection of Peter Smith and Alma Gilbert

Susan Lewin Posing for Djer-Kiss Cosmetics: Girl with Elves, ca. 1918
Modern print from original glass-plate negative
10 x 8"
Collection of the Brandywine River Museum, Chadds Ford, PA. Gift of the Maxfield Parrish Museum, Inc., Plainfield, NH. Courtesy of Alma Gilbert

ASSORTED OBJECTS AND EPHEMERA

Female Figure/Candle Holder
Carved wood
14⅜ x 3 x 3⅛"
Collection of the Brandywine River Museum, Chadds Ford, PA. Gift of the Maxfield Parrish Museum, Inc., Plainfield, NH. Courtesy of Alma Gilbert

Gargoyle/Hat Peg
Carved wood
8¾ x 5⅜ x 3"
Collection of the Brandywine River Museum, Chadds Ford, PA. Gift of the Maxfield Parrish Museum, Inc., Plainfield, NH. Courtesy of Alma Gilbert

Toy Chair
Carved wood
17⅜ x 6 x 6⅜"
Collection of the Brandywine River Museum, Chadds Ford, PA. Gift of the Maxfield Parrish Museum, Inc., Plainfield, NH. Courtesy of Alma Gilbert

Toy Crane
Carved wood
10⅝ x 7¾ x 16⅞"
Collection of the Brandywine River Museum, Chadds Ford, PA. Gift of the Maxfield Parrish Museum, Inc., Plainfield, NH. Courtesy of Alma Gilbert

Ukulele, ca. 1889
Hand-painted wood
25 x 8 x 2"
Haverford College Library, PA. Special Collections

Chemistry Notebook, 1889–90
Pen, ink, and watercolor on paper
8½ x 7"
Haverford College Library, PA. Special Collections

Memento to Augustus Saint-Gaudens, 1902
Collage, engraved stamp with drawing
4½ x 5¾"
U.S. Department of Interior, National Park Service, Saint-Gaudens National Historical Site, Cornish, NH. Gift of Mr. and Mrs. Augustus Saint-Gaudens II

Circus Bedquilt Design, 1904
Oil and collage on stretched paper
23⅝ x 22¹³⁄₁₆"
Rare Book Department, The Free Library of Philadelphia

Comic Mask, 1905
Bronze
8 x 6¼"
Courtesy of the American Precision Museum, Windsor, VT

Hubert Herkomer Statement (The Golden Age), 1906
Ink on paper
10½ x 8"
Haverford College Library, PA. Special Collections

"Welcome Home, Teddy," 1910
Mixed media on paper
15½ x 9¾"
Collection of Ron and Marilyn Sanchez

"Dear Austin" Illustrated Letter, 1911
Mixed media on paper
12½ x 19½"
Private Collection

Architectural Model for Florentine Fete, 1915
Carved wood
55 x 25¼ x 8¼"
Collection of Creston Tanner

Crane's Chocolates: Cleveland–New York–Kansas City, ca. 1915
Metal sign
19 x 13"
Collection of Jason Karp and Sandra Lake

Gnome (Snow White), ca. 1916
Painted figure cutout with jigsaw
16½ x 5"
Courtesy of the American Precision Museum, Windsor, VT

Crane's Chocolates: Garden of Allah, 1918
Candy box
8 x 14"
Collection of Jason Karp and Sandra Lake

General Electric Edison Mazda Light Bulb, 1920s
5 x 2⅜"
Collection of the Brandywine River Museum, Chadds Ford, PA. Gift of the Maxfield Parrish Museum, Inc., Plainfield, NH. Courtesy of Alma Gilbert

The Stage Manager (The Knave of Hearts), 1923
Cutout paper with pencil
14 x 12"
Collection of the Brandywine River Museum, Chadds Ford, PA. Gift of the Maxfield Parrish Museum, Inc., Plainfield, NH. Courtesy of Alma Gilbert

[Cutout Model for] Entrance to Old King Cole Room, 1936
Oil on paper mounted on masonite and wood
20½ x 21⅝"
Collection of the Brandywine River Museum, Chadds Ford, PA. Anonymous Gift

Architectual Model for Sunup, 1942
Assorted woods
12 x 26 x 14½"
Collection of Creston Tanner

NON-PARRISH WORKS

Kenyon Cox (1856–1919)
Maxfield Parrish, 1910
Oil on canvas
30 x 25"
National Academy Museum, New York

Virgil Marti (b. 1962)
Untitled, 1996
Novajet print on resin-coated paper in anaglyphic 3-D
35½ x 50½"
Courtesy of the Artist

Joan Nelson (b. 1958)
Untitled No. 432 (After Painting by Maxfield Parrish), 1997
Acrylic with oil on wood panel
59¾ x 59⅞"
Robert Miller Gallery, New York

Index

Photography Credits:

Michael Agee: *Dusk*, p. 115. **Will Brown:** *Mother Goose in Prose*, p. 45; *Sing a Song of Sixpence*, p. 46–47; *Fisk Tires: Mother Goose*, p. 48; *Hearst's Magazine: Hermes*, p. 68; *Djer-Kiss Cosmetics: Girl with Fairies*, p. 87; *Florentine Fete*, p. 97; *Ladies' Home Journal: Sweet Nothings*, p. 98; *Edison Mazda Lamps Calendar: Night is Fled (Dawn)*, p. 108; *Edison Mazda Lamps Calendar: Ecstasy*, p. 109; *The Pied Piper*, p. 95; *Young King of the Black Isles*, p. 81; *Harper's Bazar: Cinderella*, p. 98; *Italian Villas*, p. 63. **Rick Echelmeyer:** *Chemistry Notebook*, p. 20; *Mask and Wig Caricatures*, p. 32; *Old King Cole*, p. 32; *Poster Show: Pennsylvania Academy of the Fine Arts, Philadelphia*, p. 37; *The Adlake Camera*, p. 48; *Princess Parizade Bringing Home the Singing Tree*, p. 130; *Circus Bedquilt Design*, p. 96; *Daniel's Farm*, p. 114; *Moonlight Night: Winter*, p. 128; *Stormbearers of the Norsemen*, p. 129; *Hermes*, p. 134; *Edison Mazda Lamps Calendar: Spirit of Night*, p. 138; *Perspective Manual*, p. 29; *The Golden Age*, p. 55; *Concerning Witchcraft*, p. 125; *Princess Parizade Bringing Home the Singing Tree*, detail, p. 131; *Princess Parizade Bringing Home the Singing Tree*, infrared view of detail, p. 131; *Moonlight Night: Winter*, overall infrared view of painting, p. 132; *Moonlight Night: Winter*, detail, p. 133; *Moonlight Night: Winter*, infrared view of detail, p. 133; *Hermes*, overall infrared view of painting before conservation treatment, p. 134; *Moonlight Night: Winter*, detail of frame, p. 140; *Crate for Circus Bedquilt Design*, p. 141; *Princess Parizade Bringing Home the Singing Tree*, detail of paint crackle before conservation treatment, p. 137. **John Grauer:** *Ukulele*, p. 20. **Aaron Igler:** Virgil Marti. *Untitled*, p. 120. **Ron Jennings:** *Little Sugar River at Noon*, p. 126. **John Lauer:** *Early Autumn, White Birch*, p. 114; *Dragon*, p. 18; *Haverford Classbook: Class Poet; Glee Club; Ukelele Player; Historian*, p. 19. **David Putnam:** Stage Set for *The Woodland Princess*, p. 89. **Richard Wolbers:** *Hermes*, microscopic view of cross-section of paint in sky showing paint layers, normal light, p. 135; *Hermes*, microscopic view of cross-section of brown paint at bottom edge showing bright fluorescence of varnish layers in paint structure, ultraviolet light, p. 135.